£5

INTRODUCTION TO

VICTORIAN
STYLE

INTRODUCTION TO

VICTORIAN
STYLE

DAVID CROWLEY

THE
APPLE
PRESS

A QUINTET BOOK

Published by the Apple Press Ltd
6 Blundell Street
London N7 9BH

ISBN 1-85076-219-8

Creative Director: Peter Bridgewater
Art Director: Ian Hunt
Designer: Sally McKay
Artwork: Danny McBride
Editor: Shaun Barrington
Picture Researcher: Liz Eddison

Typeset in Great Britain by
Central Southern Typesetters, Eastbourne
Manufactured in Hong Kong by
Regent Publishing Services Limited
Printed in Hong Kong by
Lee Fung Asco Printers Ltd

CONTENTS

INTRODUCTION

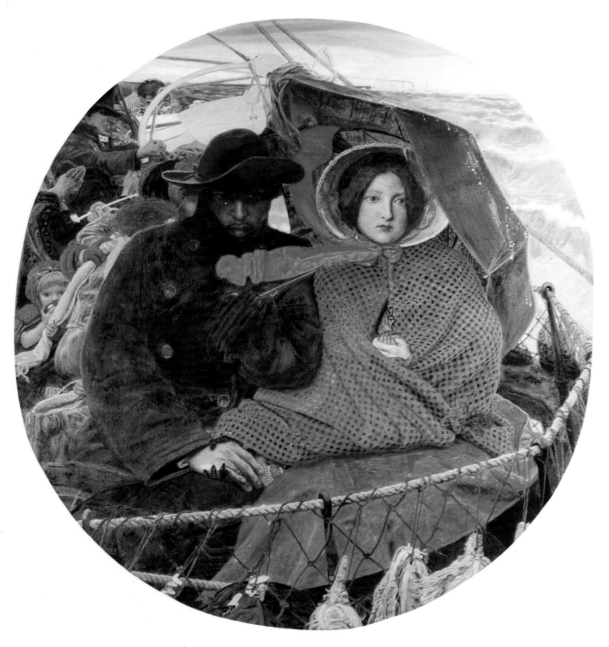

ABOVE *The gulf between the prosperous and the destitute in Victorian England concerned many artists and writers of the period. Ford Madox Brown's The Last of England of 1863 depicts the plight of those forced to emigrate to escape poverty.*

or H. Stannus and other contemporary eulogists for late 19th-century British culture the word 'Victorian' was synonymous with progress. In his 1891 study of the life and work of the artist Alfred Stevens, Stannus revealingly wrote '. . . our peculiarly modern or VICTORIAN style'. Yet Matthew Arnold, in his book *Culture and Anarchy* of 1869, equated the upper reaches of Victorian society with barbarism, and the middle classes with philistinism. The meaning of what it was to be a Victorian was as complex then as it is now. Today it does not simply describe a period in history, the 64-year reign of a queen from 1837 to 1901. For while 'Tudor' and 'Georgian' are evocative of phases in British history, 'Victorian' has entered the English language as a rich adjective that describes more than the past. It has become a term which is frequently used to describe attitudes today. 'Victorian' now rings of strict morality, prudery, solemnity, Christian ethics, ideas about individual industry coupled with responsibility to the community, and above all conventionality.

Prominent Victorians displayed these characteristics in ready measure: Prince Albert, the Prince Consort, who was once described as the most 'Victorian of Victorians'; the arch-moralist Samuel Smiles, author of *Self-Help*, the Victorian manual; John Ruskin, champion of the Gothic and Christianity in art and design; Florence Nightingale, the 'lady with lamp' in the Crimean War; General Charles Booth, the founder of the Salvation Army who combined two Victorian passions, religion and the military; Octavia Hill, the philanthropist who attempted to combine charity and profitability in housing schemes for London's working classes.

The collection of values associated with these people can be traced through to the artifacts with which millions of ordinary Victorians surrounded themselves. Paintings like Richard Redgrave's *The Outcast* of 1851 showing a women cast out into the night clutching her illegitimate child, Ford Maddox Brown's *Work*, which celebrates labour and criticizes idleness, and innumerable paintings of biblical scenes found their way into many Victorian homes as popular engravings.

Even ordinary day-to-day items found in Victorian homes echoed the values found in greater society. The rise of the Gothic style in mid-19th century Britain, which penetrated the homes of all classes, was for its proponents a highly moral style reflecting hard work and craftsmanship.

Domestic goods reflected the greater Victorian world in other ways. The British Empire and developments in international communications brought to Victorian homes new goods and materials, and exotic styles. Fashions swept across England

in the wake of colonial and international exhibitions. Liberty's, a shop selling furnishings, fabrics and decorative art in London's Regent Street built its reputation by selling Japanese style goods from the mid 1870s.

In fact, Victorians had particular relationships and fascination with the objects that surrounded them. As the middle classes grew, and the standard of living improved for the majority of the population (despite occasional trade depressions), people could increasingly afford the products of manufacturing industry. This was not lost on contemporary observers. John Hollingshead wrote in 1862:

 We may not be more moral, more imaginative, nor better educated than our ancestors, but we have steam, gas, railways and power-looms, while there are more of us, and we have more money to spend.

In a new age of mass consumption, advertising and retailing were becoming increasingly sophisticated in order to capture ever-growing markets. The late 19th century saw a series of innovations including department stores and national advertising campaigns in the press and on the streets.

To consume was to assert taste and social position. A home and its contents was the primary site of status in all levels of society. Methods of mass production were developed to make art for the common man, such as neo-Classical 'Parian' figures. In the middle years of the century, mantelpieces in Liverpool's terraced houses could display that which had previously been available only to the private collector in Mayfair.

In earlier centuries, the major problem facing people concerning the objects in their lives was how to secure them. In the Victorian period, it appears that the newly affluent lacked confidence in their new found ability to buy the products of manufacturing industry. This is revealed by the success of books like Charles Eastlake's *Hints on Household Taste*, which aimed to educate the middle classes on the appropriate ways to furnish and decorate their homes.

Victorian society was fascinated by inventive achievement and technological novelty. Popular journals, such as the *MacMillan Magazine*, chronicled new developments in science and art. Over six million people, in just six months, flocked to The Great Exhibition of the works of industry of all nations in 1851, to view the achievements of industry and handicraft.

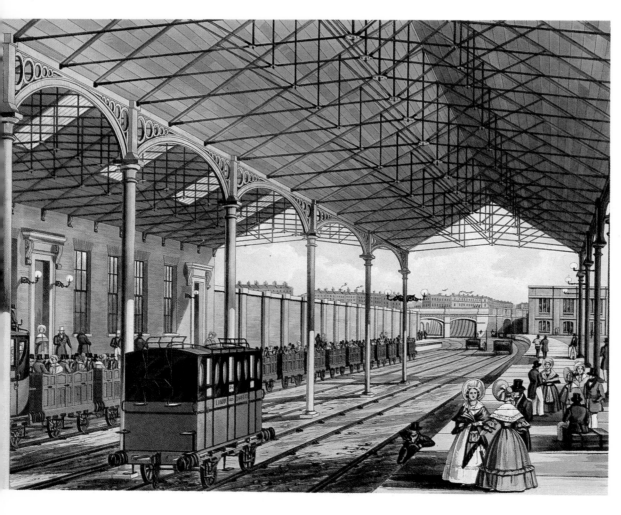

LEFT *The railway system rapidly became a key element in the infrastructure of industrial Victorian Britain boasting 6,800 miles of operational track by 1851. This coloured engraving of 1837, the year of the first publication of Bradshaw and Blacklocks railway timetable, shows the London terminus of the London and Birmingham Railway at Euston Square.*

TASTE AND HISTORY

Despite the receptivity of popular taste to the new, the novel and the exotic, the Victorian period has frequently been maligned as a low point in the history of style. The story of art and design in much of the 20th century has been written by men and women inspired by the values of Modernism. Nikolaus Pevsner's *Pioneers of Modern Design* is a good example of the Modernist anti-Victorian viewpoint. Pevsner dismissed 19th-century preferences for extravagant ornament, narrative devices, *trompe l'oeil*, sentimentality and decorative novelty as 'bad taste'. Another art historian recalled attitudes to Victorian culture in the 1960s with these words:

I was taught only to revile the memory of Edwin Landseer, painter of *The Monarch of the Glen* . . . Similarly, Edwin Lutyens, extravagantly expressive architect to an Edwardian imperial class, was always held to me as what was wrong in architecture until Modernism cleared it up. As for William Burges, High Victorian designer, well in my youth, he was just *unspeakable*.

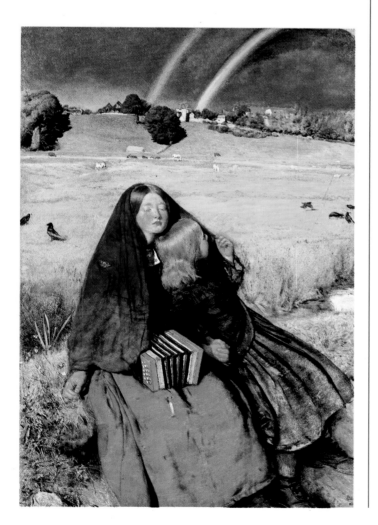

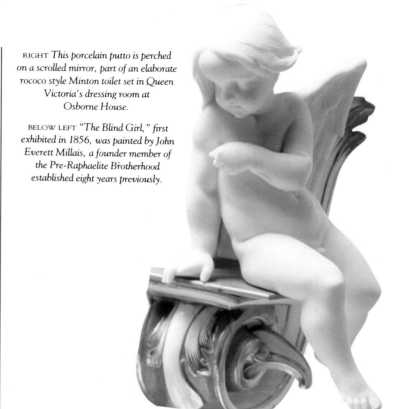

RIGHT *This porcelain putto is perched on a scrolled mirror, part of an elaborate rococo style Minton toilet set in Queen Victoria's dressing room at Osborne House.*

BELOW LEFT *"The Blind Girl," first exhibited in 1856, was painted by John Everett Millais, a founder member of the Pre-Raphaelite Brotherhood established eight years previously.*

But it is interesting to note that as the dominance of Modernism in culture has withered away, Victorian art and design has become the subject of increasing attention. In art galleries throughout the world Victorian paintings have been taken out of store and put back on display. There have been major exhibitions of Pre-Raphaelite art and the Gothic architecture and design of William Burges. One of the most successful exhibitions at the Royal Academy in London in the 1970s was 'Great Victorian Paintings'. In auction rooms, works by artists such as Ford Maddox Brown and Lawrence Alma-Tadema have reached prices that would have been inconceivable just a few years earlier.

The values in art and design that the Victorians held so dear correspond with those that Post Modernists prize today. Just as Owen Jones sought eclecticism in his survey of the styles of all periods and places, *The Grammar of Ornament* in 1856, a designer like Ettore Sottsass, founder of the Memphis design group in 1981, is celebrated for very similar enthusiasms.

During the reign of Modernist architectural thought, a building such as Charles Barry's Houses of Parliament, a 19th-century edifice decorated in the architectural style of the Middle Ages, the Gothic, was considered the height of irrationality. With the rise of Post Modernism, this building is now regarded as an important part of Britain's architectural heritage.

Of course it is an exaggeration to say that all artists and designers of the Victorian period have been relegated to minor

positions of importance by cultural historians of the 20th century. Certain figures such as the designer Christopher Dresser and the architect Lewis Cubitt, have been ascribed roles of great importance. Typically, these Victorian artists and designers have been championed by people in the 20th century who find echoes of their own ideas in the 19th century. Art Nouveau style posters, for example, became popular in the 1960s when flowing organic forms and sensual depictions of women became fashionable in graphic design.

Occasionally this has led to a misrepresentation of the intentions of a particular artist or designer. Christopher Dresser, for example, is often hailed as a proto-Modernist for his designs of electro-plated metalwork in the 1870s, produced by such firms as Elkington and Company. These highly geometric and 'functional' vessels appear to prefigure designs produced at the Bauhaus in Germany in the 1920s. Accordingly, Dresser's designs have been regarded as major stepping stones to the taste for highly abstract, geometric design in the 20th century. A closer inspection of Dresser's interests show him to have been far more a Victorian – particularly in his eclecticism – than a prophet of Modernism. The pluralism of his interests can be gauged by the fact that around the year 1880, he was still designing these 'modernist' electro-plated manufactures, at the same time working for the Linthorpe pottery designing expressive forms based on primitive art from Fiji, and promoting very restrained and sophisticated Japanese furniture.

ABOVE *An electroplated tureen designed in 1880 by Christopher Dresser for Hukin & Heath of Birmingham. Author of "Principles of Domestic Design," Dr Dresser's fresh uncluttered approach to domestic metalwork anticipated modernist design criteria.*

BELOW LEFT *A pottery cigar tray designed by Dresser for the short-lived Linthorpe pottery in Yorkshire (1879–81).*

BELOW *Dresser's Clutha glass of the 1880s and 90s, produced by the Glasgow firm of James Couper & Sons, were remarkable for their flowing organic form, subtle colouration and great delicacy.*

RIGHT *This recently restored tricycle rocking horse, still in perfect working condition, was manufactured in Paris during the 1880s.*

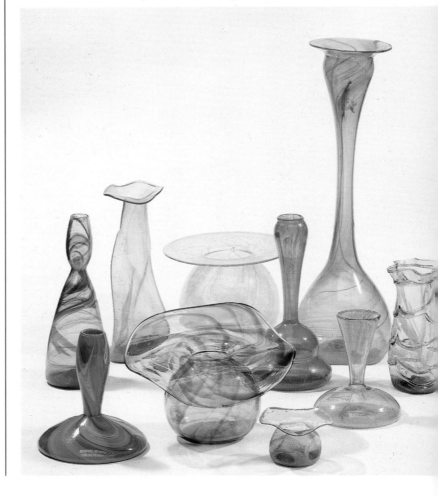

Alongside these academic debates among art historians about the merits and demerits of Victorian culture, another kind of historian has quietly but systematically contributed to our knowledge of Victorian style: the amateur collector. While museums have concentrated on the most celebrated artistic and commercial achievements of the period, all kinds of everyday ephemera have been collected. Our understanding of Victorian life would be incomplete without these collections of song sheets, stamps, advertisements, penny dreadfuls, lace, matchboxes, children's toys, *cartes de visites*, packaging and countless other day-to-day mass-produced items. WP Frith's painting *The Railway Station*, exhibited at the Royal Academy in 1858, is just as much a product of its age as a tinplate clockwork toy train made by the firm of Marklin in the 1870s. Futhermore, that child's toy would bear fruitful examination alongside a full scale steam locomotive running on the London to Birmingham line operated by the Great Midland Railway of the same period. The marks of Victorian style and the Victorian mind are to be found in all three objects.

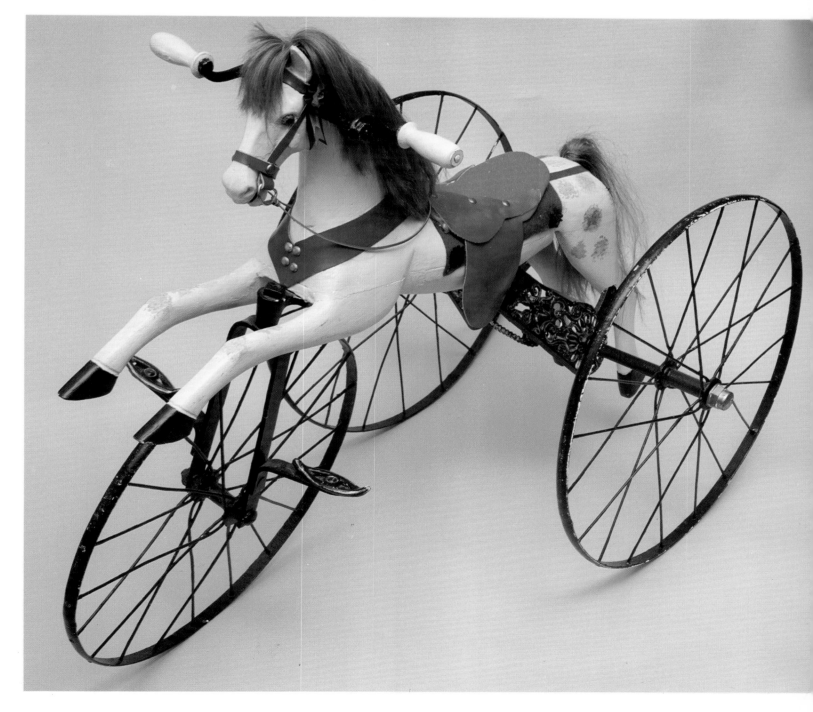

THE VICTORIAN AGE

Victorian values did not come into being with the accession of Victoria to the throne in 1837, nor did they end in 1901 on her death. Just as they were displayed in the activities of figures such as Hannah Moore, the evangelizing philanthropist in the first years of the 19th century, the early decades of the 20th century saw the continuity of the same concerns.

Victorian values, however, were not firmly entrenched until the late 1840s and were already breaking down by the 1870s. This is the age that has come to be known as the 'High Victorian period'. These years saw the height of British economic dominance, intense innovative activity in industry and communications and the untrammelled growth of the British Empire. In the 1870s Victorian Britain went through the first of a series of crises of confidence; social investigators told of the extent of deprivation in her cities, while the scramble for colonies in Africa by her European rivals disturbed the nation's confidence in the British Empire, and the economies of those same countries were clearly developing at a faster rate than Britain's. A new generation, who did not share the beliefs of their parents, came to regard the term 'Victorian' with scorn.

The same trends can be recognized in Victorian art and design. The most significant works of art, craft and industry of the High Victorian period were, in essence, celebrations of Victorian culture. The decades after 1870 saw the ascendancy of designers and artists who used their work to issue a challenge to Victorian morality, propriety and taste. These figures will be dealt with in the concluding chapter; this book's primary concern is with style in the High Victorian period.

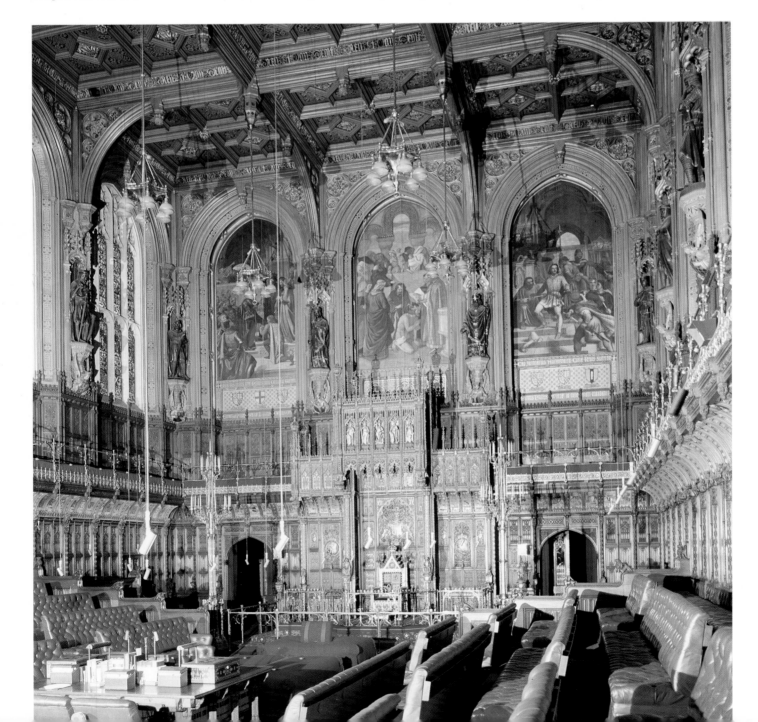

EARLY VICTORIAN STYLE

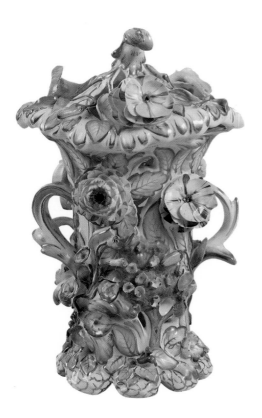

The strain of Classicism which had dominated taste in the first quarter of the century, the 'Regency' style, slowly went out of fashion. This style was typified by the highly regimented and restrained 'Greek' terraces surrounding Regent's Park in London, designed by John Nash. The Victorian mind, seeking novelty and exoticism, was not satisfied with this neo-Georgian Classicism: terraces of uniform white facades, and rooms tastefully decorated with pale freezes depicting tales of Greek mythology and furnished with Chippendale chaises longues, Wedgwood vases and Hepplewhite cabinets. Even Nash, the leading architect of the Regency period, bowed to this restlessness with 'good taste' by extending and improving William Porden's Royal Pavilion in Brighton, in the style of an Indian palace during the second decade of the century. This amazing building pre-figured Victorian fashions in architecture and design in its Chinese and Gothic details, and the use of structural cast iron. (But it should be remembered that the taste for Classical art and design never completely disappeared in the Victorian period.)

Under the influence of Paris and *Le Style Empire*, French fashions dominated British style in the 1830s and 1840s. This can be seen most directly in the Rococo Revival, which men like Benjamin Dean Wyatt, the architect and son of James Wyatt, promoted as a grand style, befitting the increasingly grand British Empire.

ABOVE *This Victorian Coalport pot-pourri with its complex florid design is expressive of the Victorian enthusiasm for decoration, often regardless of overall aesthetic effect.*

LEFT *The chamber of the House of Lords designed by Augustus Pugin (1815–52), architect responsible for the interior and exterior decoration of the Houses of Parliament in Medieval Gothic style.*

RIGHT *The elaborately carved neo-rococo furniture by Henry Belter featured in this American 19th century interior echoes the mid-18th century fashion for chinoiserie.*

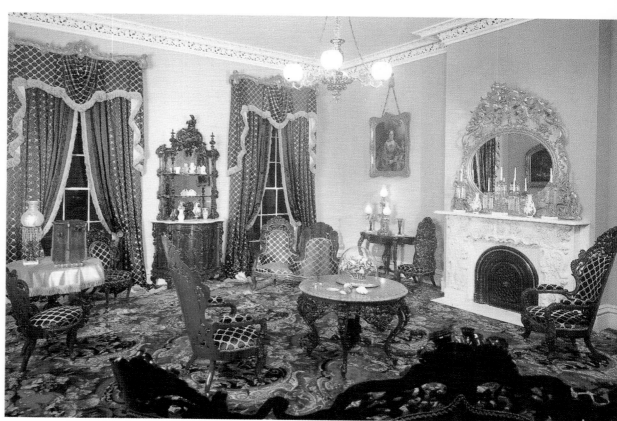

The Rococo style originated in France in the 1730s, and by the second half of the 18th century was used as a term to describe the European fashion for rich ornament, often in the form of marine and floral motifs, scrolling and curvilinear designs. Widely regarded as a frivolous style, Rococo broke all the rules of Classical good taste; symmetry, balance, geometric order and architectonic decoration. In all areas of the decorative arts, it was characterized by flights of fancy, *trompe l'oeil*, illusionary construction and, above all, ostentatious decoration.

The sources of the mid 19th-century Rococo Revival in Britain are to be found in the popularity of floral ornament in the 1820s promoted by firms such as Gillows of London and Lancaster. The firm decorated its furniture with rich acanthus ornament and lavish scrolled carving. The fashion for Rococo design had been stimulated by the availability in London of items of furniture displaying the very high standards of French craftsmanship after the Revolution. Collectors such as King George IV were able to profit from the misfortunes of the French aristocracy, and acquired the best Rococo designs of the 18th century.

The origins of the Rococo Revival in Britain were aristocratic. In 1824 the Duchess of Rutland, for example, employed Benjamin Dean Wyatt to redesign Belvoir Castle, in Leicestershire, in the Louis XIV style. Here, Wyatt and his younger brother Matthew Coates Wyatt, employed motifs and decorative forms taken directly from Rococo sources. An example of this can be found in one room at Belvoir, in which they utilized wainscoting from a late 18th-century chateau owned by Louis XIV's second wife, Madame de Maintenon. Benjamin Dean Wyatt was also employed by the Duke of Wellington to design and furnish Apsley House, and to furnish the homes of the Duke of York and the Marquis of Stafford.

But the Rococo Revival at its height – in the 1840s – was a solidly bourgeois affair. Numerous manufacturers used the Rococo style to give their products the air of expensive elegance. These goods were not historical re-creations of 18th-century designs, but generalizations of Rococo characteristics; C and S scrolls, naturalistic ornament, cabriole legs, balloon backs, deep upholstery and curvilinear forms. The kind of furniture regarded today as typically 'Victorian', originates from this mid 19th-century Rococo Revival. A button-backed, deeply upholstered armchair in a richly coloured velvet and with curved walnut legs, is as much a symbol of the Victorian era as the Albert Memorial.

Although no longer in the vanguard of style by the mid 1850s, Rococo continued to be a popular decorative style. It was an excellent vehicle for the bourgeoisie to display their wealth and taste, and consequently has been identified as the worst example of Victorian excess by historians of applied art.

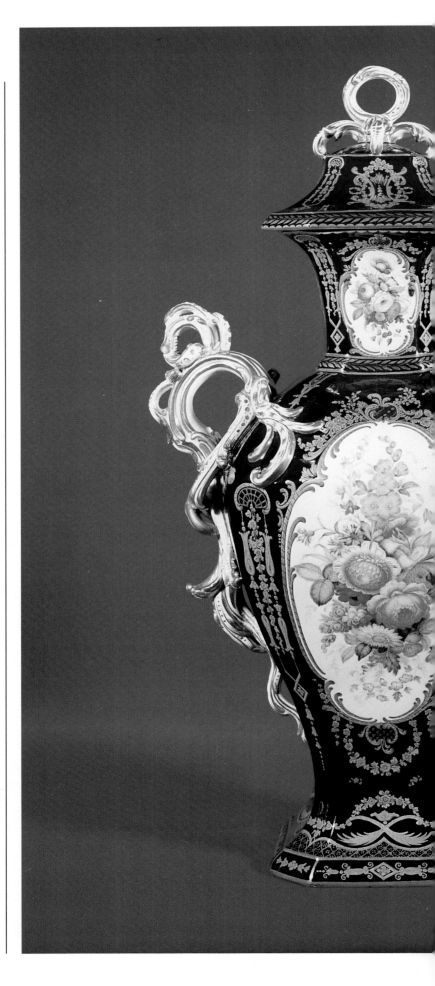

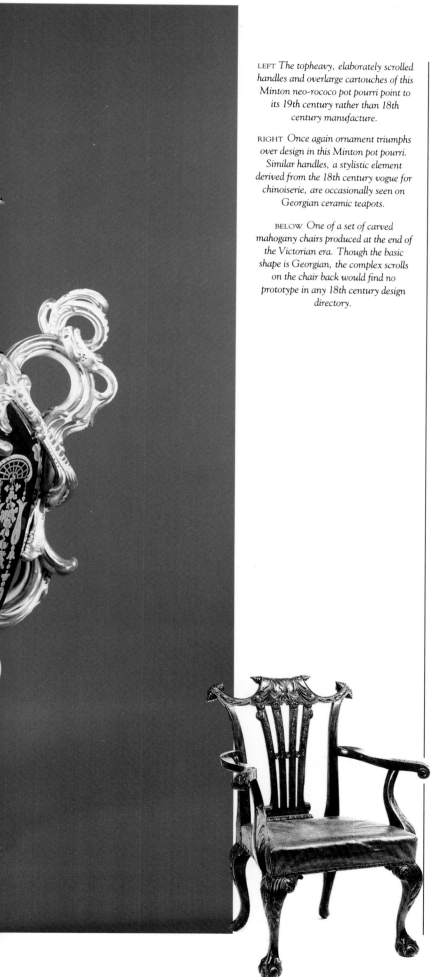

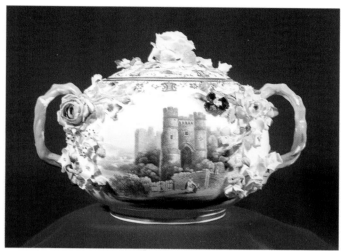

LEFT *The topheavy, elaborately scrolled handles and overlarge cartouches of this Minton neo-rococo pot pourri point to its 19th century rather than 18th century manufacture.*

RIGHT *Once again ornament triumphs over design in this Minton pot pourri. Similar handles, a stylistic element derived from the 18th century vogue for chinoiserie, are occasionally seen on Georgian ceramic teapots.*

BELOW *One of a set of carved mahogany chairs produced at the end of the Victorian era. Though the basic shape is Georgian, the complex scrolls on the chair back would find no prototype in any 18th century design directory.*

It was not popular with contemporary foreign observers who described the fashion in terms of distaste. One German aristocrat visiting the country, wrote:

 Everything is in the now revived taste of the time of Louis the Fourteenth; decorated with the tasteless excrescences, excess of gilding, confused mixture of stucco painting etc.

The apparent luxury and excess of Rococo became available to the poorer classes with developments in furniture making and decorative techniques. The firm of George Jackson and Sons produced a kind of putty which could be modelled, painted and then gilded on site to give the appearance of skilfully carved wood at one quarter of the cost. In 1833 Benjamin Dean Wyatt used this method to decorate the gallery in Apsley House, for Wellington, saving almost £1,600. Similarly, the development of papier-mâché furniture encouraged highly moulded Rococo forms such as cabriole legs, previously the products of costly craftsmen.

Both at the time and in later years, the Rococo Revival came under attack. Pevsner, reviewing Rococo style objects from the Great Exhibition wrote:

 You see an extremely elaborate pattern, the charm of which, during the Rococo period, would have been based on the craftman's imagination and unfailing skill. It is now done by machine and looks like it.

The Great Exhibition was dominated by the Victorian Rococo Revival. Ralph N. Wornum's highly critical essay *The Exhibition as a Lesson in Taste* acknowledged this highly influential style, stating rather clumsily: 'The Louis Quatorze varieties perhaps prevail in quantity, the Louis Quinze, and the Rococo'. Despite this, however, The Great Exhibition marked the first major Victorian attempt to break free from the dominance of French trends in taste and the search for a truly Victorian Style.

THE CRYSTAL PALACE AND POPULAR TASTE

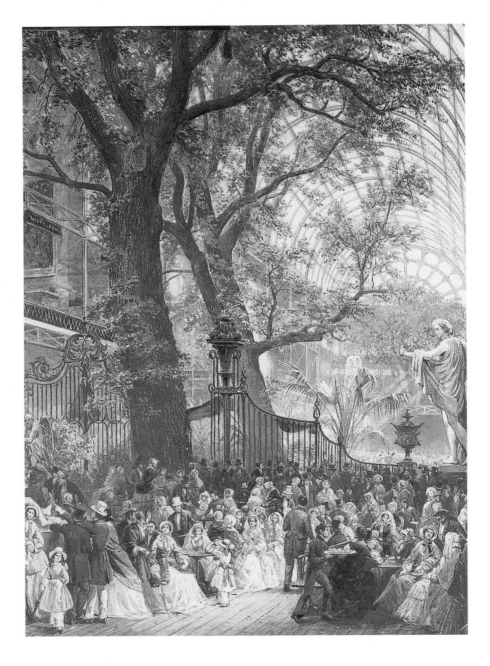

The end of the century marked the rise of the great department stores, such as Harrods, Whiteleys and Selfridges whose marble halls, filled with the manufacturing wealth of the British Empire, were in fact essentially inspired by the example of the great Crystal Palace exhibition of four decades previously.

y the middle of the 19th century Victorian Britain had proved itself to be the most successful industrial nation on earth. Thanks to the efforts of Britain's inventors, merchants and manufacturers, propped up by the markets and raw materials of the Empire, British industry dominated the world. One could buy Manchester's cottons in Delhi, and Sheffield's metalwork in Sydney; the epithet 'workshop of the world' rang true. Prince Albert said in 1851: 'No-one who has paid any attention to the particular features of the present era will doubt for a moment that we are living in a period of most wonderful transition'. Victorians felt themselves to be living in an age of unprecedented change and invention; science was redefining the world, railway travel had become commonplace, daily newspapers, printed by machine, were at their cheapest, and the homes of the middle class displayed the dramatic developments in manufacturing industry in their most basic contents; cutlery, dinner services and furnishings.

Yet questions of style perplexed Victorian designers and intellectuals. British art and design was widely regarded to be second rate when compared to French decorative arts of the period. Styles originating in Paris were held up in London, to be the zenith of artistic achievement. Writers, intellectuals, designers and manufacturers argued that Britain, with its commercial superiority and Christian moral leadership, ought to produce art and design worthy of its achievements in commerce and industry, rather than plagiarizing those of her rivals. Goods manufactured in Britain were inexpensive and dominated international markets, but the goods produced by her immediate rivals, Germany and France, were considered to be superior in terms of design and style, or in contemporary parlance 'art'. London watched as these pretenders to her commercial crown, rapidly industrialized to challenge British markets. In 1835 the Select Committee of Arts and Manufactures, formed under Robert Peel's government to investigate this very problem, reported:

 To us, a peculiarly manufacturing nation, the connection between art and manufactures is most important – and for this merely economical reason (were there no higher motive), it equally imports us to encourage art in its loftier attributes.

The Committee noted that despite the rapid industrialisation of the previous 60 years, artists and designers had not been incorporated into manufacturing industry, and that artists had distanced themselves from commerce. The Committee came to the conclusion that state-sponsored schools of design should

be established so that their graduates could be employed by industry to improve the standards of design and ornamental decoration. The first of these schools was founded in 1837 in Somerset House in London, and was given a small budget to purchase books, plaster casts of classic art and specimens of manufactured items. During the mid 1840s part of this collection toured the country by train to eleven new provincial branches of the School of Design. In the 1850s the Schools of Design secured the private collection of decorative art owned by Ralph Bernal MP and that of a French lawyer Jules Soulages, which included majolica, iron work, and goldsmiths' pieces.

During these years, Henry Cole, a senior civil servant, was addressing the same problem of raising the standards of design. Cole was a man of unbridled enthusiasm for improving the public good. During his career he reorganized the Public Records Office, helped Roland Hill to introduce penny postage, built Grimsby Docks, was the first director of the South Kensington Museum (later London's Victoria and Albert Museum) and standardized the gauge for railways. After meeting Herbert Minton of Minton and Company, the most successful ceramic manufacturer of the period, Cole designed a bone china tea service which Minton produced. Cole rigorously researched the design and style sources for this service, including going to the British Museum to study Greek earthenware 'for authority for handles'. He also went to Minton's factory to observe the manufacturing process. In 1846 these white, simple ceramic forms, hardly decorated by the standards of the day, aroused much critical acclaim, winning a silver medal from the Royal Society of Arts and receiving the admiration of the Prince Consort.

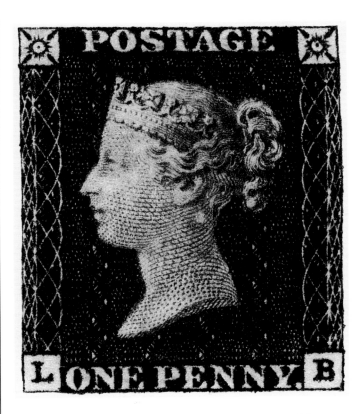

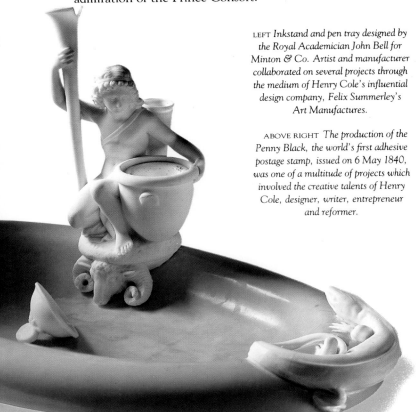

LEFT Inkstand and pen tray designed by the Royal Academician John Bell for Minton & Co. Artist and manufacturer collaborated on several projects through the medium of Henry Cole's influential design company, Felix Summerley's Art Manufactures.

ABOVE RIGHT The production of the Penny Black, the world's first adhesive postage stamp, issued on 6 May 1840, was one of a multitude of projects which involved the creative talents of Henry Cole, designer, writer, entrepreneur and reformer.

Henry Cole believed that the best way to improve Victorian design and public taste would be to persuade industry to employ fine artists. Cole looked back to the successes of Josiah Wedgwood almost a century earlier, who had employed figures like George Adams, the King's architect, to design his pottery. In much the same spirit he commissioned a painter, William Wyron, in 1839 to design the Penny Black, the first postage stamp. Similarly, in 1845 he invented a Christmas tradition by asking a painter specializing in domestic scenes, John Callcott Horsley, to illustrate a greeting card. Cole himself had some experience of art, for he had studied under the watercolourist David Cox and shown at the Royal Academy in his youth. To bring art to manufacturing industry, in 1847 he launched a company which he called Felix Summerley's Art Manufactures. Cole (under the pseudonym of Felix Summerley) acted as an entrepreneur, commissioning designs from renowned artists and persuading manufacturers to use them.

Under the Summerly scheme, the royal academician, John Bell, designed the Sabrina Urn, the Sugar Cane treacle pot, and a salt cellar decorated with a boy and a dolphin which was produced by Minton and Co. Bell's designs were frequently highly commended in the *Journal of Design and Manufactures*, although the *Art Union Journal*, a rival publication, found itself 'unable to appreciate' his 1848 matchbox in the shape of a crusader's tomb.

Richard Redgrave RA, had been appointed botanical lecturer to the Government School of Design in 1847. He also

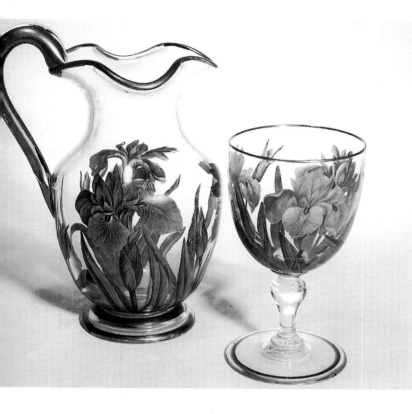

ABOVE *This naturalistically painted jug and matching glass was produced by Richardson of Stourbridge, one of the more progressive glassmakers of the mid 19th century and frequent collaborator with Felix Summerley, alias Henry Cole.*

produced a number of projects for Summerly's Art Manufacturers. This included a superb painted glass water carafe, produced by JF Christy, which is reminiscent of the very best Arts and Crafts glass at the end of the century, and a striking papier-mâché tray inlaid with mother of pearl and ivory produced by Jennens and Betteridge. Although he had trained as a painter, Redgrave increasingly became known as a designer and a respected critic of Victorian taste. In 1849 he became the editor of the *Journal of Design and Manufactures* and in 1855 he was a member of the executive committee of the British Section at the Paris *Exposition Universelle* .

Summerly's Art Manufactures employed some of the most able and popular artistic talent in Britain at that date, including William Dyce and Daniel Maclise, who had both been commissioned to paint frescoes for the Palace of Westminster, the former painting *The Baptism of Ethelbert* and the latter *The Meeting of Wellington and Blucher*. Summerly's Art Manufactures persuaded Britain's leading manufacturers to produce the designs of some of Britain's leading artists. Their products were as diverse as christening cups and letter boxes. Although, Summerley's Manufactures aimed at the reform of Victorian taste, its creations were 'conventional' in many respects: the designers did not refute historicism and encouraged the use of ornament. Henry Cole closed down the 'Art Manufactury' in 1848, not because it was commercially unsuccessful, for it appears that some of the items produced were very popular, but because his attention had moved on to other fields.

Through the Schools of Design and Summerly's Art Manufactures there emerged a core of artists, designers and intellectuals linked to Cole. The key figures in this – 'the Cole Group' – apart from those already mentioned, were Matthew Digby Wyatt, Ralph Nicholson Wornum, Gottfried Semper, Owen Jones and George Wallis. Matthew Digby Wyatt was author of *The Industrial Arts of the Nineteenth Century* and designer of ceramics and interiors. Ralph Nicholson Wornum trained as a painter, but became a writer and was, in fact, a vigorous critic of Henry Cole until offered the postion of librarian and keeper of casts at the Schools of Design in 1852. Gottfried Semper, a German refugee from the failed 1848 Revolution, was employed as a teacher by the School of Design in its new home at Marlborough House in 1852, and was noted for the ornamental details of the funeral car of the Duke of Wellington, but is most famous for his classic text, *Der Stil*, an investigation of the origin of style. Owen Jones was a prolific writer and theorist on ornament, famed for his book *The Grammar of Ornament* and a practitioner in all fields of design. George Wallis, was an artist who had studied under Dyce and was the principal at the Birmingham School of Design. The Cole Group became the

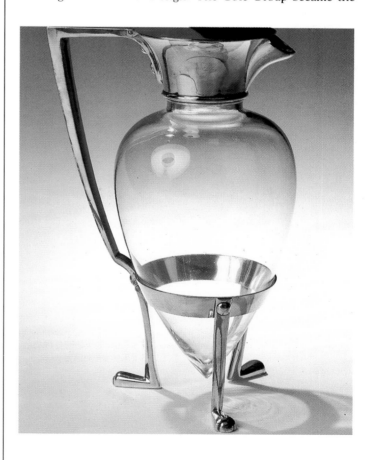

Claret jug with pear shaped glass body on three legs by Christopher Dresser, c. 1879.

design establishment of mid 19th-century Britain. They wished to bring a rational influence to bear upon Victorian style, arguing through their mouthpiece, the *Journal of Design and Manufactures*, for simplicity over complexity. Carpets and fabrics, for example, were not to be 'suggestive of anything but a level or a plain'. Considering a trowel covered with amorini decoration, the Journal was to the point: 'we think it ought to be unmistakably a trowel'. In contrast, describing a chintz by Owen Jones, the *Journal* stated in 1852:

The design is, as it ought to be, of perfectly flat unshadowed character. Secondly, the qualities and lines are equally distributed, so as to produce at a distance the appearance of levelness. Thirdly, the colours produce a neutral tint. And lastly . . . it is quite unobtrusive, which a covering of handsomer stuffs ought to be. The lines and forms are graceful too, when examined closely.

LEFT *Between 1872–6 William Morris produced 17 wallpaper designs using naturalistic motifs. "Larkspur" illustrated here was also produced as a printed cotton during this period with the help of dye-works owner Thomas Wardle of Leek in Staffordshire.*

RIGHT *This drawing, published by the illustrated London News in June 1850, gives some idea of the vastness of Thomas Paxton's great 1,848 foot long building situated between Rotten Row and the Carriage Road in London's Hyde Park.*

THE GREAT EXHIBITION OF 1851

The most eminent of Cole's collaborators was the Prince Albert of Saxe-Coburg-Gotha, husband of Queen Victoria. In his capacity as President of the Royal Society of Arts, of which Cole had been a member since 1846, the Prince Consort attempted to promote the application of art to industry. In 1847, the Prince and Cole planned a number of annual didactic exhibitions to display 'select specimens of British Manufactures and Decorative Art' to the public and industry with the specific intention of raising standards of taste. The 1848 exhibition at the Society of Arts' small house showed over 700 items. This scheme proved successful with attendance increasing five-fold in 1849, although Cole was criticized for the heavy representation of Summerly's Art Manufactures in the exhibitions.

These smaller displays led the way to an immense one; London's Great Exhibition of the works of industry of all nations in 1851. It has never been fully established whether the Great Exhibition was Cole's or Prince Albert's idea, for Cole is recorded as proposing a national industrial design exhibition in 1848, but the credit is frequently given to the Prince, whose contribution was considerable.

Cole and Digby Wyatt visited the French *Exposition Nationale* in 1849 to prepare a report for the Royal Society of Arts. Since the 1790s the French had organized a series of national industrial exhibitions, but the one in 1849 was the largest. Cole discussed with the Prince Consort the possibility of holding such an exhibition in London. The Prince's enthusiastic response included the exhortation that 'It must embrace foreign productions'.

At the first planning meeting at Buckingham Palace in June 1849, the character of the exhibition was quickly established. Its scope was to be international and orientated to industry. Awards were to be given for the best objects and machines to encourage exhibitors. It was to be housed in a temporary building in Hyde Park between Rotten Row and Kensington Drive. The organization of the exhibition was to come under the auspices of a royal commission led by the Prince Consort.

Initially financial support was slow in coming. To set the scheme in motion, the Queen gave £1,000 and Prince Albert donated £500, and in a nationalistic gesture some workmen are reported to have made small donations from their wages. In true Victorian spirit, the exhibition was financed by two speculators, James and George Munday who undertook responsibility for the building and deposited a £20,000 prize fund in return for five per cent interest on the amount advanced and a percentage of the profits. In October of that year Cole also outlined the scheme to the financial community in London, and engendered the support of 5,000 'influential persons'. Potential financial difficulties during the course of the organization and building of the exhibition site were avoided by a guarantee fund of £250,000.

With the financial arrangements secured, the Royal Commission was issued on 3rd January 1850 and Prince Albert was made its chairman. Albert was not a symbolic figurehead in these arrangements, but an energetic agent. Philip Cobden MP wrote of the Prince:

> I would not flatter anybody, but I would say, that having sat at the same board as His Royal Highness, I can speak of his efforts not as a prince, but as a working man. There is not one in the numbers of the Commissioners . . . that has done half the labour towards carrying out this exhibition'.

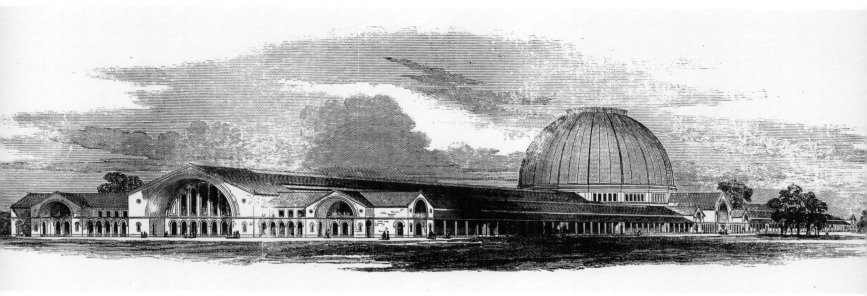

A GREENHOUSE LARGER THAN A GREENHOUSE EVER BUILT BEFORE

The design of the building housing the Great Exhibition was open to competition and entries were invited from 'competitors of all nations'. Although 245 entries were received, the Building Committee decided to amalgamate the best ideas in a number of designs into a single building made of brick, topped with an enormous sheet-metal dome, looking something like a railway station. Abuse was hurled at this scheme by such as *The Times* newspaper which had already protested at the use of Hyde Park, and in particular, the destruction of the trees on site. *The Times* leader fulminated: 'The first and main reason, why we protest against the erection of such a huge structure on such a site is that it is equivalent to the permanent mutilation of Hyde Park . . . Once more we entreat the Prince and his advisors to pause ere it be too late'.

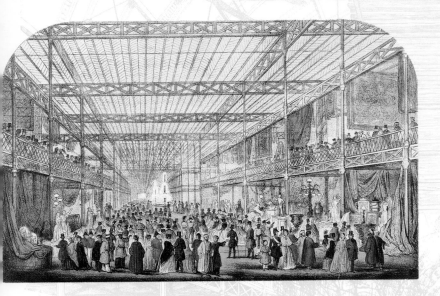

The story of how this problem was resolved, and how the Great Exhibition came to be housed in the temporary building which *Punch* magazine affectionately dubbed the 'Crystal Palace', is quite remarkable. Joseph Paxton, a gardener and landscape architect at Chatsworth, home of the Duke of Devonshire, aware of the problems facing the Building Committee, began 'doodling' at a committee meeting in Derby in June 1850. He scribbled out a basic design and structural plan for a large glass-paned building. This design extended the structural ideas he had employed in the greenhouse he had designed at Chatsworth, which in turn had been derived from the skeletal form of the leaf of the *Victoria Regia* water lily

(which Paxton had introduced to Britain in the year of Victoria's coronation). On his return home, he continued working on this sketch and wrote to the Society of Arts in London, offering to show his plans to them within eight days. These days were spent furiously working with William Henry Barlow, a railway engineer, to resolve the technical problems of design.

By coincidence, on the train to London to show his plans, Paxton met Robert Stephenson, the renowned engineer, who was a member of the Building Committee. Paxton spent the journey discussing the design with Stephenson, who appeared to be enthusiastic. In contrast, the Committee were more hesitant, and Paxton's designs toured the offices of the Society of Arts, the Board of Trade and Buckingham Palace. Frustrated, Paxton decided to go public in an attempt to win support for his design and arranged for it to be published in the most popular paper of the day, *The Illustrated London News*.

It appears that Paxton had judged the public mood correctly, for opinion swung behind his elegant design. Paxton was told that his 'Crystal Palace' would be considered if he submitted a firm tender within four days. This Paxton did, and with estimated costs that compared favourably with the price of the official building, the Committee had little choice but to accept his design, with the proviso that the height of the Palace be extended to allow the building to be constructed around the elm trees on the site, thus mollifying public opinion. This resulted in the arched transept which became the striking feature of the building.

Somewhat inevitably, as soon as Paxton's design was accepted a contrary wave of public opinion washed over London, foretelling the collapse of the glass building onto visitors to the exhibition. Even more hysterically, others suggested that London would be starved by the volume of visitors to the exhibition or that the crowds would trigger an epidemic of bubonic plague.

In August, as the foundations were being laid, another controversy welled up. It became known that Paxton was unqualified in any profession despite the successes of his career. The voices of gloom rang across London again, fortelling the imminent collapse of the Crystal Palace. Yet this criticism and alarm in no way deterred building, which steadily continued. The first column was raised at the end of September. Six months later the building was complete.

Paxton's design for the Crystal Palace stands in the history of architecture as a masterpiece of mass-produced, standardized, prefabricated parts; a precursor of the Modern Movement of the 20th century. Contemporary observers were not blind to the implications of the Crystal Palace. The architect Thomas Harris wrote: 'iron and glass have succeeded in giving a distinct and marked character to the future practice of archi-

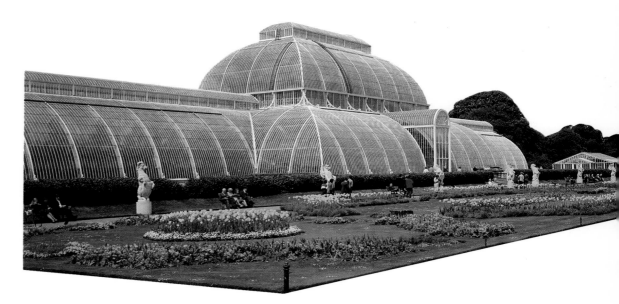

tecture'. It was an outstanding achievement in iron and glass, the materials of Victorian engineering, but what distinguished it from suspension bridges, railway stations and market halls of the period, is the speed with which it was constructed and its sheer scale. Intended to be the symbolic length of 1,851 feet (in fact, it appears that the building fell three feet short of the original plans), it was bigger than the palace at Versailles and was three times longer than St Paul's Cathedral in London.

The building was based on a 24-foot grid and was ingeniously constructed from an enormous number of prefabricated parts, the heaviest of which were the 24-four foot girders at one ton each. The amount of material employed was phenomenal; 300,000 panes of glass (of a size that had never before been manufactured), iron weighing about 4,500 tons, 34 miles of guttering, and over one million feet of sash-bars. In the six months before the opening of the exhibition on the 1st of May, 1851, an average of two thousand men were employed on site at any one time.

Paxton's design incorporated a number of novel inventions. The guttering was an ingenious system which prevented condensation. He also designed a trolley which could be moved across the site in all weather, carrying the glazier's equipment. As a consquence of the scale and novelty of the Palace, a number of unorthodox building and testing methods were employed. Soldiers marching in step were used to test the strength of the galleries before they were secured into place.

ABOVE *Queen Victoria and Prince Albert visiting the Indian pavilion. The Queen a frequent visitor, was fascinated by the "ingenious" inventions on show as she delighted in viewing the Aubusson tapestries, Turkish silks and Swiss watches.*

The appearance of the Crystal Palace was not due to Paxton alone. Owen Jones, a member of the Cole Group and superintendent to the exhibition, and with the responsibility for the decoration of the building, used primary colours, red, yellow and blue, to decorate the iron frame of the building. Jones believed that this would make the Crystal Palace 'appear higher, longer and more solid'. Charles Barry, the architect of the new Palace of Westminster after the fire in 1835, suggested placing the flags of all nations along the profile of the roof.

While the building work was under way, members of the Cole Group were planning and prophesying. Swept up in the spirit of new opportunity, they foretold a brighter future in which art and industry would meet in a new alliance. A Cole spokesman stated: 'Since the period of the Reformation we believe that the prospects of Design have never been so good as at the present time in England'. Digby Wyatt and Henry Cole himself had been on the central selection committee, emphasizing the exhibition's professional aims.

Half of the exhibition space was to be given over to exhibits from Britain, and the rest to foreign entries. Each country was allocated space, and the responsibility to fill it. British competitors had to pass through a regional and then a national committee. The entries had to fall into a three-tiered classification system devised by Prince Albert; 'the raw materials of industry, the manufactures made from them, and the art used to adorn them'. In true Victorian spirit, Dr Lyon Playfair, a member of the central selection commitee, subdivided these into a further 30 divisions, such as 'Machines for direct use, including Carriages, and Railway and Naval Mechanisms' and 'Woollen and Worsted Manufactures'. Although Fine art was excluded, for theoretically the exhibition was concerned with the 'Works of Industry', it was represented in a final category entitled 'Sculpture, Models (in Architecture, Topography and Anatomy) and Plastic Art'. Each division was overseen by a panel of specialists in that area.

BELOW *The Agricultural section of the Crystal Palace exhibition featured new farming machinery that still required horse power.*

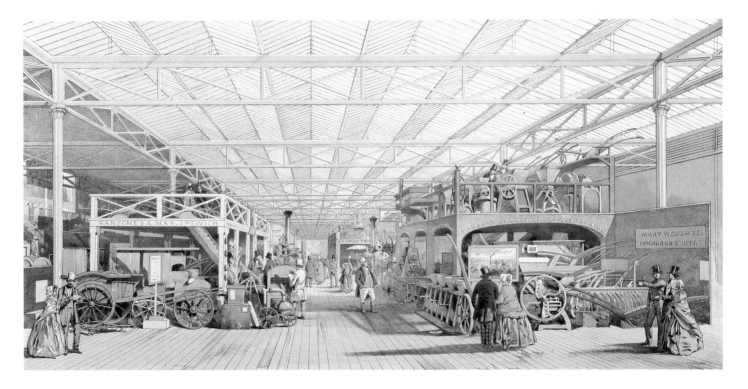

THE EXHIBITION OPENED

The world's first international exhibition of industry was opened on the 1st of May 1851 by Her Majesty Queen Victoria. It was originally planned that this inauguration would be a private ceremony because the Queen had been attacked in June of the previous year by Robert Pate, and was wary of public attention. But again *The Times* thundered, its leader column stating:

> What an unworthy part would these nervous advisers cause the Queen of England to play! Surely Queen Victoria is not Tiberius or Louis XI, that she should be smuggled out of a glass carriage into a great glass building under the cover of the truncheons of the police and the broadswords of the Life Guards. Where most Englishmen are gathered together, there the Queen of England is most secure!

And so again public opinion swayed officialdom, and the Great Exhibition was opened to a crowd of 25,000 observers. The Police estimated that as many as 700,000 people filled Hyde Park that day.

The opening ceremony was full of the pomp and circumstance that characterized Victoria's reign; the Archbishop of Canterbury offered prayers, guns saluted, dignitaries and royalty read addresses, soldiers marched and a choir of 600 sang Handel's *Hallelujah Chorus*.

On the 11th of October the exhibition closed to the public. In the course of the five and half months that it was open over six million visitors attended. The busiest day, during the last week, saw 109,915 people pass through its doors.

The Crystal Palace was a superb exhibition space. All contemporary comment described the galleries and transept bathed in brilliant light. Charles Barry, even though a Gothic architect, paid great compliment by writing that it 'flashed on the eye more like the fabled palace of Vathek than a structure reared in six months'. Another observer described the central court thus:

> In the midst is seen the Fountain of Glass; behind it, and also in groups near the south entrance, are beautiful tropical plants, sheltered by the elm-trees which rise above them; and above all springs the light and elegant arch of the wonderful Transept. The glitter of the falling waters in the gleaming light which pours down unobscured in this part of the building, and the artistic arrangement of the groups of the objects of art and industry in the immense vicinity of the Transept, renders this a peculiarly attractive part of this immense structure.

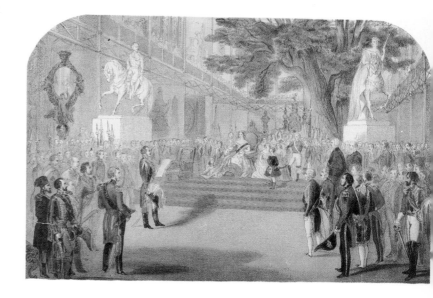

TOP *Queen Victoria, accompanied by Prince Albert, the Prince of Wales and the Princess Royal, inaugurated the Great Exhibition with impressive pomp and ceremony. The great day was declared a public holiday, thereby attracting at least half-a-million visitors to Hyde Park.*

The main avenues of the building were filled with large freestanding exhibits and decorated with colourful flags and red banners stating the name of the exhibitor in white letters. The galleries overlooking the central avenues housed hundreds of cabinets containing smaller items, and hanging tapestries. Despite being dubbed somewhat icily, 'the Crystal Palace' the splendid pomp of the exhibits and Owen Jones' primary colour scheme, made the experience of visiting the Great Exhibition a colourful, and exciting one. In trying to assess the impact of the exhibition on its visitors, it ought to be remembered that many had never travelled outside their own towns and villages, let alone to London and an international event of such a scale. The Queen recorded in her journal meeting a Cornish woman, aged 80, who 'had walked up several 100 miles to see the exhibition'. On special 'shilling' days the lower middle classes flocked in their thousands. Thomas Cook made his fortune by taking over 160,000 people on excursions which included travel and the price of entry to the exhibition. Even *The Times*, initially very critical of the exhibition plans, wrote of the first day: 'There were many there who were familiar with the sight of great spectacles . . . but they had not seen anything to compare with this'.

An event as fantastic as the Great Exhibition inevitably generates an accompanying mythology. Two weeks before the opening ceremony, for example, an unforeseen problem arose, when Crystal Palace became home to flocks of sparrows who threatened to redecorate the building and its visitors in somewhat less pleasant hues than those intended by Owen Jones. The Commissioner's solution to this problem, after much

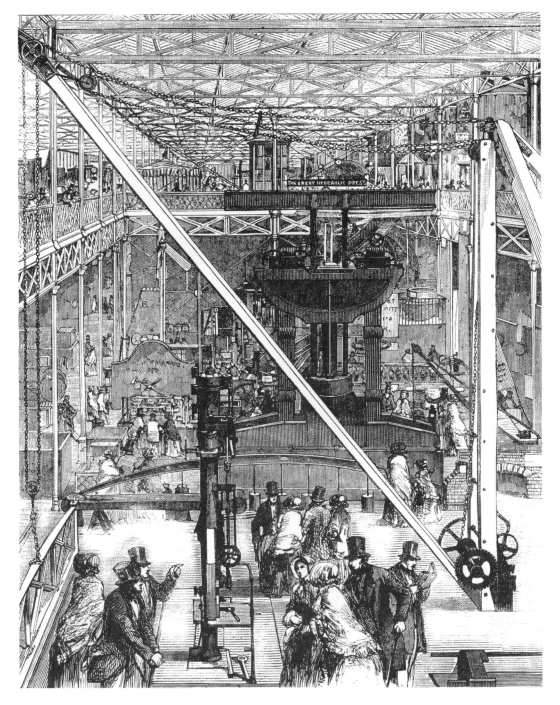

LEFT *The Machinery Court of the Exhibition, situated in the central aisle, included the "Great Hydraulic Press" used in 1849 for the construction of the Britannia tubular bridge over the Menai straits.*

deliberation, was to employ two sparrow hawks. A letter to the *Morning Chronicle* stated that the 'most universal complaint' about the Great Exhibition was that the refreshment staff serving there were unwashed, and that 'their hands and faces would be greatly improved by a moderate use of soap'. An Admiral at Portsmouth dockyard offered to place a vessel at the disposal of the workmen, so that they would be able to visit the exhibition in the capital. Henry Cole retold the story of when the Duke of Wellington, a national hero, attended the Great Exhibition:

When at its fullest, 93 thousand present, the Duke of Wellington came, and although cautioned by the police, he would walk up the nave in the midst of the crowd. He was soon recognized and cheered. The distant crowds were alarmed and raised the cry that 'the building was falling'. There was a rush.

Fortunately, the building did not collapse, although it appears as if the Duke of Wellington did, for Cole proceeds to describe him being carried out of the palace looking 'pale and indignant'.

THE EXHIBITS

There's taypots there,
And cannons rare;
There's coffins filled with roses;
There's canvas tints,
Teeth insthrumints,
And shuits of clothes by Moses,
There's lashins more
Of things in store,
But tim I don't remimber;
Nor could disclose
Did I compose
From May time to Novimber.

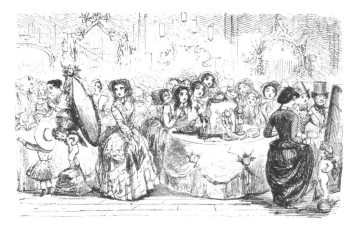

ABOVE *Punch, whose editorials dubbed the exhibition building the "Crystal Palace," here gently mock the vanity of a crowd of female visitors.*

William Makepeace Thakeray's humerous ode *Maloney's Account of the Crystal Palace*, written in the style of the satirical magazine *Punch*, acknowledged the vast scale of the Great Exhibition. More precisely, there were 13,937 exhibitors, a large number of whom, according to the *Official Catalogue*, arrived after the opening on the 1st of May, 1851. Over half of the exhibits were from British competitors, who used this opportunity to produce and display their best, most extravagent, and beautifully finished manufactures. These British objects were placed in the western end of the building.

Exhibits were arranged along the categories established by the Prince Consort and Dr Lyon Playfair. There was a stained glass gallery, a Mediaeval Court, a Hall of Furs, Feathers and Hair, a moving machinery section and so on. Every Victorian enthusiasm was represented in some shape or form. The Queen, for example, thougt that a collection of stuffed animals in comical poses such as 'The Kittens at Tea' was 'really marvellous'. The cutting, drilling, riveting, wire-drawing machinery of the moving machinery section were as frequently dressed in historical architectural styles such as Gothic and Egyptian, as the lamps and furnishings in other sections. *The Exhibition Anthem* was composed by Martin Tupper and translated into 30 languages.

Every conceivable style of decorative art was there on view: bookbindings in ecclesiastical Gothic; elegant urns in Grecian styles; Italianate tea services; silverware in Renaissance styles illustrated with cupids and arcadian scenes; innumerable chairs, escritoires and side-tables in the fashionable Louis XIV style; Japanese lacquered boxes, and thick piled carpets and richly decorated cloths of floral motifs. Tuberville Smith produced a richly coloured floral fabric, which the official catalogue described as a 'flower garden (which) seems to have been rifled of its gayest and choicest flowers . . . it almost requires one well instructed in botany to make out a list of its contents'.

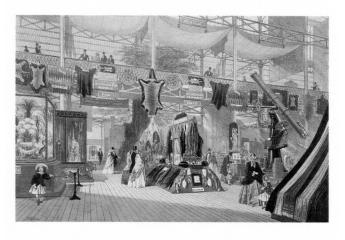

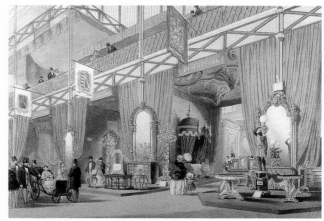

ABOVE *John Dickinson's two volumes of colour lithographs entitled "Comprehensive Pictures of the Great Exhibition" (1854) bring to life the extraordinary variety and quantity of products on show, estimated at approximately 112,000 items.*

A number of novel decorative techniques were developed by craftsmen and manufacturers to produce strikingly innovative objects. A Mr Kidd, for example, developed a technique by which he laid jewels and precious ornaments under glass and flooded them with silver creating what he called 'Illuminated Glass'. British craftsmen adopted techniques from all over the world to display their skills. Messers. Hewett and Co., for example, exhibited an ivory basket which the official catalogue compared to the best Chinese craftsmanship.

Semi-scientific objects such as clocks and telescopes received just as much attention from the stylists and ornamentalists. Gray and Keen of Liverpool showed a number of barometers in a range of styles, including a Gothic form with an elaborate dial plate and another in the shape of a patent anchor. Multi-function furniture was a further preoccupation of the Great Exhibition. The firm of Taylor and Sons produced a sofa for a steamship and the company of RW Laurie, manufactured a portmanteau, both of which could be turned into life rafts.

Machinery and raw materials filled much of the exhibition space. Outside the west end of the building visitors could survey the engine room housing two Armstrong boilers which supplied the power to the machinery inside. Here too the public could marvel at a 24-ton block of coal, symbolic of Britain's industrial achievement, which had been hewn at the Staveley mine owned by the Duke of Devonshire. Alongside this were placed slabs of concrete, granite obelisks and massive iron anchors. Inside the Crystal Palace, the public's attention was demanded by the triumphs of Victorian inventive genius, confirming Albert's belief in a 'period of most wonderful transformation'. The Victorians could wonder at working telegraph machines, Crampton's *Liverpool*, the fastest express locomotive in the world, the De La Rue envelope-making machine, much admired by Queen Victoria, which could fold 2,700 an hour. A whole section was given over to agricultural implements. Commentators were greatly impressed by their mechanization.

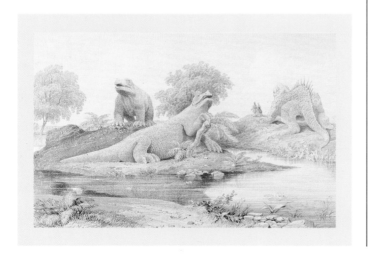

The exhibition also contained many bizarre items, which were frequently great achievements of their kind. To design reformers like Henry Cole and the Prince Consort, they were curiosities that distracted from the concern of the Great Exhibition to improve public taste. From Prussia came an iron stove designed by Edward Baum in the shape of a full suit of armour, and a garden seat made from coal for Osborne House was on display in the British section. There were a number of *tour de force* items intended to show the skill of the maker or the versatility of a particular material, such as J Rodger and Sons' sportsman's knife which had eighty blades, or the Daydreamer chair, which became a major topic of discussion. This chair was made from papier-mâché, a material associated with small domestic, ornamental items such as trays, and inlaid with mother-of-pearl in the forms of snowdrops, poppies and angels, and covered with buttoned upholstery. It was decorated with 'two winged thoughts:' one 'troubled', in the form of bat-like wings, and one 'joyous', illustrated by a crown of roses, both divided by a symbol of hope, the rising sun. The centre-piece of the entire exhibition was a 27 feet high crystal fountain which was made from four tons of glass by F and C Osler.

The international sections generated enormous interest from the British public, and large numbers of visitors travelled from all over the world to see this unique event. For the first time under one roof it was possible to see the products of industry and handicraft from all over the globe. To walk through the eastern avenues of the Great Exhibition was to observe the industrial achievements of North America, the British Empire, the Near and Far East and Europe. One visitor from Nottingham was overwhelmed at what faced him:

 I was astonished at the outside of the building, but when I entered at the door of the south of the transept I beheld a site which absolutely bewildered me. The best productions of art and science of almost all lands lay before me. I gazed with astonishment. I knew not what direction to take.

The Indian section was a British cause célèbre, as the jewel in the crown of the her Empire. Victoria praised it very strongly and a French writer claimed that it took viewers back to a 'heroic age'. It was assembled by the East India Company and contained, among other items, shawls and fabrics, particularly beautiful silks, a stuffed elephant (which they were unable to find in India, but secured in a museum less than fifty miles from London) draped with hangings and a covered and canti-levered howdah, ornamental swords and shields in precious metals. The Koh-i-noor or Mountain of Light diamond was specially transported from Bombay by *H.M.S. Medea* and presented to the Queen at a ceremony two months after the exhibition had opened.

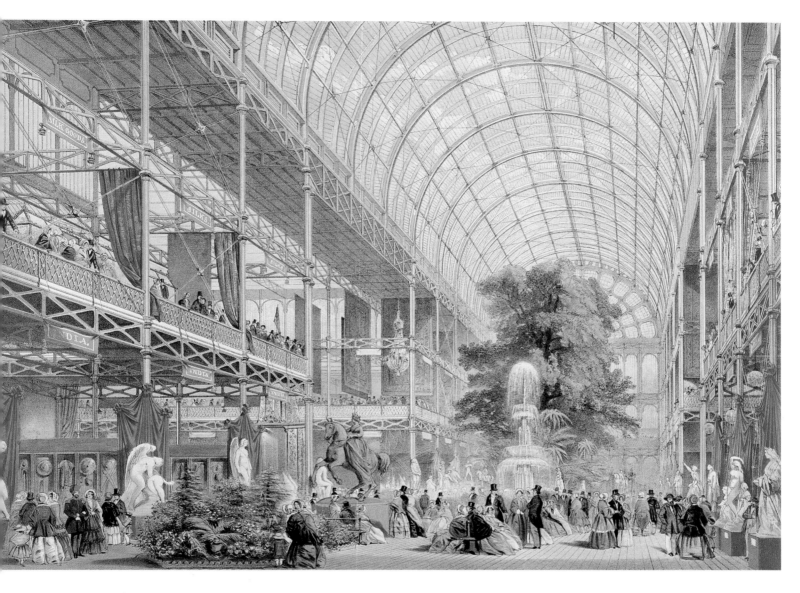

The substantial French section appears to have been widely regarded as the height of fashionable style. With the rivalry characteristic to both nations, one English writer discussing French silks, argued:

> As yet France triumphs; a highly cultivated taste both in the combination of colours and the beauty of design in all its detail excercises a powerful influence over the demand and supply; but when once England has succeeded in educating her workmen, so that they will produce designs which will carry off the prestige which now attatches itself to the productions of the loom of Lyons, the superiority of France will be at an end.

With about 1,750 exhibitors, the French display was as diverse as that figure suggests; from highly carved Rococo cabinets made from exotic woods such as pear and ebony, highly naturalistic floral ornamentation on decorative boxes, and book-

ABOVE *The 27 foot high crystal fountain manufactured by F. & C. Osler located in the centre of the building was greatly admired by the Queen.*

LEFT *On closure of the exhibition, the Crystal Palace was dismantled to be reassembled at Sydenham in South London where it remained until burnt down in 1936. The grounds, laid out by Thomas Paxton, featured these model dinosaurs.*

ABOVE LEFT *The Cyrus McCormick reaping machine from America, prototype of our modern combine harvesters, was seen to have revolutionary implications.*

covers in carved ivory, to more prosaic objects such as a sewing machine 'adapted for coarse cloth'. Despite examples of French technical and scientific ingenuity, such as a prototype submarine which had traversed the English Channel, and a calculating machine, English comment concentrated on the achievements of French applied art.

The American display deserves special mention, for apart from the stuffed black-eyed squirrels and over 6,000 fossils

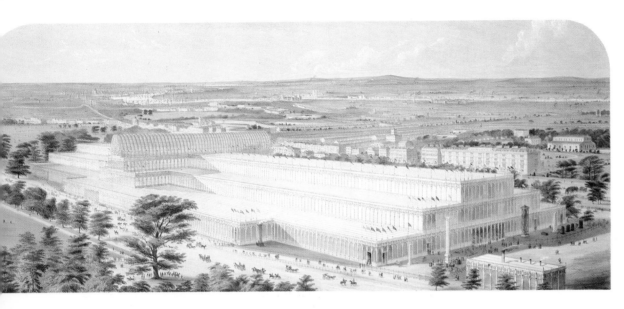

LEFT *An aerial view of the formally titled "Palace of Industry for all Nations" as seen from Kensington Gardens.*

BELOW *This Bohemian red etched glass goblet is one of the many souvenirs manufactured to commemorate the Great Exhibition.*

were some objects that received much enthusiastic attention at the time and have subsequently come to be seen as key designs of the 19th century. In American industry lay the seeds of the future, for her McCormick Reaper, Hobbs lock, and Colt revolver displayed characteristics that came to be highly valued in 20th century design; a simplicity of form, restrained ornament and an emphasis on functionality. In marked contrast to countries like France, ornamented decorative design was very rare in the American section. This was widely attributed at the time to the new country's lack of traditions and a market for expensive applied art.

American art also turned a few heads: August Kiss's *Amazon* was a novelty made from zinc, and Hiram Power's famous *Greek Slave* proved to be very popular. The latter, a classically posed nude chained, and leaning against a tree-stump was the centrepiece of the American section, set against a background of red plush and under a special canopy. One critic wrote of this piece: 'The Greek Slave is one of the "Lions" of the exhibition and most deservedly so'.

Among the other nations represented, China aroused great curiosity with the peculiar eastern workmanship of its exhibits. There was colonial produce from the Bahamas, Trinidad and the Eastern Archipelago. Tunisia recognized the trade opportunities that would result from showing her unique handicrafts and raw materials to the rest of the world. Russia concentrated on jewellery from St Petersburg, and items made in malachite. Switzerland's goods generated respect, if not enthusiasm. Canada's national display was judged to have similar qualities to American design. The display from Turkey was very popular for the exoticism and quality of the arabic patterns found there. Arranged without the formal rigidity of some of the European states, this section was frequently described as a 'Turkish

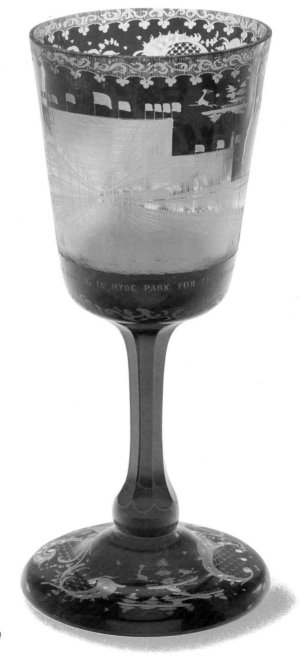

Bazaar', a phrase with evocative power in conservative mid-Victorian Britain.

Juries were established by the commissioners of the Great Exhibition to search out in every category 'the best of their kind'. Constituted by an equal number of foreigners and British subjects, the 34 juries were able to bestow bronze Council Medals for 'some important novelty of invention or appreciation, either in material or process of manufacture, or originality combined with great beauty of design', or a lesser Prize Medal to those who had shown 'a certain standard of excellence in production or workmanship'. Out of a total of 13,937 exhibitors, 170 Council Medals were awarded. Britain, not unexpectedly, received the greatest number of prizes, followed by France. In the categories of applied art, such as the class entitled 'Furniture, Upholstery, Paper Hangings, Papier Mâché and Japanned Goods', the French were dominant. France won 54 medals in all categories. Britain won 52 of her 78 medals in the categories that related to machinery.

When the exhibition closed, it was declared a triumph. It made a phenomenal profit of £186,437. Much debate centred on what to do with this money; Paxton was awarded £5,000 for his contribution to the success of the venture and most of the rest was spent on educational purposes. An 87-acre plot of land was purchased in South Kensington, in London. On this site today stands the Victoria and Albert Museum (which contains many of the best examples of decorative art and design on display at the Great Exhibition), the

Science and Geological Museums, the Royal Albert Hall, the Imperial College of Science and Technology, and the Royal College of Music.

The Crystal Palace was dismantled, despite calls for it to remain on its Hyde Park site to be used as a winter garden. It was reconstructed in Sydenham in South London and was re-opened by the Queen on the 10th of June, 1854. It became a much loved place for Londoners to spend their leisure time, visiting the new Renaissance Court, designed by the Cole Group member, Matthew Digby Wyatt, or wandering through the grounds laid out by Thomas Paxton. It was used as an exhibition space again in 1911, the year of the coronation of George V, for a festival of Empire. In November, 1936, its central transept caught fire and the building was destroyed. The closing hours of the Crystal Palace were as spectacular as the opening ones, for the flames which engulfed it could be seen in eight counties.

The Great Exhibition set in motion a number of enormous international exhibitions. Each subsequent show tried to be larger, grander and more exotic than the preceding one. They were given hyperbolic names like the *Exposition Universelle* and the *Weltausstellung* and were symbolized by amazing icons championing industrial inventiveness. The World's Colombian Exposition in Chicago in 1893 displayed an enormous ferris wheel with 36 cars each carrying 40 people. At the 1889 Paris *Exposition Universelle*, Gustave Eiffel built his famous Eiffel Tower, then the tallest building in the world.

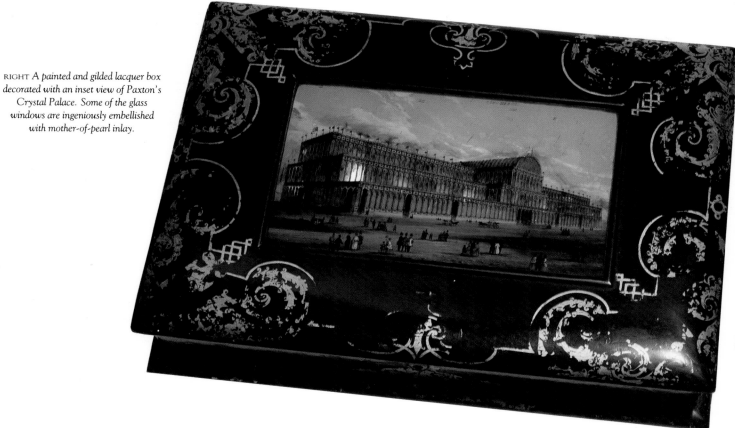

RIGHT *A painted and gilded lacquer box decorated with an inset view of Paxton's Crystal Palace. Some of the glass windows are ingeniously embellished with mother-of-pearl inlay.*

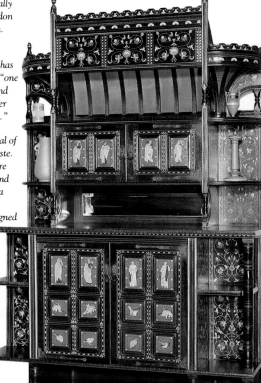

LEFT *"Sutherland," an Arts and Crafts textile design by Oen Jones originally produced as silk tissue by the London firm of Warner, Sillet & Ramm.*

RIGHT *This painted rosewood cabinet of 1871 by T.E. Collcutt has been described by a recent critic as "one of the most original, attractive and influential pieces of furniture ever designed by a Victorian architect."*

BELOW *This drawing room is typical of the eclecticism of late Victorian taste. Elaborate papier-mache furniture decorated with painted flowers and mother of pearl inlay vies with a Japanese style cabinet and "Chrysanthemum" wallpaper designed by William Morris.*

POPULAR VICTORIAN TASTE

To Henry Cole the exhibition was a disappointment, for his hopes of finding a union between art and industry had not been met. The critics lashed out at the use of excessive ornament, the out-and-out historicism and the absurdity of the majority of the exhibits. *The Times* stated: 'The absence of any fixed principles in ornamental design is apparent in the Exhibition – it seems to us that the art manufactures of the whole of Europe are thoroughly demoralized'. Cole and his colleagues could only extend their support to a few of the objects displayed. Of the exhibits, Gottfried Semper wrote that only 'objects in which the seriousness of their use does not allow for anything unnecessary, e.g. coaches, weapons, musical instruments and the like, sometimes showed a higher degree of soundness in decoration and in the methods by which the value of functionally defined forms is enhanced'.

But the comments of design theorists should be contrasted with those of mid-century enthusiasts for Victorian culture. Dr W Whewell was inspired by the Great Exhibition to write: 'we perceive that in advancing (from earlier ages of history) to our form of civilization we advance also to a more skilful, powerful, comprehensive and progressive form of art'. The flocks of visitors that travelled to the Great Exhibition, and particularly those who returned again and again (for it was possible to buy a season pass), were more likely to agree with Whewell than Cole. The most popular exhibits and frequently those that incurred the critics' wrath, were the ones that displayed the most ostentatious ornament, and that were the most historicist, and in the terms of their critics the most 'dishonest'.

The same values and qualities so prized by visitors at the Great Exhibition were echoed in the furnishing and decorative predilections of middle class Victorians. They liked their furniture to be ostentatious and conspicuous, emphasizing surface over structure, and display rather than rational construction. The middle decades of the 19th century saw the dominance of veneering, graining, ormolu, gilt, embossing and chasing and many other forms of decorative treatment. Even wheel chairs were given scrolled, carved legs.

Although widely associated with Victorian architecture, historicism also dominated the decorative arts. Greek, Roman, Gothic, Egyptian and other historical styles provided sources which manufacturers could plunder at will. They were able to purchase 'grammars' of decorative and ornamental patterns which could be imitated, often without due respect for the nature or the overall form of the artifact. The manufacturers of the 'Daydreamer' papier-mâché chair, exhibited at the Crystal Palace (see above), could not be specific about the hybrid style in which they had cloaked this novelty, so they described it as simply 'Italian'. History sometimes provided inappropriate models for the demands of Victorian life. George Angell's silver flagon in the Gothic style was wholly impractical, awkward to handle and difficult to clean. But to many, ownership of this object would confer prestige outweighing its impracticalities.

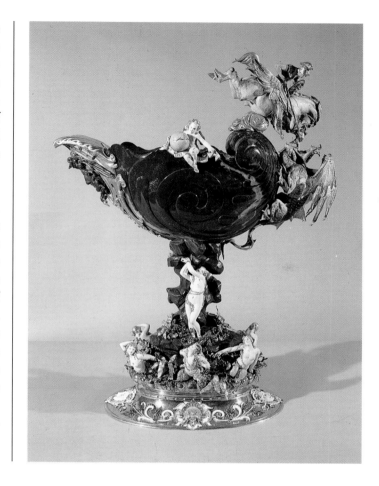

ABOVE RIGHT *The Hope vase (1855), designed for Henry Thomas Hope by Louis Constant Sevin and carved by J.V. Morel, depicts the rescue of Andromeda from the dragon by Perseus. A blend of rococo fantasy and renaissance ornament, this centrepiece's decorative complexity nevertheless bears the stamp of the 19th century.*

Although highly decorated, this sideboard (below right) by Philip Webb (c.1862), a founder member of the Morris firm, reveals a growing concern of the burgeoning Arts and Crafts Movement with plain forms, in radical opposition to the High Victorian yen for profuse plastic ornamentation (below left).

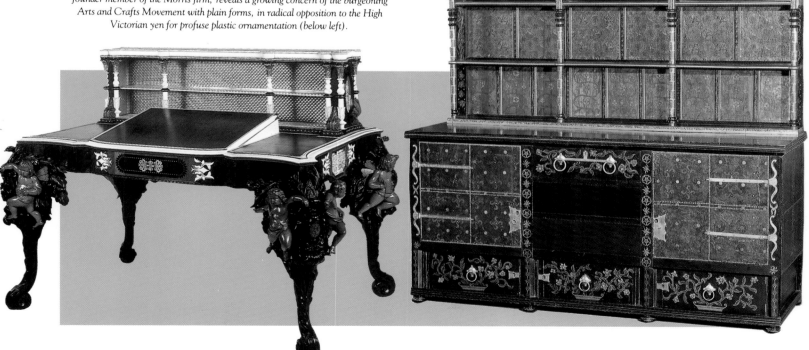

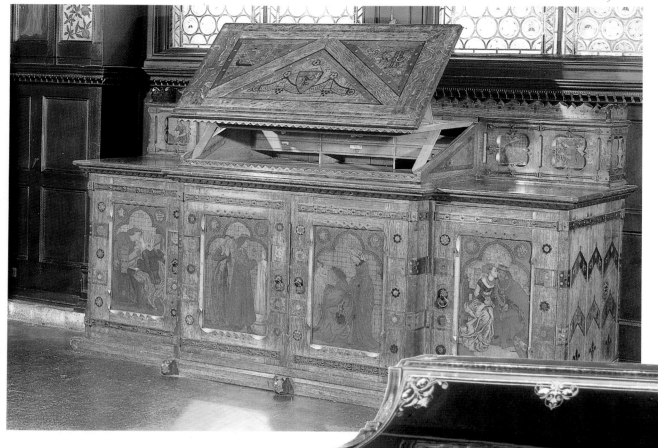

ABOVE *Medieval style oak cabinet designed by J. P. Seddon with decorative panels painted by Madox Brown, Morris, Burne-Jones and Rossetti illustrating the honeymoon of King Rene of Anjou.*

RIGHT *Ormulu and gilt decorated desk in the French style, typical of the ponderous furniture so eagerly amassed by wealthy Victorian families.*

ABOVE RIGHT *An Emile Gallé vase, with engraved and enamelled moths, 1885–90. Gallé drew his inspiration from many sources, including Venetian and Islamic glass. This design reveals the popular Japanese influence.*

BELOW RIGHT *A Minton ewer (1865) with relief neo-rococo syle modelling by H. Protat, decorated with majolica glazes.*

FAR RIGHT *This steel vase, damascened in gold and silver and inlaid with emerald and ruby settings by French silversmith Frederic-Jules Rudolphi incorporates an eclectic mix of Gothic and Islamic design motifs.*

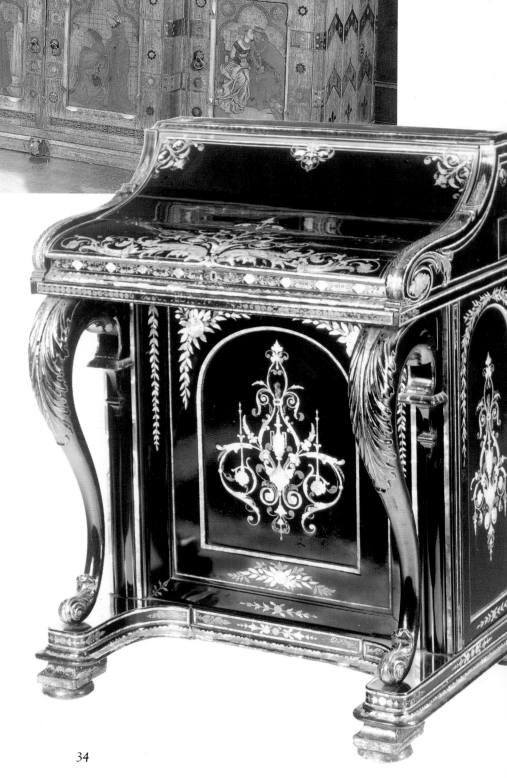

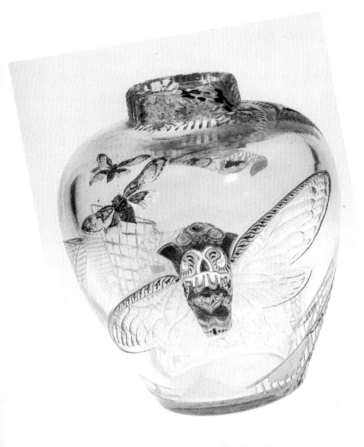

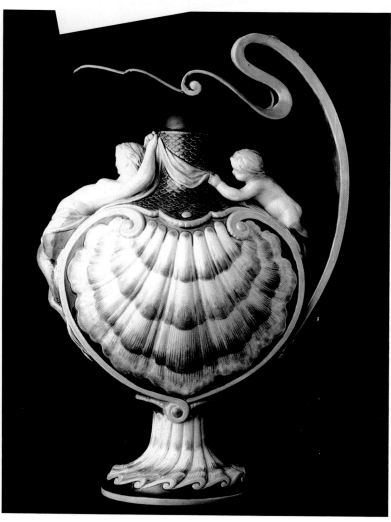

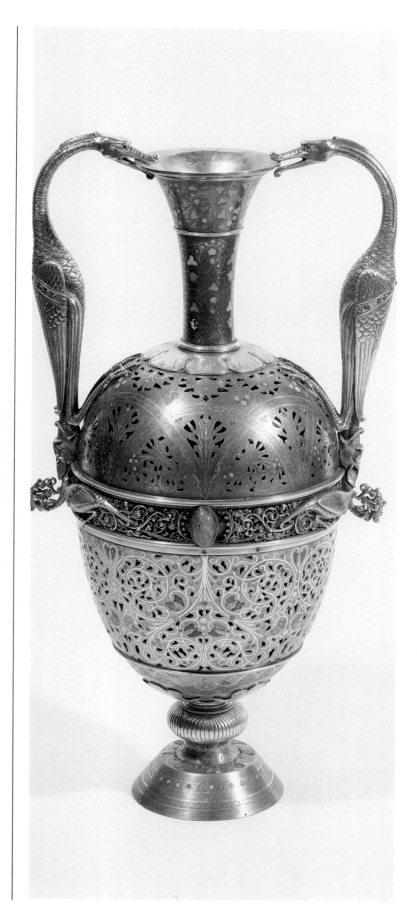

The Victorians were also fond of *trompe l'oeil* effects, particularly if they simulated expensive materials. Glass was painted to look like marble, and zinc was electro-plated to make it indistinguishable from sterling silver to the untrained eye. This was not just the province of British Victorians: in America, Alexander Jackson Davis was commended for his painted illusionary canvas walls at Lyndhurst, the country home of Jay Gould in Tarrytown, which resembled ashlar stonework.

Victorians liked their objects to contain narrative devices. Mottoes, pithy sayings and psalms were engraved into metalwork, stitched into fire screens and cushions and carved into chair backs. Sets of cutlery, engraved with coats of arms were most prestigious domestic items, rifles would have hunting scenes engraved on their gunstocks, fishknives would be illustrated with views of fishermen, and clocks with Old Father Time. A Rococo-style chair from Dublin shown at the Great

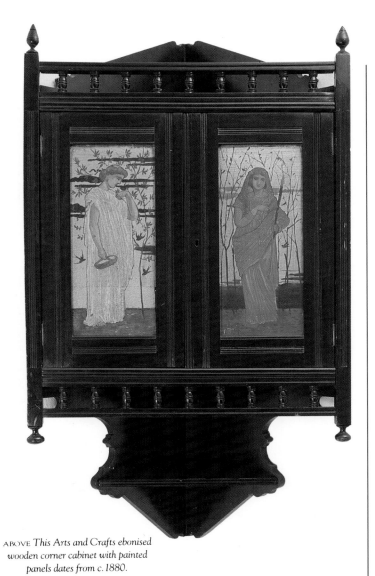

ABOVE *This Arts and Crafts ebonised wooden corner cabinet with painted panels dates from c.1880.*

FAR RIGHT AND BELOW *G.P. Wetmore's Chateau sur Mer in Newport, Rhode Island. The new American millionaire class aped European styles, particularly the neo-rococo, in an effort to invest social position based on money with grandeur and cultural respectability.*

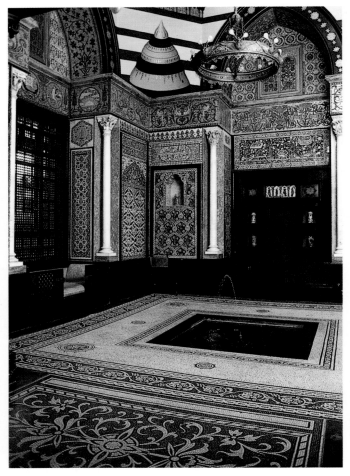

Exhibition, with carved dogs for arms, had carved across its back the legend: 'Gentle when stroked, angry when provoked'.

The rising middle classes, prosperous on the incomes from commerce and industry, were keen to display their wealth. Drawing rooms were brimming with armchairs, sofas, chaises longues, rich drapes and curtains, thick pile carpets and so on. Their concern was usually not with the patronage of craftmanship or art, or the cultivation of a knowledge of the antique, but the overt display of fashionable taste. Manufacturers responded by developing techniques for mass producing furniture, ceramics and metal ware, and even fine art. In 1844 Benjamin Cheverton patented a 'three dimensional pantograph' which allowed scaled down copies of busts of 19th-century heros such as the Duke of Wellington, to be made cheaply in alabaster or wax, and machine-carving, anathema to the purist, enabled the furniture industry to create pieces with the scrolling and turned balusters of handcrafted masterpieces.

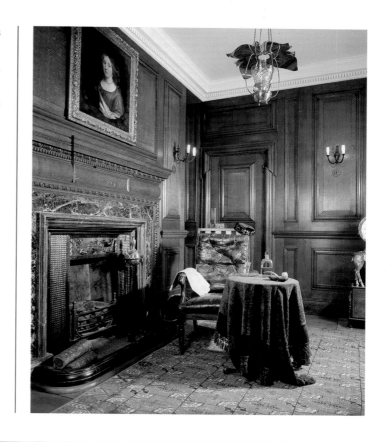

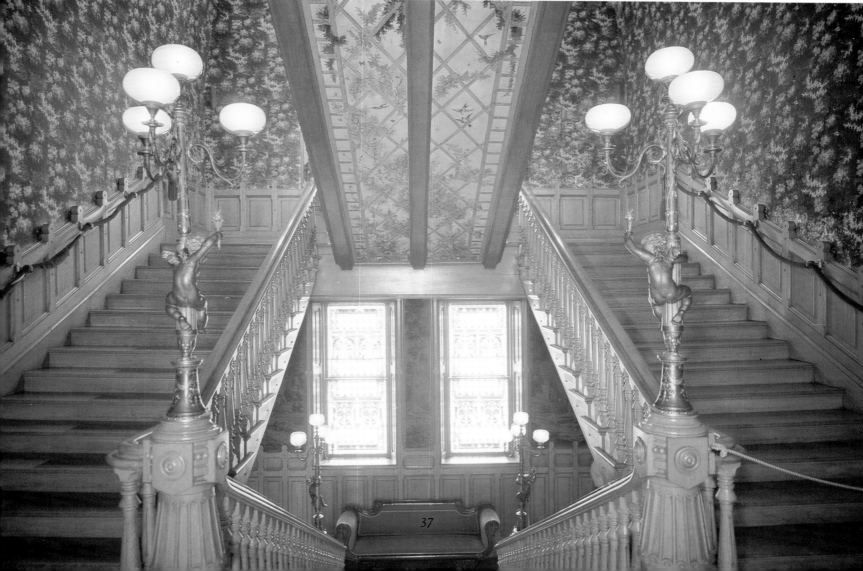

ROYAL INFLUENCE

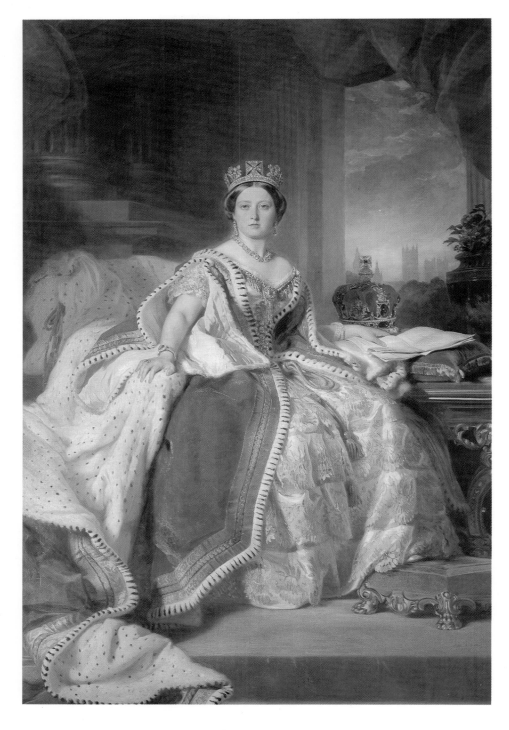

*Queen Victoria, painted by Franz Xavier Winterhalter in 1859.
Described by his royal patron as "excellent, delightful Wintherhalter," the German
artist was commissioned to produce a large number of pictures, of which over a
hundred still form part of the Royal Collection.*

ueen Victoria was crowned in 1837 at the age of 18. By the end of her long rule in 1901, the country over which she reigned had been transformed in every aspect. When she came to the throne, after George IV, the popular support for the monarchy as an institution was uncertain. When her son Edward became King, he inherited the high esteem in which the sovereign was held by her subjects, and the monarchy was widely regarded as a fundamental institution in British society. But the transition from what could be described as mass indifference to the new Queen in 1837 to a sense of national loss when she died, was not an even one. Her reign was marked by a number of low points in support for the crown at the time of the death of her husband, Prince Albert, in 1861, and her ensuing period of widowhood during which she was reluctant to play out her public role. But this was retrieved in later years when there was widespread public recognition of her hard work and concern with the Empire. At the end of the century, text books and children's primers embroidered a cult of regal glorification:

 'Beautiful England – on her island throne –
Grandly she rules, with half the world her own.
From the vast empire the sun ne'er departs:
She reigns a Queen – Victoria, Queen of Hearts.'

Made Empress in 1876, the Queen was not just a figurehead for the *realpolitik* of statesmen like William Gladstone and Benjamin Disraeli, but played an active role in international affairs. Although the relationship between the monarchy and parliamentary politicians slowly diminished after the death of Albert, who had exerted a discreet influence on the affairs of state, on occasion she challenged the positions of her ministers, such as Gladstone's support for Irish Home Rule. Yet Victoria's devotion to duty was not maintained without doubts and tribulations. She wrote in her journal on New Year's Day 1881:

 I feel how sadly deficient I am, and how oversensitive and irritable, and how uncontrollable my temper is when annoyed and hurt. But I am so overdone, so vexed, and in such distress about my country, that that must be my excuse. I will pray daily for God's help to improve.

Although obviously not a typical Victorian, for as a woman her life was not circumscribed by the demure, domestic roles that most women were forced to play, she held the beliefs and attitudes so characteristic of Victorian Britain. As a devoted Christian, her actions were guided by faith, and the moral codes of the day. Her preferences in art, decorative art and

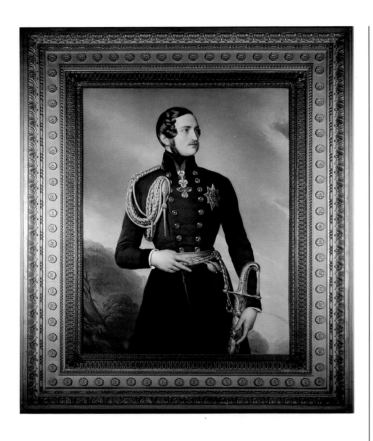

ABOVE *Prince Albert's election to the Presidency of the Society for the encouragement of the Arts, Manufactures and Commerce in 1849, nine years after his marriage to Queen Victoria (below) was official recognition of his enthusiastic involvement in many aspects of his adopted country.*

design were as conservative and middle brow as those of the majority of most of her subjects. In this sphere, as in many aspects of her life, Victoria followed the lead of her husband, to whom she was devoted. She exclaimed in her journal after the opening of the Great Exhibition: 'This day is one of the greatest and most glorious days of our lives, with which to my pride and joy, the name of my dear Albert is for ever associated!'

The Queen and Prince Albert had married in 1840, three years after her succession to the throne. He was born in Rosenau, Coburg in 1819 and was the son of the Ernest, Duke of Saxe-Coberg-Gotha. As a youth he was a great lover of nature and country sports. In his late teens he went with his brother to Brussels to study history, science and European languages. Here, a friend wrote:

> Albert was distinguished by his knowledge, his diligence, and his amiable bearing in society. He liked above all things to discuss questions of public law and metaphysics, and constantly, during our many weeks, juridical principles or philosophical doctrines were thoroughly discussed'.

His marriage to Victoria was considered by statesmen throughout Europe to be politically advantageous. But it must be

noted that their love for one another was genuinely felt. The young Princess wrote to her uncle after first meeting with him; 'Albert's beauty is most striking, and he is most amiable and unaffected – in short fascinating'.

Albert's position as the Prince Consort, after Victoria's accession to the throne in 1837, was difficult. He was unable to play a public role in national political affairs and in fact he was expected to be no more than a discreet advisor to the Queen. Frustrated by these restrictions, he ploughed his energy into good works and cultural patronage.

It must be remembered that the royal preferences in fine and applied art exerted a major influence on the fashionable taste of the day. The Prince Consort acknowledged this, saying:

> There are two great auxillaries in this country which seldom fail to promote the success of any scheme, – fashion and a high example. Fashion, we know, is all in all in England, and if the Court – I mean the Queen and myself – set the example hereafter . . . the same taste will extend itself to wealthy individuals.

The royal couple were expected to be more than interested consumers of paintings and furniture. As patrons of the arts, they were to set an example for less cultivated minds. Prince Albert is known to history as a great promoter of industry and the economy (not least for his part in organizing the Great Exhibition), but Queen Victoria and the Prince Consort were

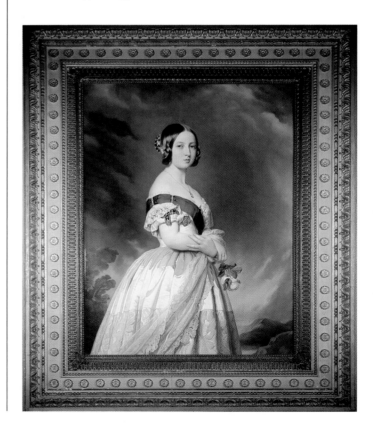

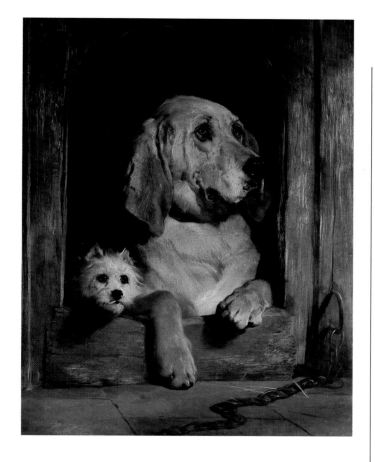

ABOVE *"Dignity and Impudence" by Sir Edwin Landseer (1802–73), favourite painter of the Queen. A specialist in depicting animal subjects his popularity was based on his ability to blend Victorian sentimentality with high moral tone.*

BELOW *Balmoral Castle, bought in 1852, rapidly became a popular and idyllic retreat for the Royal pair. The mania for all things Scottish provoked a national and international boom in tweed and tartan manufacturing.*

fully conscious of their roles as a tastemakers in the fine arts. Characteristically, Prince Albert enacted this role with the vigorous and rational enthusiasm that is found in all his other interests be they model farms or the decoration of the Palace of Westminster.

ROYAL PATRONAGE OF THE FINE ARTS

Fine art described every event in the lives of Victoria and Albert. The Queen kept albums of watercolours by artists such as Eugene Lami and John Nash with which to recall royal trips to foreign countries, their houses, and official events. Other painters were engaged to paint specific subject matter. Sydney Cooper, for example, was brought to Osborne House, the Royal home on the Isle of White, to paint a favourite Guernsey cow. He recorded in his autobiography Albert's great interest in the progress of the painting and their conversations about art. The painter Wilhelm Keyl went to Windsor Castle to record the Queen's pets and the farm animals.

Another popular Victorian painter, Sir Edwin Landseer, was a regular visitor to the royal households at Balmoral, Osborne and Windsor. This brilliant Romantic painter of animals prided himself in being able to capture animals in movement, such as in his painting *The Hunted Stag* which

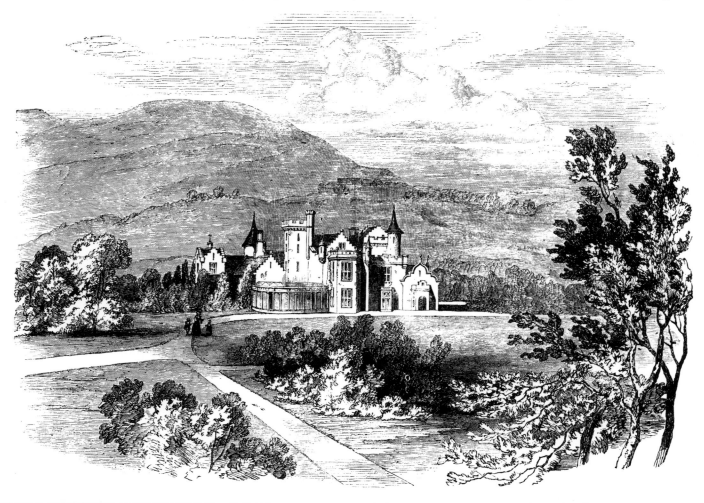

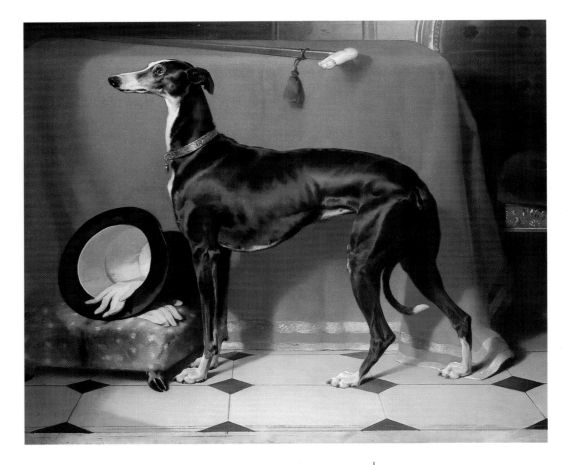

hangs in London's Tate Gallery. From 1839 onwards, Landseer was engaged by the Queen to record the royal family's pets and sporting animals, including the very beautiful portrait of a greyhound *Eos*. In this classically composed canvas, the dog stands in profile against a tiled floor and a table, and a charmingly painted top hat and white kid gloves are at its feet. Landseer was one of the Royal couple's favourite artists, and was rewarded by the Queen with a knighthood for his services in 1850.

In 1840 he started work on a portrait of Victoria and Albert and their daughter, the Princess Royal, Victoria, which is now in the Royal Collection. This portrait is far more elaborately finished than his paintings of subjects from nature, probably respecting Albert's preferences, and in accordance with the tastes of the time for glossy varnishes and a studied informality of pose. The conversation piece illustrates the Queen meeting the Prince, who in the German aristocratic tradition was a keen hunter, in the Green Drawing Room at Windsor after his return from a day's sport. At his feet lie a brace of ducks, and the royal dogs frolic on the floor giving Landseer the opportunity to display his virtuoso talents as a painter of animals. The Queen is reported to have been very pleased with the painting, which portrays her husband as a handsome, affectionate man. She wrote in her diary that the effect was 'altogether very cheerful and pleasing'.

Landseer also gave the Queen and the Prince Consort lessons in drawing and etching in 1842, for both were keen amateurs. At the begining of their marriage they spent many hours drawing, and in later life they produced together a delightful portrait of their children. Under the influence and the teaching of Landseer, the Queen drew and the Prince etched a portrait of their pet dog Islay (a dog much despised by many of Victoria's courtiers).

But neither the Queen nor the Prince laid any claim to being an artist. Explaining his philosphy of royal support for the arts to Lady Bloomfield over dinner at Windsor, Albert is reported to have said:

 I consider that persons in our position of life can never be distinguished artists . . . Our business is not so much to create, as to learn to appreciate and understand the works of others, and we never do this till we have realized the difficulties to be overcome. Acting on this principle myself, I have always tried to learn the rudiments of art as much as possible'.

Prince Albert was well known as a connoisseur of art. The illustrator of Dicken's novels, Phiz (Hablot Knight Browne), produced an affectionate pen drawing of the Prince as a life model posing for a group of young artists entitled *The Hero of a Hundred Portraits*, such was Albert's reputation as a patron to the arts. W P Frith, the painter of such popular paintings as *Derby Day*, a great success at the Royal Academy of 1858, paid tribute to the Prince by describing how, in response to suggestions from Albert, he modified the engraving of his

painting. He wrote: 'I put many of the Prince's suggestions to the proof after the close of the exhibition, and I improved my picture in every instance'.

It would appear that the Prince Consort was more advanced in his tastes than his Queen, for when he brought John Everett Millais' *Christ in the House of his Parents* to show her in 1850, she appears to have declined the opportunity to buy it. This painting, now hanging in the Tate Gallery, was originally displayed at the Academy's exhibition of 1850, and was a key painting of the avant-garde of the period, the Pre-Raphaelite Brotherhood. This and four other Pre-Raphaelite canvases hung there, came under heavy attack from the art establishment of the day. William Rossetti, Millais' colleague, wrote in his diary: 'Millais' picture has been the signal for a perfect crusade against the PRB ... in all the papers – *The Times*, the *Examiner*, *The Daily News*' even Dickens' *Household Words*, where a leader was devoted to the PRB and devoted them to the infernal gods – the attack has been most virulent and audacious'. It is interesting to note that, despite the scorn heaped upon these artists the Prince's artistic curiosity was sufficiently raised to ignore these cries of artistic perversity.

As well as encouraging contemporary artists, the Prince Consort was renowned as a collector of early German and early Italian paintings. It is widely recognized that Albert's activities as a collector made major contributions to the Royal Collection and the National Gallery. He employed a German painter and engraver, Ludwig Gruner as an advisor on art. Gruner acquired a number of major works of art on the Prince's behalf in the 1840s and 1850s, including Lucas Cranach's *Apollo and Diana*. The Prince also acquired a Duccio *Crucifixion* in 1846, and Fra Angelico's *St Peter Martyr*, which the Queen bought for him.

The Prince's activities were not only restricted to collecting works of fine art. He began work on a study of the entire *œuvre* of Raphael, the Italian Renaissance painter. In the true Victorian spirit of classification, he began collecting reproductions (prints, engravings and photographs) of works, both attributed to Raphael and those of established provenance. Over 1,500 items were catalogued and now reside in the British Library. Raphael, was for the Prince, the pinnacle of artistic achievement. Buckingham Palace and the Frogmore Mausoleum were decorated with reproductions of Raphael masterpieces.

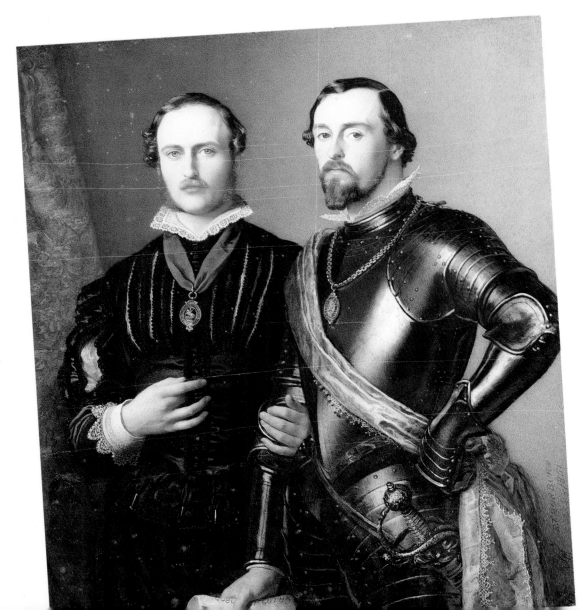

LEFT *This miniature by Richard Thorburn presents Prince Albert and his brother Ernest II of Saxe-Gotha in 17th century costume, an affectation reflective of the historical revivalism of the day.*

THE ROYAL HOMES

The two great royal homes of Buckingham Palace and Windsor Castle were not greatly modified by their new inhabitants in the years after Victoria's 1837 Coronation. Windsor had received much attention from George IV who had employed the architect Jeffrey Wyattville to redesign much of the interior, and Victoria and Albert concerned themselves with the grounds and its lesser buildings. Civil servants had plans to demolish the Royal Lodge and the small fishing cottage near Viginia Water, but the Prince orchestrated their restoration. New stables were built and the grounds near the Park were re-landscaped to give more privacy to the royal family. The estate itself was the focus of the Prince's attention at Windsor, with its twin functions of a sporting park for deerhunting and agricultural land. However, the Prince's fondness for hunting fuelled controversy, with *Punch*, the satirical magazine, leading the pack of critics.

Similarly, Buckingham Palace was not greatly changed by the Queen during her long reign. Improvement and extensions were hampered by problems of finance. As a building owned by the British people in which to house their monarch, any work on it could not be financed from the private purse of the Queen or the Prince Consort, but had to be approved by parliament by due proceedure. George IV's architect, John Nash, had started a series of very costly alterations to the building in the 1820s, and had incurred the displeasure of parliament for it. Despite these alterations, the Palace's new occupants found that it did not meet their requirements, for it was barely habitable and incomplete. The Palace was un-hygienic, with strange smells rising out of the sewers, and kitchens that shocked Dr Lyon Playfair, who had been called in to survey the building. The ever growing royal family, with its servants and perpetual guests, felt cramped by the building. In February 1845, Robert Peel, the Prime Minister, replying to pleas from the Queen for money to extend and improve the building, had to state that it was not a judicious moment. These were the 'hungry forties', a period of terrible economic hardship in Britain.

In the following year, after a commission had investigated the problems at the Palace, the Government allocated a sum of £150,000 for improvements. A number of changes were made to the exterior of the building, of which the most significant was the architect Edward Blore's redesign of the facade, done with the Prince's encouragement. According to one recent history of the building, this facade was influenced by Caserta, a Bourbon Palace which the Prince had seen in 1839 on a visit to Italy. Unfortunately, this new architectural aspect did not last long, for it was built in poor quality stone which

ABOVE AND BELOW *Osborne House, like Balmoral, was bought from the savings that resulted from Prince Albert's reform of Royal Household expenditure. Situated near Cowes on the Isle of Wight, this seaside house was purchased in 1845 and redesigned in the Palladian style by Thomas Cubitt, following the specifications of the Prince Consort.*

began falling before the building was completed. Despite contemporary architectural thought, which then preferred unstuccoed stone, the building had to be plastered white to prevent further damage to its frontage.

Royal influence can be seen to a greater degree in the interiors of Buckingham Palace. The Queen owned Brighton Pavilion, Nash's marvellous Indian-style regency residence in the heart of the town, but thought that it was an inappropriate setting in which to bring up her family. The building offered no privacy from the crowds that were flocking to the seaside town in increasing numbers. In 1847 the interiors of the Pavilion were dismantled and many of their fittings removed to Buckingham Palace. Despite Blore's suggestion that Buckingham

Palace ought to have new modern interiors, the Prince insisted that the superb fittings from Brighton be used for the new reception rooms. The small dining room has a number of items, notably a magnificent mantelpiece, from Brighton. A number of rooms were added to the south side of the Palace in the early 1850s, including a ballroom and a supper ballroom. The Prince's preference for Italianate art and design is reflected in this ballroom, with its copies of Raphael's series of paintings, *The Hours*. The Queen described the opening ball in 1856 in her diary: 'everyone could rest and every one could see. It was most truly a successful fête, and everyone was in great admiration of the rooms'.

But it is Osborne House, built in the late 1840s for the royal family, and Balmoral Castle purchased in the autumn of 1852, that give a greater indication of royal taste, and a much better picture of the day-to-day lives of the royal family.

Osborne House on the Isle of Wight was first seen by the the Queen and the Prince Consort in 1844, and they immediately fell in love with it. They purchased it in the following year, the Queen writing:

BELOW LEFT *The nurseries at Osborne are typical of the relaxed informality that characterised this Royal retreat.*

RIGHT *This horn stool and chair at Osborne House illustrate the often bizarre nature of Victorian taste.*

We have succeeded in purchasing Osborne on the Isle of Wight . . . It sounds so snug and nice to have a place of one's own, quiet and retired, and free from all woods and forests, and other charming departments who really are the plague of one's life.

The royal couple liked Osborne, for unlike Brighton Pavilion, it offered a quiet retreat near the sea, allowing the Queen to use her new steam-powered yacht. The Prince could excercise his ideas about running an estate with complete freedom. Although the initial plans were to improve the existing 16-room building, Thomas Cubitt's survey of the mansion suggested that it would be less expensive to build afresh. Cubitt submitted his plans for the new building in April 1845 which offered a private pavilion for the use of the royal family and a number of rooms for her guests. These did not meet all their social and political commitments, and so a number of smaller houses were built. A Swiss-style cottage stands in the grounds, brought over from Germany, which the royal children used to play in. It contained a scaled down shop and a kitchen. The inspiration for the Italianate style of Osborne House is assumed to be the Prince Consort's, for its views reminded him of the Bay of Naples. He is reported to have altered Cubitt's original classical designs, to make them 'more academically correct'.

Osborne was a far more familial, domestic home than any of the Queen's other residences. It contained a number of up-to-date features including ventilation and bright nurseries for Victoria and Albert's nine children. The theme of the family

was continued in the works of art decorating the house, including a family portrait by FX Winterhalter, and a number of statues of the children by Mary Thornycroft. While Buckingham Palace housed a grand organ, Osborne heard the sounds of Albert playing the piano and harpsichord. It seems as if Osborne marked a very happy period in the lives of the Queen and her Prince. In her long widowhood she often recalled their time there fondly.

Both Victoria and Albert were keen on the Scottish Highlands making a number of trips in the early 1840s. It appears that Albert was much taken with Scottish life, and the Highlands may have reminded him of the mountains of Thungria and time spent there in his youth. They first saw Balmoral Castle, in the Deeside region, in 1848 and fell under its spell. It had been rebuilt in the 1830s in the then fashionable Scottish Baronial style; a heavy, Scottish Gothic, characterized by a

ABOVE, LEFT AND OPPOSITE
Osborne House,
like Balmoral, was bought from the
savings that resulted from Prince
Albert's reform of Royal Household
expenditure. Situated near Cowes on
the Isle of Wight, this seaside house was
purchased in 1845 and redesigned in the
Palladian style by Thomas Cubitt,
following the specifications of the
Prince Consort.

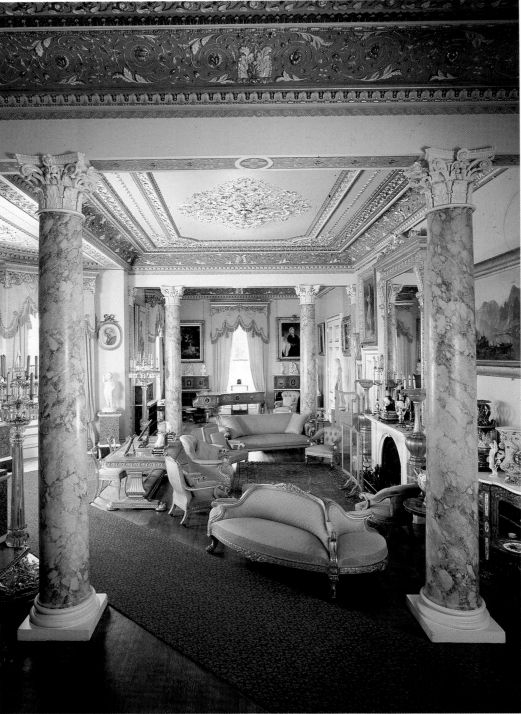

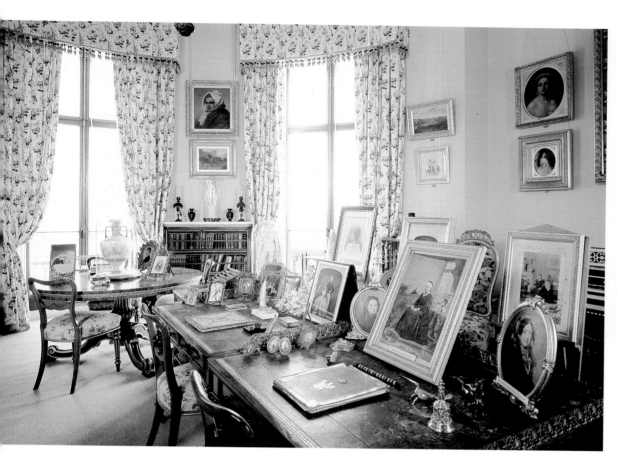

light coloured granite and historicist detailing such as tiled turrets and archer's slits.

The Prince Consort took possession of Balmoral four years after first seeing the castle, because complications in Scottish law demanded an Act of Parliament to allow its purchase. The Prince again planned to improve and enlarge the building. A new ballroom was built. In decorating the interiors the Prince was swept up in an passion for all things Scottish, to the distaste of one visitor:

> The curtains, the furniture, the carpets, the furniture (coverings) are all of different plaids, and the thistles are in such abundance that they would rejoice the heart of a donkey if they happened to look like his favourite repast which they don't.

John Philip painted a portrait of the Prince, in full highland dress with Balmoral Castle in the background, and both the Prince and the Queen had lessons in traditional Scottish dancing. Albert, never at home in London, loved the Highlands with its opportunities for hunting and drawing nature. Royal parties made expeditionary trips into the wilder parts of the countryside which were recorded by the artist Carl Haag, and the Queen in her book *Leaves from the Journal of Our life in the Scottish Highlands*, in 1868.

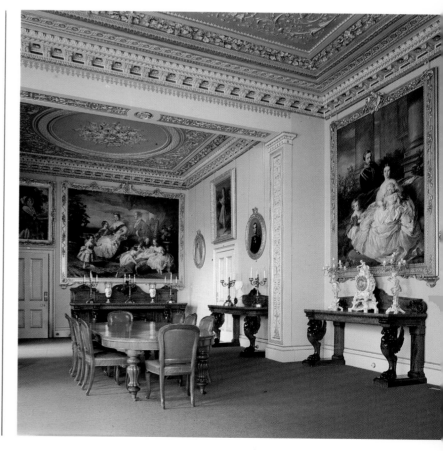

GOOD WORKS

The Victorian period was an age of great social changes and reforms. Many of the key institutions of British society today were initiated in the second half of the 19th century. These included the education system which was extended to all sections of society by the 1870 Butler Education Act, and public libraries, initiated by an Act in 1850 which empowered local authorities to offer their services for free. Growing concern was felt over public health, and in particular the threat of cholera which claimed the lives of many early Victorians. This led to the development of municipally run sewage systems and clean water distribution. Increasingly, the upper and middle classes felt obliged to improve the standards of living of the poor. Many individuals excercised their philanthropic concerns by starting or joining charities. A number of charitable schemes were begun in the last decades of the century to provide sanitary housing for the poor, such as the Peabody Trust, or to provide pensions for domestic servants, or to encourage temperance. Characteristically, Victorian social improvement was generally felt to be an area for voluntary effort; the work of the individual rather than parliamentary legislation and public funding.

The Prince Consort was no less Victorian in this aspect than any other member of society. In 1844 Albert was made the president for the 'Society for Improving the Condition of the Working Classes', which set itself the task of designing cheap sanitary housing for the poor. Employing the architect, Henry Roberts, the Society displayed some of their houses at the Great Exhibition, near the Hyde Park Barracks. These homes were technically far superior to any of the speculative buildings then being erected in Britain's cities. They included a number of novel features such as hollow bricks to prevent dampness and better insulation. Interestingly, they were not simply plain, utilitarian shells for their poor occupants to inhabit, but contained some pretty brick detailing, and had a pleasant 'Elizabethan' character. After the exhibition these buildings were taken down and re-erected in South London, where they still stand at the entrance to Kennington Park.

It seems that the Prince Consort was a much greater enthusiast for reform than the Queen and he took on many engagements as her deputy. These included the laying of innumerable foundation stones and the opening of hospitals, colleges and homes for retired sailors and soldiers. He was also a great educationalist and was inaugurated as the Chancellor of Cambridge University in March, 1847. His activities there, perhaps to the dismay of some of those around him, were not those of a figurehead and he achieved considerable changes in the curriculum. His greatest educational legacy was the complex of scientific and educational institutions in South Kensington, which was dubbed 'Albertopolis' in his honour. As has already been noted in Chapter Two, the Great Exhibition was a considerable financial success. Albert dictated that its profits should be spent in the spirit of the exhibition, suggesting:

an establishment in which by the application of Science and Art to industrial pursuits the Industry of all nations may be raised in the scale of human employment, and where by the constant interchange of Ideas, Experience and its results each nation may gain and contribute something.

ABOVE *French engraver Gustave Dore, already celebrated for his illustrations to Dante's Inferno and the Bible, produced during 1869–71 a telling series descriptive of the endemic squalor and poverty of Victorian London. Prince Albert's model lodging house (below) erected in Hyde Park for the 1851 Exhibition, was one of many high-minded attempts to ameliorate the problem.*

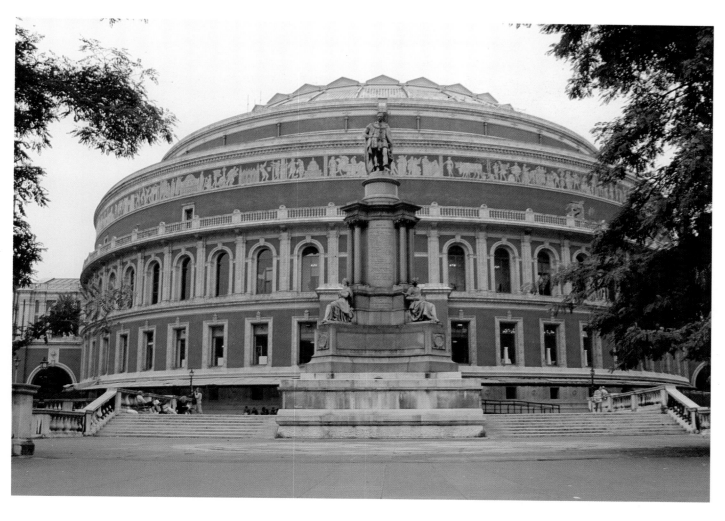

The government matched the profits of the exhibition, and an 87 acre plot of land in South Kensington was purchased. The site on which the Albert Hall now stands was originally intended to house the National Gallery, which the Prince wanted moved from its busy spot overlooking Trafalgar Square.

The keystone to the development was the South Kensington Museum, which was built by Captain F Fowke of the Royal Engineers. This museum, then surrounded by fields, and opened to the public in 1857, was in the Italian Renaissance style, with earthy red brick, and detailed terracotta mouldings. The interiors of the South Kensington Museum mark the progression of Victorian style through the 1860s and 1870s. Most of the initial interiors were decorated by School of Design pupils, such as Godfrey Sykes and James Gamble who designed the first refreshment room. The enamelled iron ceiling of this room was a technique revived by the French Sèvres Factory in the 1840s and highly lauded at the Great Exhibition of 1851. This room was a stunning *tour de force* in cream, red and ochre tiles successfully combining industrial design and decoration.

The firm of Morris, Marshall, Faulkner and Co., the leading edge of mid-Victorian design, was commissioned to decorate the West Dining Room, next to Sykes and Gamble's room. This second space marks a great contrast with the first, for it is replete with mediaevalist touches, including stained glass

ABOVE *The Royal Albert Hall, designed by Captain Francis Fowke, was built in 1867–71 as a vast amphitheatre, 273 ft across and 155 ft high, with a capacity for 8000 spectators.*

windows and painted wall panels representing the seasons of the year. The Museum's exhibits were of both scientific and artistic interest and included the Sheepshank collection of paintings, and objects on loan from the patent office, drawing great crowds to the Museum.

The Prince Consort died in 1861, before much of the South Kensington complex was begun. But the Science Museum, the Royal College of Music and the other educational institutions commenced after his death, stand as tributes to his reformist and educationalist zeal.

Another of the Prince's notable activities was his chairmanship of the commission which selected the works of art to decorate the Houses of Parliament. Three years before Victoria came to the throne, the Palace of Westminster was destroyed by a fire so great that it could be seen on the South Downs. A competition was launched in 1835 to design a new building in either Elizabethan or Gothic style, which Charles Barry, a Gothicist won. Building work began in 1840, and in 1841 the commission, led by the Prince, was instituted. The commission was constituted by, in the words of Richard Redgrave RA, 'the most eminent statesmen of all parties, with some

representatives of literature and dilettantism of the country: art was strangely omitted'. With Barry's plans complete, it was clear to the commission that large, decorative paintings and major works of sculpture were demanded. Seeking advice on their preference for frescoes, the commission turned to Germany where Ludwig I was employing leading members of the Nazarene school to decorate his Munich home. This led to some concern that the Prince, as a German, would wish to employ German artists to decorate the home of British democracy. But in April 1842, the commission announced a competition for cartoon drawings depicting scenes from British history or literature. One year later, 140 cartoons were displayed to the public at Westminster Hall. The winning entry was Edward Armitage's *Caesar's Invasion of Britain*, with GF Watts' *Caractacus Led in Triumph Through the Streets of Rome* and CW Cope's *Trial by Jury* coming second and third.

It was decided that the commission needed to test the ability of these, and a number of other favoured painters as fresco artists, for the technique was not practised or taught in Britain at the time. Consequently, the first commission was not awarded until 1845, to William Dyce for his *The Baptism of Ethelbert*. This work shows Ethelbert, the 7th century King of Kent, being christened by St Augustine in Canterbury. Appropriately for the technique, this fresco has some of the character of early Renaissance art in its treatment of space and triangular composition. Dyce had spent some time in Italy studying fresco painting, and was heavily influenced by the Nazarene school, who were a group of artists working in the early years of the century in Germany. Johann Overbeck and Franz Pforr formed this quasi-religious brotherhood in 1809 and began painting in the deserted monastry of St Isadoro in Rome. Heavily influenced by Durer, Raphael and Perugino, they aimed to regenerate German religious art. A further three artists, Cope, Daniel Maclise and J C Horsley, were commissioned a year later and all four frescoes were unveiled to the public in 1848.

Despite the authority of the commission and the talent of the artists who worked on them, the frescoes at the Palaces of Westminster have not been highly regarded by historians of art. The high aspirations behind the project were not met: the technique of fresco was not revived, as had been hoped by the Prince. Others have noted that these works lack the maturity and richness found in the oil paintings by these artists. It also appears that the commission's concern with technique was not rigorous enough, for within a few years the frescoes were visibly deteriorating.

RIGHT *One of the reading rooms in the Library of the House of Lords designed by Augustus Pugin. Converted to Catholicism in 1835, Pugin believed that a Medieval Gothic revival would encourage a return to pre-Reformation spiritual values.*

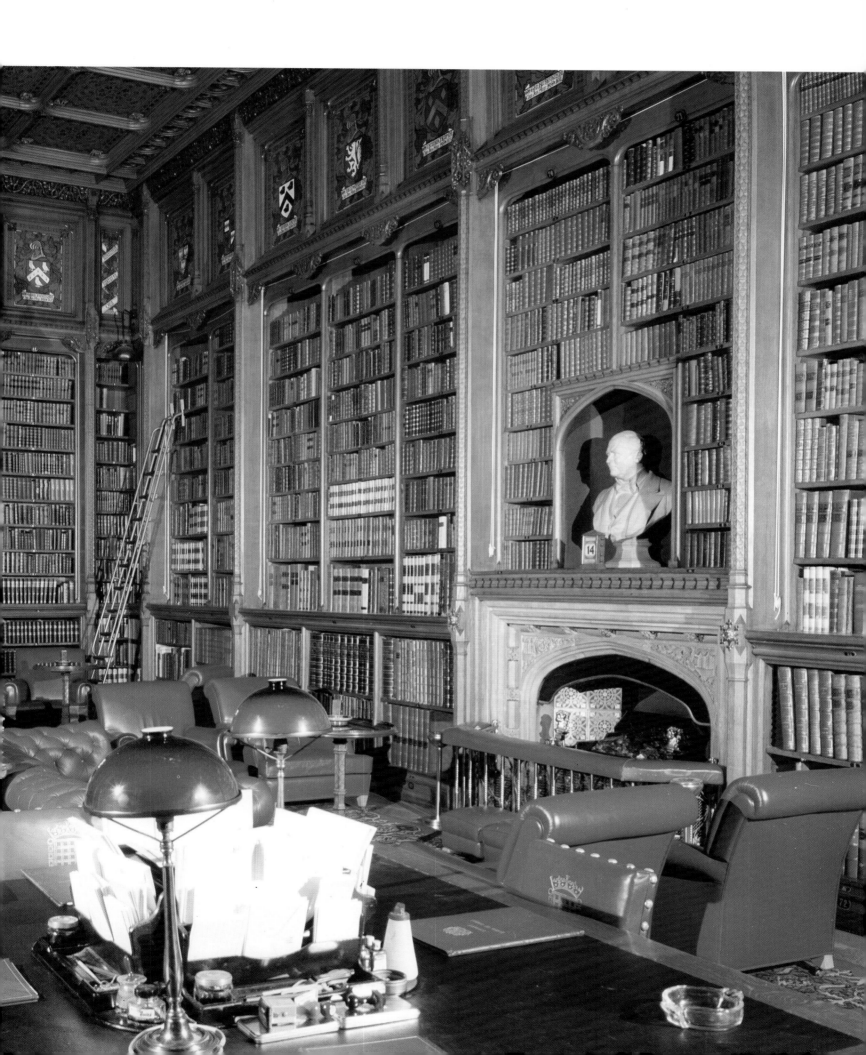

The image of royalty during the Victorian era was disseminated throughout England and the colonies on a mass scale. Public works, like the coat-of-arms embroidered on the Coronation chair in the House of Lords (above right) and the royal cypher blazoned on this marble drinking fountain (below right) were matched by commercial production. Ceramic portraits of the Queen and her family, such as this 1837 Goss ware likeness (above), were found in most middle class homes.

Allegory played a large part in royal iconography. Thomas Brock's Queen Victoria Memorial in front of Buckingham Palace (below) presents the Queen surrounded by eight symbolic marble and bronze groups. Similarly Gibson's sculpture in the Prince's Chamber, House of Lords, (above) has Victoria flanked by Justice and Mercy.

THE CULT OF MONARCHY

During the course of her long reign Queen Victoria was transformed into a national and imperial icon. In tribute, her name was given to areas of the world: new stretches of Empire such as the Victoria Falls; the State of Victoria; and hundreds of towns across the globe. With less pomp, the products of manufacturing and commerce adopted her regal name for even the most prosaic of products, such as the 'Victoria' fountain pen and the 'Victoria' chiming clock. The lives of the royal couple were enveloped by a personality cult, so that even their own property was graced by their names. In 1844, for example, her new steam yacht was named *Victoria and Albert*.

Another Victoria and Albert, the museum, is an interesting case in point. The Museum of Manufactures was renamed as

the Victoria and Albert Museum in May 1899, the date of the Queen's last public engagement. She was in South Kensington to lay the foundation stone of a new facade designed by Aston Webb. As she made her short speech under the cover of a pavilion, she may have looked back to the building and seen the original facade, above the lecture theatre. On the pediment, designed by Reuben Townroe, she would have seen herself portrayed as Hera giving laurels to industry, art and other virtues, with her name, V I C T O R I A, radiating above her head like a halo. This mosaic in gold and terracotta tiles made by Minton and Company, a memorial to the Great Exhibition, payed greater tribute to the Queen. Similarly in the refreshment room thousands of ornamental tiles simply stated 'Victoria'.

The name Victoria and her image were associated with a number of objects emblematic of their age. The Penny Black, as an example, the first postage stamp, introduced by Roland Hill and Henry Cole, depicted the Queen's head in profile.

COMMEMORATIVE MEMORABILIA

Victoria's accession in 1837 marked the beginning of the royal souvenir industry. Objects such as this jug (below left) commemorating her proclamation are comparatively rare, a situation which changed radically in the years that followed. The Diamond Jubilee of 1897 inspired objects as diverse as these four lace and gilt framed royal photographs (bottom right), a porcelain mug decorated with the royal coat-of-arms (below right), stitched ribbons (right, opposite right), and this embroidered commemorative picture (left) Ephemera such as this dinner menu (opposite bottom centre) and reception programme (opposite bottom right) celebrating the Golden Jubilee of a decade before, were treasured as much as this emphatically imperial commemorative plate (top right).

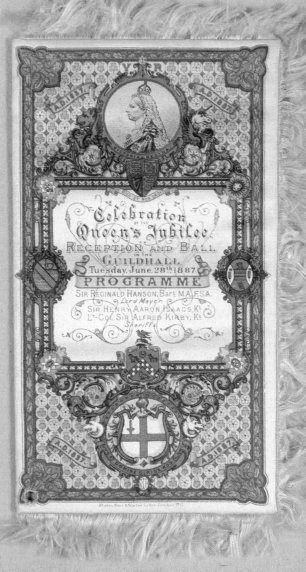

Hill's national postage system was a triumph of the Victorian Age, and it was appropriate that it was symbolized by the Queen. In June 1857, the first Victoria Cross medals were awarded in Hyde Park to heroes of the Crimean War. The Queen gave her name to the greatest symbol of military valour, an iron maltese cross made from guns captured at the battle of Sebastopol in 1855.

Royal jubilees and anniversaries presented manufacturers with the opportunity to produce popular items to celebrate these occasions. Although the Silver Jubilee of her coronation

LEFT AND BELOW *The Albert Memorial is a complex construction based around a 15ft high gilt-bronze figure of the Prince enshrined beneath a richly decorated Gothic revival canopy. Designed by George Gilbert Scott, the memorial was erected during 1863–76 at a cost of £120,000, raised by public subscription.*

was overshadowed by the death of the Prince Consort in the previous year, the Golden Jubilee of 1887 saw floods of jubilee medals, ceramics and popular prints all depicting the Queen. The marriages of her children to the aristocracy and nobility of Europe also provided opportunities for commemorative objects.

When Victoria came to the throne in 1837, a number of fashions were triggered that appear slightly odd today. The Victorian doll was the essential toy for children of the middle classes. It was the subject of fashion changes that mimicked life and technical innovations, such as the development of talking dolls in the 1830s. On Victoria's accession blue eyes became fashionable, superseding the taste for brown.

But the fashionability of the living Queen was little compared to the veritable cult of the Prince Consort after his death in December, 1861. This was fuelled by the Queen's protracted period of mourning. She demanded that his rooms at Windsor, Balmoral and Osborne remain as he had left them. Every night his clothes were laid out by his bed as if he was to wear them the following day. In her own bedroom was a photograph of the dead Prince and casts of his face and hands, which had been taken by the sculptor William Threed. She sent to their children relics of his life and locks of his hair.

Despite the Prince Consort's request that she would not 'raise even a single marble image to his name', the Queen commissioned a number of memorial projects, including scale statues and busts for the royal homes and as gifts to friends and servants. Key royal portraits from the early 1860s depicting the Queen alone or with her children, feature busts of Albert as the focal point. Both Albert Graefle and Joseph Noel Paton were commissioned to produce such paintings in 1863.

Following the Queen's example, a number of commemorative projects were set in motion throughout the country. The most famous of these was the 'The National Memorial to His Royal Highness the Prince Consort', which is better known as the Albert Memorial and stands in Hyde Park. The design was by the Gothic architect, George Gilbert Scott, selected from among several projects by seven prominent architects who worked as the advisory panel to the memorial committee. He regarded it as a chance:

> to erect a ciborium to protect a statue of the Prince . . . designed in some degree on the principles of the ancient shrines. These shrines were models of imaginary buildings, such as had never in reality been erected, and my idea was to realise one of these imaginary structures with its precious materials, its inlaying, its enamelling etc. etc.

It appears that Scott's scheme was selected because he placed great emphasis on the Gothic being Albert's preferred architectural style, and the English tradition of Gothic memorials,

artists were carved in a running frieze around the podium supporting the memorial.

John Clayton designed glass mosaics which were made in Venice and placed in the gables of the canopy, on the themes of art and virtue. A running mosaic, below the gable, relates the inscription: 'Queen Victoria and Her People – To the Memory of Albert Prince Consort – As a Tribute of their Gratitude – For a Life Devoted to the Public Good'. Smaller white sculpted figures decorate the heights of the towering structure, which is topped with a cross.

Critics noted that the statue of the Prince was dwarfed by the magnificence of the structure designed to house it. *The Times* argued that it was inappropriate to commemorate the Prince's life of 'purity' with wealth and luxury. But the format of Albert memorials had been set, and in the following years other cities, like Manchester, erected Gothic memorials to the Prince.

Stained glass windows, appropriate symbols of illumination and piety, were commonly chosen as memorials to the Prince. These often alluded to the Prince's life and good works through biblical scenes and parables. St Mary's in Nottingham, for example, chose New Testament stories that were 'emblematical of the Reformatories, Schools, Hospitals, Asylums, and other institutions, which H.R.H. patronized; and of the

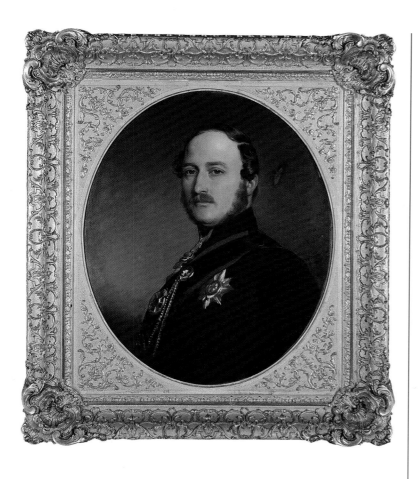

ABOVE *Prince Albert, Queen Victoria's "dear angel" died suddenly of typhoid in 1861, to her immense grief. His study (right) was preserved after his death.*

citing the example of the Eleanor Crosses erected by Edward I after the death of his wife in the late-13th century. All the other proposed designs were derived from Classical architectural forms. Scott's design was not without its critics, including Henry Cole, who challenged the historical veracity and plausibility of Scott's scheme. Despite this, the memorial was begun in May 1864 and was opened to the public in July 1872.

The memorial consists of a 175 feet high, richly ornate architectural canopy, which protects a bronze statue by J H Foley, of the Prince, who sits looking south to where the Albert Hall stands. The canopy rests on a base which has groups of figures at each corner representing Manufactures, Agriculture, Commerce and Engineering; the cornerstones of Victorian wealth. At the bottom of the steps which lead up to the memorial stand a further four groups symbolizing Europe, Asia, Africa and America. These eight groups were commissioned from the major sculptors of the day – John Bell, William Theed and William Calder Marshall. Characters from history, placed in thematic groups such as poets and musicians and

general benevolence which he practised'. The most important stained glass window dedicated to the Prince's life was installed in Saint George's Chapel at Windsor in 1863. This Gothic window made reference to the Prince through biblical symbolism and was intended 'to stir up one deeper feeling of love, and thankfulness for an example so noble'.

A number of institutions commissioned paintings as memorial tributes to the dead Prince. The Royal Society of Arts, of which the Prince had been the President, raised a sum of £700 by subscription. It decided to spend part of this sum on portraits for the Society's Great Room. This room had been decorated by James Barry in the 1790s with a series of history paintings, supplementing the portraits of Lord Romney by Joshua Reynolds and Lord Folkstone by Thomas Gainsborough that were already hanging there. In 1863 the Society proposed to replace these two portraits with contemporary ones of the Prince and the Queen. CW Cope was commissioned to paint the portrait of the Prince. The Prince stands, in garter robes, staring directly out at the viewer. By his left hand lies the Charter of Incorporation of the 1851 Great Exhibition, his greatest achievement. A weeping cherub and the hourglass in the painting refer to the fact of the Prince's death, and the overall effect of this painting is of sombre tranquillity. Appropriately, J C Horsley's portrait of the Queen has more verve. She is

shown with their children, in a composition formed by a twisting plan of the Crystal Palace held by the young Prince Edward and his sisters.

Many popular portraits of the Prince were produced in different media. A number of firms made woven silk portraits of the dead Prince, shown with his family, his coat of arms or with edifying epithets such as 'The Earth is the Lord's and the fulness thereof'. The demand for photographs of the late Prince was very great, with 70,000 postcard images being sold during the first week of national mourning. The writer Alfred Mumby noted:

 Crowds round the photograph shops, looking at the the few portraits of the Prince which are still unsold. I went to Meclin's to buy one: every one in the shop was doing the same. They had none left: would put my name down, but could not promise even then. Afterwards I succeeded in getting one – the last the seller had – of the Queen and Prince: giving four shillings for what would have cost but eighteen pence a week ago.

All kinds of ceramic wares were produced in Albert's memory. At the Great Exhibition of 1862, a number of manufacturers displayed such items, including Copeland with their famous 'Albert Tazza'. This large porcelain ornamental plate depicts

Albert's successes as 'promoter of the arts', 'president of societies for science' and 'chancellor of an university'. The same company also issued a small statuette of a relaxed Prince, dressed in a morning coat and seated in an armchair. This figure, designed by George Abbott was made in Parian ware, an unglazed porcelain developed in the 1840s.

A range of more utilitarian memorial goods found their way on to the Victorian marketplace including buckles and belt clasps and a tape measure decorated with a photographic portrait of the Prince. Amateur artists could hand colour prints of such subjects as the Union Jack at half mast, musicians could buy sheet music for hundreds of ballads and hymns dedicated to their Prince, and others could spend their leisure hours reading numerous pen portraits of his life in penny editions.

Despite the fact that the Queen was not amused by many of the popular commemorative items produced by opportunist manufacturers, the popularity of memorial items across all price ranges and contemporary comment testify to the genuine sense of loss at the death of the Prince.

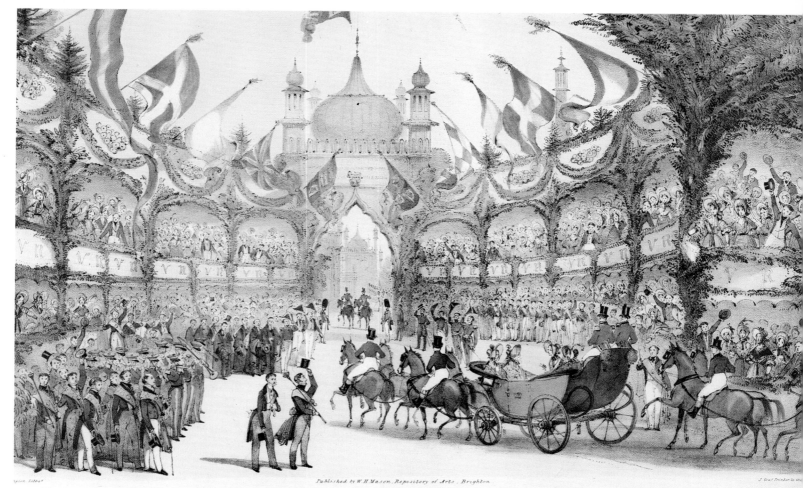

Published by W H Mason, Repository of Arts, Brighton

Her Majesty QUEEN VICTORIA *passing under the* TRIUMPHAL ARCH *through the* AMPHITHEATRE *(designed by M^r Fabian) erected in Honor of* HER MAJESTY'S *first visit to* BRIGHTON *Oct^r 4^th 1837. Dedicated by permission to the* QUEEN *by Her Majesty's Most Obed^t Humble Servant.*

W. H. MASON.

THE BATTLE OF STYLES

"Isabella and the Pot of Basil" (1866–8) by the Pre-Raphaelite artist William Holman Hunt. Based on a scene from the Keats' poem, the painting brings together an extraordinary amalgam of cultural styles, ranging from a Turkish hanging lamp to a majolica pot reminiscent of contemporary "Art Pottery," that seem far removed from the original medieval Italian setting.

id 19th-century architecture and design was trapped in a paradox. The Victorians lived in an age of amazing inventiveness and imagination. They were as aware of the progresses made in their time as any historian today. The triumphs of their age and the leading figures behind these success were proclaimed, although without mention of the ill-effects of many of their achievements, by writers like Samuel Smiles in books such as *Invention and Industry* and in journals like the *MacMillan Magazine*. But while engineers, entrepreneurs and scientists were building the future, 'the mother of the arts', architecture, appeared to be sinking into ever greater retrospection. Historicism dominated architecture, and architecture exerted great influence over the applied arts. It is hard to distinguish separate developments in these two areas of design until the end of Victoria's reign because the leading decorative artists were usually, first and foremost, architects. Futhermore, it is hard to talk of design as a separate profession until the last decade of the 19th century, when the Arts and Crafts Movement, under the influence of ideas drawn from traditional handicrafts, came to prominence.

THE DUNGEON OF ARCHAEOLOGY

Historicism was widely regarded as a problem, even by those architects whose practice was most firmly entrenched in one of the many historical styles of the day. George Gilbert Scott, the Gothicist, wrote in 1850:

I am no mediaevalist, I do not advocate the styles of the Middle Ages as such. If we had a distinctive architecture of our own day, worthy of the greatness of the age, I should be content to follow it; but we have not.

The proponents of each divergent style believed that it had the most to offer modern man. Scott, as he implied in the quote above, chose the Gothic because he believed that it combined the spiritual in its 'Christian' forms and the rational in that it provided building solutions for every kind of architectural problem, from his great St Pancras railway station to the humblest of cottages. Conversely, the Classicists, men like Sir Robert Smirke, the architect of the British Museum, believed that their chosen architectural language embodied the great transcending values of art, democracy and civilization.

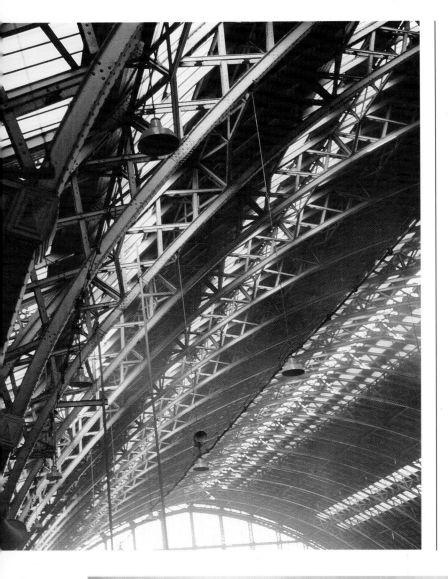

Futhermore, beyond the very general architectural classifi-cations of Classical and Gothic, a series of sub-divisions can be drawn up, whose proponents were pitched against each other. Until the Enlightenment of the 18th century, architecture had followed a set of conventions that established a hierarchy of appropriate forms. The monumental Doric order, for example, was considered suitable for buildings such as prisons, whereas the more decorative Corinthian, was used in buildings such as clubs. With the rise of notions of the picturesque in the late 18th century, these Classical rules of design broke down. Architects began to search for novelty and variety. Great architecture came to be seen as less the successful application of established rules and more the source of delight and surprise.

The earliest Gothic Revival buildings of the mid 18th cen-tury paid little heed to historical accuracy. They were the projects of romantics and enthusiasts rather than pedants. Horace Walpole's home Strawberry Hill, begun in 1749, ori-ginally contained a number of Classical elements such as a Palladian chimneypiece in the style of Willliam Kent. He augmented these details with a diverse range of Gothic forms: the staircase wallpaper was derived from ornament found in Worcester Cathedral; St Alban's Abbey provided the inspir-ation for the doors to the gallery, and Richard Bentley designed a set of chairs to match some 16th-century stained glass Walpole had installed there.

During the 19th century British architects began to be con-cerned with greater veracity and historical styles were divided into periods and sub-styles. Thomas Rickman's book *Attempt to Discriminate the Styles in English Architecture* of 1819 estab-lished the three categories still used to describe the Gothic

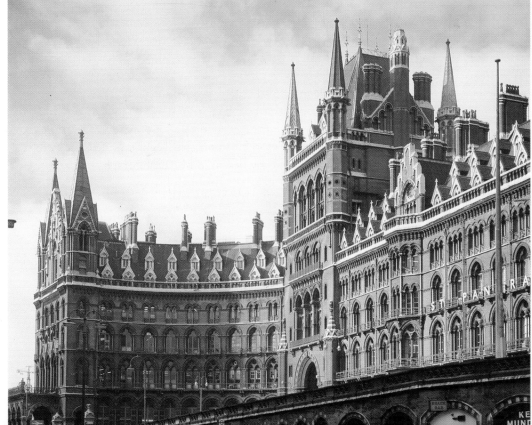

ABOVE *Built in 1867–74 by George Gilbert Scott, St Pancras Station, one of the two great termini of the London Midland Region, incorporates design elements from both French and Italian Gothic architecture. W.H. Barlow's great glass and steel 690 ft trainshed (below) runs behind this imposing frontage.*

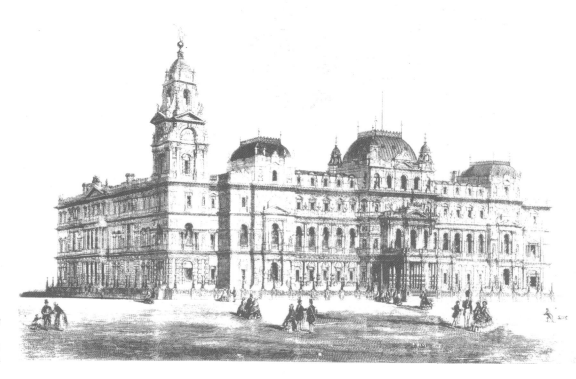

RIGHT *Coe & Hofland's design for the new Foreign Office building, to be located near Downing Street, was one of many submitted in the classical style.*

today: Early English, Decorated, and Perpendicular. By the middle years of the 19th century, each of these styles had its supporters. As an example, although most Victorian Gothic buildings were typically in the Perpendicular style, the great architectural theorist, August Welby Northmore Pugin, was a dedicated proponent of the Decorated (preferring to call it 'English Middle Pointed'). Similarly, Classical architecture was subdivided into a number of styles; neo-Classical or Palladian and so on. The architect and archaeologist, Charles Cockerill, in his support for a variant called 'Classical Antiquity', was just as concerned with historical veracity as his Gothic counterparts.

Victorian architectural practice hit a crisis in the middle of the century because of this highly self-conscious and academic approach to historical style. Victorian thinking was widely based on a belief in the evolutionary nature of progress, but in their new found concern with accurately recreating the achievements of the past, architects hit a dead end. Scott acknowledged this, writing: 'The peculiar characteristic of the present day, as compared with all former periods, is this – that we are acquainted with the history of art'.

The crisis in Victorian architecture, and in particular, its fixation with historical styles, is neatly encapsulated in the story of the competition for the Foreign Office building in Whitehall in 1856. This episode not only reveals the extent to which architects were bound by historicism, but also the meaning that was attached to particular styles within Victorian society.

THE FOREIGN OFFICE COMPETITION

By the mid 1850s, due to Britain's growing role in international affairs, the Foreign Office had outgrown its headquarters. Lord Palmerston's Liberal government announced a competition to build new offices on a site near Downing Street. Most of the projects submitted were in Classical style and the winning design by H B Garling was heavily influenced by the new Louvre building in Paris. Palmerston did not like this design, and set Sir James Pennethorne, architect to the Board of Works, the task of designing the building.

George Gilbert Scott was one of the small number of Gothic architects who had submitted a design in the original competition and had been awarded third place. On hearing that the winning design was to be rejected and a non-competitor commissioned, Scott lobbied strongly to have his project reconsidered, or in his words; 'I thought myself at liberty to stir'. He described this design in his autobiography of 1879, thus:

> I did not aim in making my style 'Italian Gothic', my ideas ran much more towards the French, to which for some years I have devoted my chief study. I did, however, aim at gathering a few hints from Italy . . . I mean a certain squareness and horizontality of design. . . . I combined this . . . with gables, high pitched roofs and dormers. My details were excellent and well suited to the purpose.

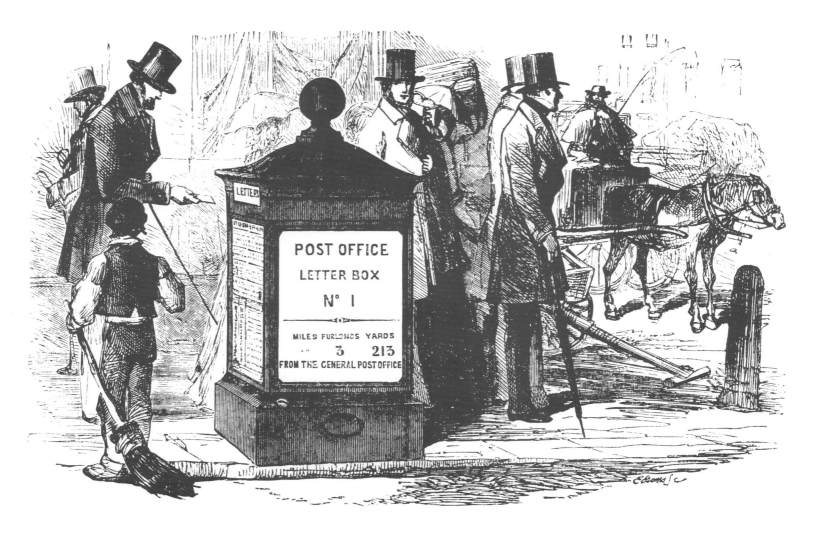

There were many in parliament who supported Scott, for it was felt that the Gothic was the most appropriate architectural style for a major state commission. This architectural language was argued by its proponents to be a singularly national style echoing the nearby Westminster Hall, the Henry VII Chapel of Westminster Abbey and the still incomplete new Houses of Parliament by Charles Barry. The Gothic style, particularly in its Perpendicular form, was also associated with Anglicanism, ie the High Church, and nationalist and royalist politics, ie High Tory. In February1858, a new Tory Government came into power, bringing a number of Scott's supporters in with it. One of these, Lord John Manners, was made First Commissioner of Works with the responsibility for the Foreign Office project. He appointed Scott as architect to the scheme.

However, another political swing occurred and in June 1859 the Liberal Party was brought back into power. Scott attempted to persuade Palmerston of the merit of his design. But when Palmerston suggested that another architect might be able to meet his demands, Scott capitulated and produced further designs in a 'Byzantine' style. These too did not meet with the Prime Minister's approval, who called it a 'neither one thing nor t'other – a regular mongrel-affair'. Scott was only able to secure Palmerston's necessary consent with an

LEFT *Despite its prosaic function, the first letter box, set up at Ludgate Circus in 1855, was ornamented and surmounted by a ball finial.*

Italian Renaissance-style design. The great claims made for the new Foreign Office, at its opening in 1873, seem somewhat reduced by Scott's admission that he 'bought some costly books on Italian architecture and set vigorously to work'.

The conflict between Scott and Palmerston had little to do with the fitness of the design; it came about because of their divergent stylistic preferences. When the building was complete, in plan, it differed little to Scott's original design. The building, in Portland stone and coloured granite, is dominated by an Italianate tower, that could just as easily have been erected in polychromatic bands of brick and carved masonry underneath a tower mimicking the Venetian Early Renaissance.

But what the episode does illustrate is the importance placed on style in the this period. Victorian edifices and artifacts were seen to be made attractive, fashionable and meaningful by being cloaked in historical decoration and ornament. Even the most functional things were disguised in this manner; water works were dressed up as Greek temples, and sewing machines as painted *objets d'art*.

RIGHT *Now a museum, Monkwearmouth Station was opened in 1848. Local architect Thomas Moore was responsible for the classical design whose frontage employs a pediment supported by columns of the ionic order.*

BELOW LEFT *Parian ware, as can be seen in this Minton example of "Una and the Lion," lent itself well to classical treatment. This unglazed porcelain proved remarkably popular with those who could not afford contemporary marble statuary such as E. Miller's "Venus and Cupid" (below right), bought by Queen Victoria for Osborne House.*

VICTORIAN NEO-CLASSICISM

The story of neo-Classicism in the 19th century can be traced back to the Palladianism of William Kent in the early 18th century. Its development was also influenced by James 'Athenian' Stuart in the 1760s, notable for his Spencer House and his book *Antiquities of Athens* of 1762. In the 1760s, Stuart was succeeded in his position of eminence by Robert Adam, whose calm elegant variant of Classicism, inspired by Pompeii, led fashionable taste until the 1780s. He in turn was superseded by James Wyatt, whose allegiance to Classical idioms was erratic, and who produced his most famous buildings in the Gothic style such as Lee Priory in Kent.

Around the turn of the century the interest in Classicism, which had until that point been diverse in character, took on a particularly Greek aspect with men like Thomas Hope arguing for Greek over Roman orders. The installation of the Parthenon Sculptures in the British Museum in 1816, brought back from Athens by Lord Elgin in 1806, fuelled the interest in neo-Classicism. This was reinforced by manufacturers such as Wedgwood, who had been producing highly Classical ranges of ceramics in their black basalt since the 1760s.

Neo-Classicism peaked in the first decades of the century when a number of prestigious architectural commissions such as the new Covent Garden Theatre, University College in London and the British Museum were assigned to Classicists. At that point, this Classical heritage in Britain was particularly vigorous; some observers believed it had become the national style. They felt that British art and design, derived from Greek models, outshone the rest of Europe. 'At the present moment', wrote Thomas Kebble Hervey in 1834, 'no school of sculpture can claim to take the lead of England'.

The taste for neo-Classicism, or 'the Greek' as contemporaries referred to it, had declined by Victoria's accession to the throne in 1837. This is usually characterized as a revolt against

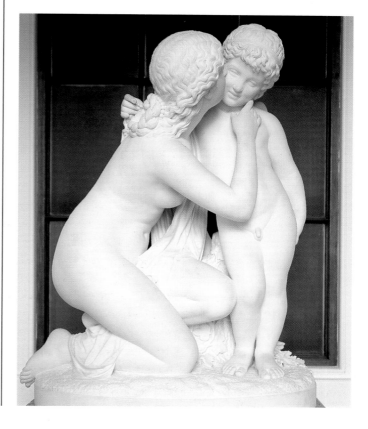

LEFT *The British neo-classical sculptor John Gibson (1760–1866) studied under both Flaxman and Canova. His "Tinted Venus" (1851) is the best known of his attempts to revive the classical practice of colouring statues.*

RIGHT *This ornamental Minton vase of tinted Parian ware overlaid with exquisitely fashioned passion flowers and foliage in decorative relief, was manufactured in 1854.*

FAR RIGHT *The Elgin Vase with its delicately etched classical motifs and running frieze was completed by John Northwood.*

James Bunning's Coal Exchange, for example, which was finished in 1849, in its exterior form recalls the Tower of the Winds in Athens.

In Scotland and the industrial cities of the north of England the neo-Classical style continued to be popular. Perhaps the greatest of these buildings is J A Hansom's Birmingham Town Hall which was opened in 1849. Hansom's classical design had been chosen in preference to Gothic designs by Charles Barry and Thomas Rickman. It was based on the the form of the Temple of Castor and Pollux in Rome, and stands on an open site in the centre of the city. Although not a large building, an impression of massiveness was achieved by beautiful, fluted Corinthian columns supported by a rusticated podium. In Scotland a number of late Classical buildings were erected in the 1850s. These included W H Playfair's National Gallery of Scotland in Edinburgh of 1850–4 and Alexander Thomson's Caledonia Road Free Church in Glasgow in 1856–7, which

the 'good taste' of Chippendale furniture and Nash terraces, and a desire for novelty and 'flights of fancy' exemplified by the bizarre tastes on display at the Great Exhibition. It was specified in the competition to design the new Houses of Parliament in 1835 that the only acceptable styles were to be the Gothic or Elizabethan. But neo-Classicism continued to exert an influence on Victorian art and design until the 1860s when many of its leading proponents died, including the sculptor, John Gibson in 1866, and Sir Robert Smirke, the architect, in the following year. Although other architectural styles, such as the Gothic, won many of the prestigious commissions of the day and had more vigorous advocates, 'the Greek' continued to be popular in certain fields of design, such as municipal building and memorial sculpture.

Although Sir Robert Smirke's British Museum, the most prominent Victorian neo-Classical building in London, was completed in 1847, it was designed in the 1820s and so belongs to an early period of architectural taste. Other buildings in London of the Victorian period displayed neo-Classical traits.

are both conspicuous examples of the Grecian style in Scotland. Thomson was in fact the last great polemicist of the neo-Classical style. In the 1860s, as the Goths took the high ground with their concern with Christianity and morality, he retaliated with his *Enquiry into the Appropriateness of the Gothic Style for the Proposed Buildings for the Univeristy of Glasgow*. But the battle was lost and the university was built in the architectural language of the Middle Ages.

Futhermore, railway companies continued to commission neo-Classical buildings in the 1840s and the 1850s. This association with railway architecture was established by Philip Hardwick's monumental Doric arch at Euston Station in London in 1835–7. The affluence of mid-century railway companies can be seen in the quality of some of the classical buildings which they commissioned. The railway station in Ashby-de-la-Zouch, designed by Robert Chaplin in the late 1840s, contains many superb details. Despite the relative anonymity of this minor architect, this building is a work of great scholarship in its precise detailing, with crisp guttae and laurel wreaths running around the metope.

Despite its apparent decline, neo-Classicism continued to dominate mid-Victorian sculpture. John Gibson RA, who achieved great notoriety for his polychromatic *Tinted Venus* at the Great Exhibition, was the most successful sculptor of the period. But it must be noted that, as he had lived in Italy since 1817, he was somewhat outside debates about style in Victorian Britain. His best known commission was his statue of the Queen in the House of Lords of 1854.

Novel techniques in the manufacture of *objets d'art*, such as Parian ware, also stimulated the taste for neo-Classical sculpture. Parian is a kind of near-porcelain developed by the firm of Copeland and Garrett in 1842, quickly followed by other ceramic manufacturers such as Minton and Company. It was used as an inexpensive substitute for marble in the production of busts and figurines, and because of this was suited to neo-Classical forms. By using a pantograph, manufacturers were able to produce accurately scaled-down versions of well-known works of sculpture for the mass market. A number of well known neo-Classical sculptures were reproduced by firms like WT Copeland in this fashion. The *Bust of Clytie* in the collection of the British Museum, for example, was reproduced by Copeland in 1855 at the request of the Art Union of London and displayed in the firm's Bond Street shop four years later. Copeland also commissioned contemporary Classicists, including Edgar George Papworth RA, to produce works which they reproduced as 'Parian Statuary'.

If the death of neo-Classicism appeared obvious to contemporary commentators, Victorian manufacturers paid more heed to their customers. There was always room in the market-

The vaulting and walls of the choir of St Pauls Cathedral are resplendent with glass mosaic work of Byzantine richness designed by Sir William Richmond. The ceiling with its saucer domes illustrating the Benedicite canticle from the Morning Prayer, pictured here was completed during 1892–5.

place in decorative objects for a small number of neo-Classical items. All the major firms producing decorative art and furnishings continued to produce neo-Classical goods, including the cabinetmakers, Holland and Sons; Minton and Company, the ceramic manufacturer, and Elkington, Mason and Co., a firm famous for their electro-plated metal ware.

In the years of the presidency of the 'frontier candidate', Andrew Jackson, from 1829 to 37, neo-Classicism fared in America in much the same way as it did in Britain. Many prominent commissions were given to neo-Classicists, including Thomas U Walter who built Andalusia, the imposing Pennsylvania home of the banker, Nicholas Biddle, in 1833. In the south, many Greek-style mansions were built along the banks of the Mississippi. It is also worth noting that a number of architects attempted to compose in this style, generally associated with brick and masonry, in wood, occasionally with great aplomb and success.

At the Great Exhibition, the American sculptor Hiram Powers' *Greek Slave* was the subject of much attention. This statue, created eight years earlier, was only allowed to be shown in public after it received the assent of a committee of prominent clergymen, who were persuaded by its author that her nudity was a consequence of her slavery.

But by the 1840s the Gothic Revival came to dominate American design led by two architects, Richard Upjohn and Alexander Jackson Davis. Similarly, in the fine arts the fashion for classical subjects, notable in the early years of the 19th century, gave way to a taste for Romantic scenes, typified by the work of the Hudson School.

THE VICTORIAN RENAISSANCE REVIVAL

British artists and designers, since the age of the Grand Tours, looked to Italy for inspiration. Just as the English miniaturist Samuel Cooper travelled to Rome in the 1640s, William Dyce followed him there in the 1820s. Accordingly the Victorian period was not exempt from the influence of the Italian Renaissance, and many of the best late 19th-century paintings

show it. In fact, it is difficult to distinguish a particular revival for the Italian Renaissance proved to be a perpetual influence on Victorian artists and designers.

MID VICTORIAN RENAISSANCE REVIVAL

At the beginning of the 19th century, 15th- and 16th-century paintings were barely represented in the National Gallery; by the end of Victoria's reign it had the greatest collection of these works outside Italy. Interest was stimulated in the Italian Renaissance by some of the greatest works of art history scholarship, among them John Ruskin's *Stones of Venice* of 1849, and Walter Pater's *The Renaissance* of 1873. And no doubt the Victorians enjoyed the idea of associating their own *risorgimento* in the arts with the glories of that period.

Beyond a minor vogue for picturesque Italianate villas in the first few decades of the early 19th century, such as Charles Parker's Villa Rustica built in the 1830s, it is possible to discern two groups of artists and designers who were considerably influenced by the Italian Renaissance.

THE RENAISSANCE STYLE AND ESTABLISHMENT TASTE

The first of these groups were the circle of designers and theorists around Prince Albert and Henry Cole. The Prince Consort was a major influence on the revived use of Renaissance style in the Victorian period. His 'Island Palace Home', Osborne House on the Isle of White, is in the form of an Italianate villa. In addition to this he was also instrumental in the decoration of a garden pavilion in the the grounds of Buckingham Palace in 1844. The central room in this picturesque summer house was decorated with a fresco depicting Comus, the Greek god of mirth, and two others were decorated with classical themes derived from Pompeii, and romantic episodes from the novels of Walter Scott. Here the Prince employed eight eminent royal academicians, including Charles Eastlake and Daniel Maclise, to direct the project. It is not too fanciful to compare the Prince Consort's patronage of these artists with the princely patronage of Raphael at the Villa Farnesina in the early 16th century.

Henry Cole, through Felix Summerly's Art Manufactures, encouraged a number of Renaissance revivalists, including the sculptor John Bell who designed for Minton a salt cellar in the form of a boy with a dolphin and a shell. This figure in Parian ware is straight from Botticelli.

Cole was also instrumental in the appointment of the most important revivalist, Alfred Stevens, to the School of Design in 1845, where he was employed to teach 'drawing and painting, ornament and geometrical drawing and modelling'. Stevens, born in 1817, was the son of a decorator from Dorset. Although a precocious talent in his youth, he had been unable to afford the apprenticeship premiums to study under Edwin Landseer, and was sent to Naples in 1833, presumably to study. But

ABOVE *William Holman Hunt's painting "The Light of the World," was by the end of the century to achieve the status of a Protestant icon as a result of its wide dissemination in photographic and engraved reproductions.*

Stevens was no 'grand tourist', for when he arrived he knew no Italian and no arrangements had been made for his stay.

During his eventful 18 months in Naples, he was involved in a number of political intrigues and moved in the criminal circles of that city. He made his living from producing paintings and portraits. In 1835, he walked to Rome, which he found in political chaos, and so moved on to Florence where he spent four years working in the Uffizi Gallery. Here, he produced near copies of masterpieces, which dealers would sell to wealthy tourists as original works of art, a number of which found their way back to England. Consequently, on his return in 1842, he had a better grounding in Italian Renaissance art than any other English artist bar William Dyce.

In England, Stevens used his broad range of talents, and proved to be an astute self-publicist. Working as a painter, he entered the competition for the decoration of Westminster Palace. As a decorative designer he worked for a number of British manufacturers. In 1850 he left London and the Schools of Design, and moved to Sheffield, where he was employed by

the iron-founders, Henry E Hoole and Company. They exhibited his designs at the Great Exhibitions of the middle years of the century. He designed an andiron to match Hoole and Company's Pluto Dog stove shown at the 1862 International Exhibition in London, which was decorated with classical scrolling and two symmetrical muse-like figures. He was also employed by Minton and Company, the ceramic manufacturers, to produce a series of vases and plates. When these were exhibited in 1862, Stevens was awarded a Certificate of Honourable Mention.

His first major success was as a sculptor when he produced the winning entry in a competition to design the memorial to the Duke of Wellington for St Paul's Cathedral in 1856. (This was actually only a partial success, for it was not erected until 1920, 45 years after Stevens' death.) The shrine was inspired by Matteo Carmero's early 16th-century high altar in the church of St John and St Paul in Venice. It is constructed in contrasting light stone and inky bronze, and depicts Wellington on horseback on a superb neo-Classical base. Underneath this architectural canopy lies a sepulchral Wellington. Set against the architectural order of the canopy, Stevens sculpted contorted allegorical figures of valour and cowardice.

At St Paul's in 1864, he also executed some beautiful mosaics which ornament the spandrel panels between the main arches. They depict three old testament figures: Isaiah, who is shown scanning a message from God; Jeremiah, who dictates a warning against cruel leaders; and Daniel receiving guidance from God through the intercession of angels. These mosaics echo the style of fresco work in the Sistine Chapel, and Stevens was regarded a 'mere copyist of Michelangelo'.

From 1851, Stevens was employed to design the interiors and furnishings of a number of rooms in Dorchester House in London's Park Lane by its owner, Robert Stainer Holford. The dining room is in a High Renaissance style with beautifully sculpted caryatids crouching around the fireplace. In Carrara marble, they support the classical entablature-shelf, which is made from Bardiglio marble. The border around the grate is superbly decorated with inlay work. This fireplace and a number of other details in the house, including some very fine furniture, mirrors and doors, are exceptional examples of the Renaissance Revival in Victorian Britain. Unfortunately Stevens never completed his work at Dorchester House. He appears, for all his considerable talents, to have been unable to see his schemes through to their conclusion.

Stevens' influence as a teacher, inspired by the glories of the Italian Renaissance, can be seen in many projects of the 1860s and 1870s by his pupils from the School of Design. The most prominent of these was Godfrey Sykes, a key figure behind the decoration of the Victoria and Albert Museum. Here, Sykes

designed the ceramic and terracotta ornament that characterizes the western wing of the building. Terracotta decoration received a timely revival in the 1860s, prompted by Ludwig Gruner's *The Terracotta Architecture of Northern Italy* of 1867. Sykes also designed an influential alphabet in earthenware tiles, for the refreshment room in the Victoria and Albert Museum, which revived a Venetian 16th-century tradition of letters decorated with figures symbolizing each initial.

Another member of the Cole Group was the German emigré Gottfried Semper. With his encyclopedic knowledge of the history of architectural and ornamental style, Semper was a key supporter of the Renaissance Revival. While practising as an architect in Germany in the 1840s, he designed the Dresden Gallery and Opera House in a neo-Renaissance style. In Britain, Semper designed a cabinet for the London firm Holland and Sons which was shown at the Paris *Exposition Universelle* in 1855. This cabinet in ebony is ornamented with a centrally set porcelain panel, a copy of William Mulready's *Crossing* painted by George Grey, and a number of Wedgwood plaques. The most striking details of this piece of furniture are the carved legs which are decorated with lion heads and shields.

It should be noted that the Renaissance style was chosen by the mid-Victorian design establishment; the Prince Consort and the Cole Group. As the experience of the Foreign Office competition showed, it was also the architectural preference of the political establishment of the day. A number of prestigious schemes resulted in Renaissance-style buildings. The Gothic architect William Burges, under pressure from his client, produced a Renaissance Worcester College in Oxford, 1864.

HIGH RENAISSANCE REVIVAL ART

The harbingers of the second wave of the Victorian Renaissance Revival, in contrast to the first, were regarded at the time as a *nouveau arrivé* movement in art. A writer in the *Art Journal*, reviewing an exhibition of the work of some of the key figures, in 1871, wrote:

> Since Pre-Raphaelitism has gone out of fashion, a new, select, and also small school has been formed by a few choice spirits . . . The brotherhood cherish in common, reverence for the antique, affection for Italy; they affect southern climes, costumes, sunshine also a certain *dolce far niete* style . . . Taken as a whole, it may be accepted as a timely protest against the vulgar naturalism, the common realism, which is applauded by the uneducated multitudes who throng our exhibitions.

This author may have overstressed the extent to which these Renaissance revivalists constituted a 'brotherhood', but he was correct in his characterization of their works.

A core of four Renaissance revivalists can be identified in the painters; Albert Moore, George Frederick Watts, Frederic Leighton and the sculptor, Alfred Gilbert. From 1877 to 1891, the painters lived and worked near each other in Kensington. Watts and Leighton were close, although Moore is reported to have been a more withdrawn character. Leighton, who also worked a sculptor, was a great supporter of youthful Gilbert.

Like their Renaissance heroes Titian and Cellini, all four artists drew inspiration from the antique, clothing their allegorical characters in flowing classical costume like figures from the Elgin Marbles. More direct inspiration came from the 16th century masters. Leighton's bronze *Athlete Struggling with a Python*, for example, bore a strong resemblance to Michelangelo's David. This *tour de force* of anatomical detail, de-

scribes a muscular athlete straining to hold a snake at arm's length. It was exhibited at the Royal Academy in 1877, to much critical acclaim. Ten years later, Carl Jacobsen a Danish brewing magnate, commissioned Leighton to make a replica of this piece in marble for his museum in Copenhagen. Leighton's sculpture, regarded by Jacobsen as one of the best classical works of the 19th century, was acquired to complement his great collection of classical art.

These artists drew their Renaissance inspirations in a characteristically Victorian fashion. In the 18th century, classical subjects would be widely understood as symbolic social or political comments on the society of the day. Jacques Louis David, for example, used classical allegories in such paintings as *The*

RIGHT *Erected in 1893 to the memory of the seventh Earl of Shaftesbury, Alfred Gilbert's Angel of Christian Charity, popularly known as Eros, still dominates Piccadilly Circus. The extraordinary delicacy and poise of the figure was achieved by casting in light-weight aluminium rather than the traditional but less malleable medium of bronze.*

Oath of the Horatii, to great political effect in late 18th century France. The Republican sympathies of this painting of 1785, were an important pre-signifier of the impending French Revolution. In contrast, the political stability of late Victorian Britain – or perhaps more accurately the complacency of the ruling classes – led some artists to find their Renaissance inspiration in the luxury and beauty of Mediterranean civilization. These Renaissance revivalists shared little of the social moralism and documentary concerns of realist artists in Britain during the same period, such as Luke Fildes and Frank Holl.

George Frederick Watts, Frederic Leighton and Albert Moore painted canvases of luxuriating beauty and sumptuous colour. Typically, their art depicted leisurely scenes of figures in repose or children playing in arcadian landscapes. Only Watts appears to have allowed worldly troubles to enter his Renaissance Revival dreams of perfected civilization. His *The Denunciation of Cain* of 1872 was exhibited at the Royal Academy under the title *My punishment is greater than I can bear*. It is a masterly canvas depicting a contorted Cain overcome with guilt after murdering his brother. Overhead, six

angels plummet earthbound to witness the scene. The figure of Cain was widely thought to have represented a London slumlord, racked with guilt for his actions. In the mid-years of his career, Watts was fascinated with grand theatre and tragic myths, painting canvases with titles like *Love and Death* and *Chaos*. But throughout his life he painted beautifully calm poetic works on the themes of love and hope as found in classical mythology. His late work of 1900, *Peace and Goodwill*, shows a mother and child, an outcast Queen and her son, calmly sitting and looking toward a glowing light at the edge of the picture.

Albert Moore's work from the 1860s onward was populated with carefully modelled figures, adopting poses of great restraint and serenity. He is best known for his paintings of women in dream-like states, such as *Beads* of 1875 and *A Workbasket* of 1879. Draped in transparent silks, they lie on beige sofas in rooms bordered by screens and drapery and littered with classical artifacts; ewers, urns and so on. His considered use of colour tended to the pale and the pastel, and his brushstrokes were thin and flattened. Although Moore painted Greek maidens, he achieved a transcendental, timeless sense of place, and his work was not that of an historian but an aesthete.

Frederick Leighton, later Lord Leighton of Stretton, was a painter of quite exraordinary ability. Like Moore, his paintings frequently depict sleeping women in classical dress and poses. In works like *Flaming June* of 1895, he displayed his virtuoso talent by exquisitely portraying every fold of a dreaming woman's transparent dress veiling her beautiful body. The colour scheme is dominated by this flaming orange dress. She lies, folded within herself; a difficult pose to render in correct perspective but one which the artist successfully mastered.

Alfred Gilbert, born in 1854, was 24 years younger than his ardent supporter and fellow Renaissance revivalist, Frederick Leighton. In the early 1880s he travelled to Florence and was inspired there to produce his first statue in bronze. This piece, *Perseus Arming* of 1882, was cast by the almost forgotten method of *cire-perdue*. It bears a strong similarity to Donatello's *David*, although Gilbert said that he intended it as a challenge to Cellini's *Perseus with Head of Medusa*. When it was exhibited at the Grovesnor Gallery in 1882, it was a great success, drawing comment for its novel colouring and surface texture. When it was shown at the Paris Salon of 1883, it was given an honourable mention, an honour which was rarely extended to an English artist.

This bronze was seen by Leighton who was so impressed that he commissioned a statue from Gilbert on the theme of Icarus. After the showing at the Royal Academy in 1884, Gilbert became overnight the most famous sculptor in England, and Leighton persuaded him to return to his native country. In the 1880s he was commissioned to produce major sculptural works celebrating Queen Victoria in Winchester Castle, Henry Fawcett in Westminster Abbey and the Earl of Shaftesbury in Piccadilly Circus.

This memorial to Shaftesbury, commonly known as *Eros*, has become one of the best known works of sculpture in Britain. Anthony Ashley Cooper, Seventh Earl of Shaftesbury, had been a leading Victorian philanthropist and the Lord Mayor of London. In 1886 he commissioned Gilbert to create a statue in his memory. The memorial is a fountain topped by a bronze statue of Eros firing his bow. Gilbert felt that both these elements appropriately embodied Shaftesbury's selfless love. Gilbert's relationship with the committee overseeing the project was fraught and when he looked back on these years at the end of his life he regretted ever leaving Italy.

To Victorian Britain the Renaissance Revival, a variant of historicism in the fine arts, was strikingly new. These artists were British equivalents of such continental *fin de siècle* masters as Gustave Klimt in Vienna, and Puvis de Chavannes and Gustave Moreau in Paris.

HIGH VICTORIAN GOTHIC

The mid Victorian period saw the culmination of the Gothic Revival which had been progressing in a rather sporadic fashion since the 1750s. In the 18th century, interest in the Gothic was the dilettante hobby of aristocrats and the rich. Under the influence of romantic novels by writers like Hugh Walpole, who owned an early Gothic Revival home, and Sir Walter Scott, men like William Beckford at Fonthill Abbey and Sir Roger Newdigate at Arbury Hall planned homes in the Gothic style. For these patrons, this style was a picturesque diversion rather than an exercise in historical veracity. Like Scott's *Waverley* novels, these buildings were to their owners places where they could escape the realities of business and politics and dream of a chivalrous time of mediaeval knights and pageants. Edward Blore published a rhapsodic book called *Monumental Ruins* in 1826 which became an important source book for early 19th-century designers and patrons fantasizing about a picturesque past. At Goodrich House in Herefordshire, Sir Samuel Rush Meyrick employed Blore to create his 'Hastilude Chamber' in which to house his famous collection of armour.

Related to the rise of the Gothic was the increasing popularity of antiquaria. Led by academic and literary taste in the late 18th century, in the early part of the 19th century it became highly fashionable to collect and decorate one's home with antiques and authentic architectural details. The Gothic encouraged the taste for mediaevalist objects; suits of armour, heraldic motifs, stained glass and carved masonry. The market in old Flemish architectural carvings grew to such an extent that there was a flourishing trade in fakes emanating from Belgium.

Many writers have characterized this phase of the interest in the Gothic as merely pastiche when compared with the mid-Victorian's highly moral and clerical attitude to it. But it must be noted that this romantic and picturesque phase of the Gothic was underpinned by some serious scholarship such as E J Wilson's *Specimens of Gothic Architecture* of 1821–3. Furthermore, the later phase of the Gothic, although inspired by the writings of theorists like John Ruskin and A W N Pugin, was for the many people who bought mediaevalist objects and lived in Gothic style homes just another turn of fashion. Many manufacturers who borrowed this style for their products saw it as just another language in the repertoire of style.

LEFT *Wall paper designed by A. W. Pugin for the Houses of Parliament. Incorporating the Tudor Rose and the portcullis intertwined with the royal cipher, it was produced by S. Scott, J. G. Crace*

RIGHT *The chromolithographed frontispiece to Pugin's "Glossary of Ecclesiastical Ornament and Costume, Compiled and Illustrated from Ancient Authorities and Examples" (1844), one of several major works of research on Medieval Gothic styles.*

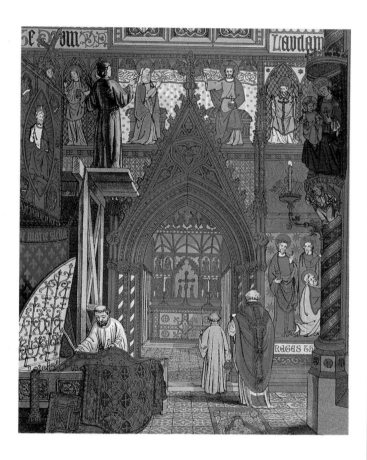

THE ARCHITECTURE OF TRUTH

The Gothic Revival shifted into a new phase and intensity under the influence of a young designer, and more significantly, a theoretician, called August Welby Northmore Pugin. In the year of his death, 1851, he wrote, although without humility, but quite correctly:

> My writings, much more than what I have been able to do, have revolutionized the taste of England.

He was led into his chosen career by his father, August Charles Pugin, who was renowned as a draughtsman and the author of a number of seminal books on mediaeval architecture. Pugin's short life was punctuated by many dramatic events: at the age of 15 in 1827 he was employed as a furniture designer by the firm of Morrel and Seddon at Windsor Castle; three years later he was shipwrecked in Scotland while captain of a schooner; at 19, he was the director of a firm of stonemasons on the verge of bankruptcy; in 1835 he was employed as a designer on the new Houses of Parliament; in his twenties he converted to Catholicism, a major turning point in his life; and in his thirties he worked for a number of firms as a designer of ecclesiastical items. He married three times and had eight

children. His death in 1851 was reputedly due to a nervous breakdown and overwork. He was a prolific designer of furnishings, stained glass, ceramics and metalwork.

Pugin's most important designs were for furniture and fittings for the Houses of Parliament under the architect Charles Barry. This commission, secured by Barry in 1835, was a major milestone in the story of the Gothic Revival in the 19th century, Parliament having decided that it was the appropriate style for this most important of national buildings. The project was on such a scale that it came to dominate the rest of the lives of both designers. Charles Eastlake wrote in 1872, in his book *A History of the Gothic Revival*:

> It would be impossible to overrate the influence brought to bear upon decorative sculpture, upon ceramic decoration, ornamental metal-work, and glass-staining, by the encouragement given to those arts during the progress of the works at Westminster. In the design of such details Pugin's aid was, at the time, invaluable. It was frankly sought and freely rendered. Harman's painted windows and brass fittings, Minton's encaustic tiles, and Crace's mural decoration bear the evidence of his skill and industry.

Despite achieving his place in the history of art for these designs, Pugin regarded himself as first and foremost an architect, although he received only a small number of commissions. His first major project was to remodel Scarisbrick Hall for Charles Scarisbrick, a wealthy Catholic aristocrat. Here, between 1837 and 1845, Pugin tested out his ideas about the Gothic as a style suitable in every aspect. His intention was to build an authentic mediaeval manor house. He wrote:

> As regards the hall I have nailed my colours to the mast – a bay window, high open roof, two good fireplaces, a great sideboard, screen, minstrel gallery – *all or none*. I will not sell myself to the wretched thing.

This uncompromising concern with every aspect and detail of a design can be seen in all his buildings, from his own small house, St Marie's Grange, for his family in Wiltshire, to larger commissions such as St Wilfred's at Hulme in Manchester, built between 1839 and 1842.

But Pugin's historical significance lies in his activities as a propagandist for the Gothic style. As a keen student of architectural history, Pugin brought to the Gothic Revival a moral and ideological urgency which his predecessors had lacked. Through his books and to a lesser degree, his designs, he harangued Victorian Britain on the themes of spirituality, and honesty. In his book of 1836, *Contrasts, or, A parallel between the Noble Edifices of the Fourteenth and Fifteenth Centuries, and Similar buildings of the Present Day; Shewing the Present Decay of*

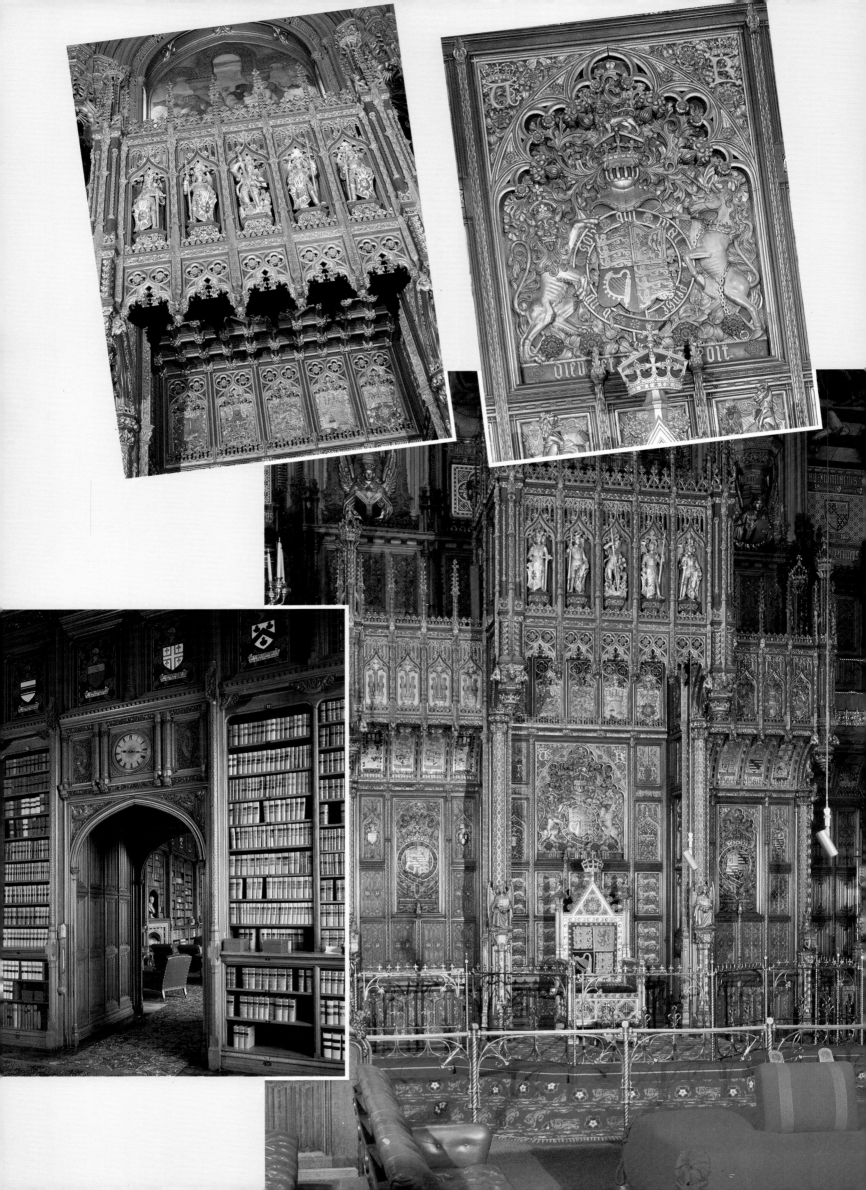

THE HOUSES OF PARLIAMENT

Under Barry's supervision Pugin produced designs in metalwork, such as the great brass gates that lead into the Lords Chamber (right), furniture, stained glass, encaustic tiles, decorative painting and woodcarving. His work can be admired in the Lord's library (opposite lower left) and more particularly in the Chamber itself. Here the magnificent painted and gilded throne canopy (below left) bears the royal coat-of-arms (left), surmounted by effigies of St George and four knights holding the badges of the four main orders of chivalry (far left).

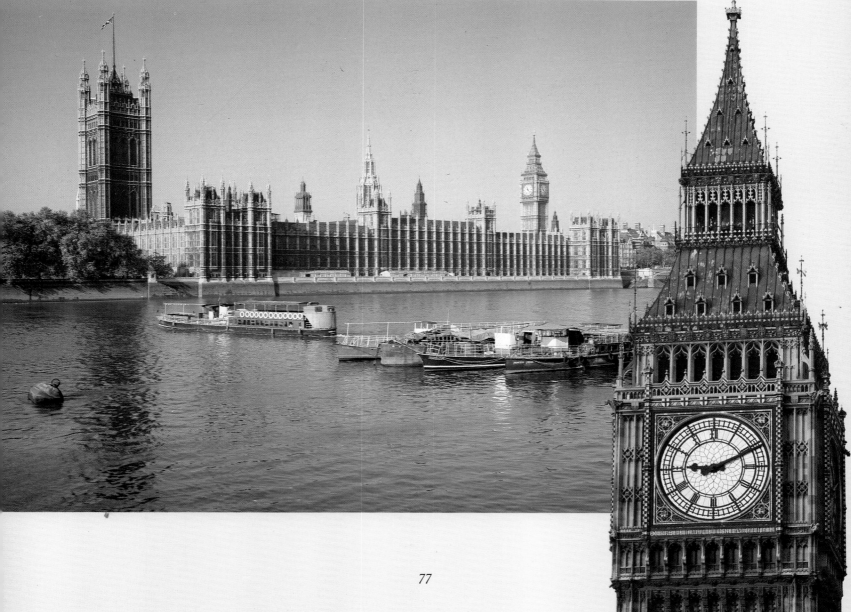

LEFT *Strawberry Hill, Twickenham, a unique building in the "Gothick" style commissioned by Horace Walpole, Earl of Orford (1717–97), a suitably eccentric abode for the author whose "Castle of Otranto" (1864) initiated the Gothic horror genre.*

RIGHT *The central hall of the Natural History Museum, London. The inclusion of Medieval italianate features reflects the celebrated critic John Ruskin's broader approach to Gothic revivalism.*

Taste, Pugin rhetorically made the case for Gothic architecture by contrasting an idealized mediaeval Britain with contemporary society. A typical example is the section entitled 'Contrasted Residences for the Poor', which compares the daily lives of the poor in both societies. According to Pugin a typical diet of a poorhouse in the Middle Ages was; 'beef mutton bacon/ale and cider/milk porridge/wheat bread/ cheese', signifying wholesomeness and a traditional, national diet. In the mid 19th century, a poorhouse menu read '2oz of bread 1 pint of gruel/2oz of bread 1 pint of gruel 1oz of bread ½ pint of gruel/oatmeal potatoes', a far more restricted and dull diet. The conclusion to be drawn was obvious: Victorian society lacked the variety and goodness that characterized the mediaeval period. Pugin saw in the Middle Ages a sense of social order and Christian values lacking in his own era. Victorian architecture must therefore also be deficient.

Pugin developed a philosophy of architecture which centred around the model of English Gothic of the 14th century. For Pugin, firstly, it was the national architecture and as such correct for Victorian Britain, just as the Renaissance Revival was correct for Italy; secondly, it was a Christian architecture in its concern with 'upwardness', in contrast to variants of Classicism which was symbolic of mammon; and thirdly, it was an architecture fit for the purposes to which it was put.

This philosophy was augmented with ideas about honesty in architecture. Pugin believed that historical details should not be copied unless they had a useful function. For example, he rejected castellated forms and battlements as inappropriate in the Victorian world. But conversely, to prove that the Gothic was a flexible and evolving architectural language, Pugin set about designing two railway bridges, that highly charged symbol of the industrial age.

Pugin stated that: 'There should be no features about a building which are not necessary for convenience, construction or propriety'. Ornament was to be avoided unless it 'enriched the essential construction of the building'. This was not an out and out rejection of ornament in architecture but a concern with 'propriety'. In Pugin's thought, a clear architectural hierarchy existed which equated decoration with decorum. He felt that it was entirely suitable for the area around the altar, to be treated with the richest ornamental detail, but areas like the naves should be left plain. Pugin's concern with truth meant that these functional parts of buildings were not to be disguised, but to be revealed honestly.

Pugin's ideas about 'fitness' translated to furniture design. In a pattern book published by Ackermann in 1836 entitled *Gothic Furniture in the Style of the 15th Century*, he showed a heavy X-framed chair and stool. These items of furniture were highly unusual for their day, as Pugin made no attempt to hide their simple constructional elements with marquetry or hidden joints. His theories of design rejected contemporary preferences for disguised construction and applied decoration as dishonest. In much the same way, Pugin believed that architects should not hide or distort the functional aspects of a building such as the flues to achieve a symmetrical facade, as was the practice in Classicism. In his own house, St Marie's Grange in Alderbury, built in 1835–6, he self-consciously broke the roofline with irregularly placed chimneys.

Pugin's influence on his contemporaries was muted by his Roman Catholicism, which restricted his contact with other influential promoters of the Gothic. John Ruskin was another major theorist of the style who distanced himself from Pugin because of his religion, although many of the latter's ideas surface in Ruskin's key writings; *The Seven Lamps of Architecture* published in 1849 and his *The Stones of Venice* of 1851–3. In these texts we find the same concerns with craftsmanship, honesty, Godliness and national style, although with different emphases. Ruskin's main lines of attack were against what he called 'dishonest' and machine-made ornament. He believed that; 'all noble ornamentation is the expression of man's delight at God's work'.

Accordingly, Ruskin was highly critical of the Crystal Palace and its contents, and the design theories of the Henry Cole group, describing the teachings of the latter as 'a state of distortion and falsehood'. He believed that the best example for young British designers could be found in the craft traditions established in the Middle Ages. Here, like Pugin, he found a model of a happy society which produced beautiful things and concluded that these two facts were not unrelated. In his books he developed a social theory of doing, encapsulated in the rhetorical question: 'Was it done with enjoyment – was the carver happy while he was about it?' But Ruskin himself was never a designer, artist or craftsman, and has been much ridiculed by historians for a failed attempt at bricklaying during the building of the Natural History Museum in Oxford in the late 1850s.

Ruskin travelled widely through Europe in the 1840s, and, as revealed in his book *The Stones of Venice*, was greatly influenced by Italian mediaeval art and architecture. His preferences in art were the Italian 'primitives', artists such as Fra Angelico and Massacio, rather than the celebrated heroes of the Renaissance, Raphael and Titian. From these sources, he developed a strong sense of colour and a taste for smooth surfaces, and throughout his life argued the merits of constructional simplicity and massive composition over fussy detail and complex ornament.

The Natural History Musuem in Oxford of 1855–60 is the realization of a number of Ruskinian ideas. The building also marked the end of the dominance of the English Perpendicular style, used to such strong effect by Barry and Pugin in the new Houses of Parliament, and the beginning of the High Gothic Revival. Many small Perpendicular churches had been built over the country in the 1830s and 1840s including Benjamin Ferrey's Christ Church, in Endell Street, London of 1842–44 and St Giles by George Gilbert Scott and W B Moffat in Camberwell Church Street, London in the same period. But

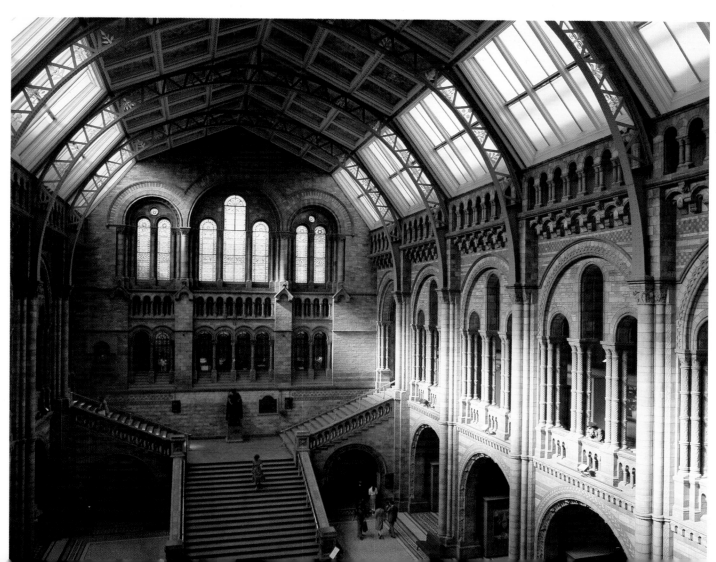

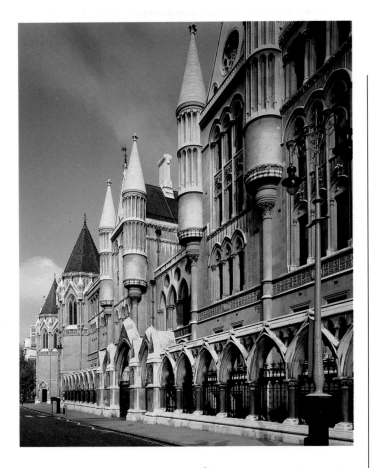

LEFT *The Royal Courts of Justice in the Strand, desribed as Victorian "perpendicular", were begun in 1874 by G. E. Street and completed in 1882, a year after his death. The Central Hall (right), 238 ft long by 80 ft high, gives access to the various courts.*

as Gothic architects began entering competitions for grander buildings and a younger generation began to practice, the Gothic became a more eclectic style. In true Victorian fashion, and under Ruskin's influence architects began to include French, German and Italian Gothic elements in their buildings. In addition to a larger variety of styles, the proponents of the High Victorian Gothic advocated a wider range of materials than their predecessors, including marble and coloured brick. Through Ruskin's influence two supporters of the High Victorian Gothic style, Thomas Deane and Benjamin Woodward, were commissioned to design the Natural History Museum. This beautiful building displays a broad range of architectural devices: constructional polychromy borrowed from Venetian Gothic of the 14th century; a sharp roof topped with a metal finial that echoes Flemish Gothic, and attendant buildings, housing laboratories, inspired by the 14th-century Abbott's Kitchen, Glastonbury. Here, the thrusting verticality of the 'English Pointed' style gave way to an Italian horizontality. Ruskin's influence can be seen in the capitals above each window, for each was to be carved differently with motifs indicating the function of the building. Highly skilled stone masons, the O'Shea brothers were brought from Ireland to carve these features depicting flora and fauna. The heart of the museum is a tiled courtyard, under a canopy of glass and Gothic ironwork. Around this airy room run two raised cloisters supported by columns. Each column is made from a different stone, with an individual carved capital.

The Gothic (despite Pugin's Roman Catholicism) was strongly identified as an Anglican style. The Cambridge Camden Society, for example, was established in 1836 to promote Anglicanism and Gothic architecture of the 14th century. This group, renamed the Ecclesiological Society in 1846, exerted an influence on such projects as Anthony Salvin's restoration of the Holy Sepulchre Church in Cambridge and Sydney Smirke's improvements to the Temple Church in London in the early 1840s. The Society also produced a book entitled *Instumenta Ecclesiastica* which was a kind of pattern book of church fittings and decorations. They employed well-known Gothic architects such as William Butterfield who designed an alphabet 'intended for use where a most legible character, and yet one in harmony with Pointed work is required' and other items such as church plate.

Butterfield was a key architect in the development of High Victorian Gothic. His first major building project was All Saints Church, in London, commissioned by the Ecclesiological Society in 1849. Butterfield had been strongly under the influence of Pugin's ideas until this scheme which marked a new stage in his thought. Built on a restricted site in Westminster, the church was reported to have been the tallest spire in London – 222 feet at that date. It is rather simply decorated, with bands of coloured brick. In the higher parts of the spire and the clergy residence, this simple ornamental effect is enriched by diagonal patterning. This accords with John Betjeman's observation that: 'A general Victorian principle was that Gothic is more elaborate the nearer it reaches heaven'. This is reinforced by narrow tall windows set above each other so that the general effect of Butterfield's design is of a thrusting verticality.

The interior of All Saints is as significant as the exterior. It is very brightly decorated in geometrical patterns in rich colours; reds, black, different hues of white, striking green and yellow. Butterfield also employed a number of different decorative techniques. Following Pugin, the chancel and other significant parts of the church are more highly decorated; the east end of the church, for example, is superbly frescoed. Pugin's influence can be seen in the concern to reveal the structural features of the building through different materials and treatment; the piers are of unornamented polished red granite and the pulpit incorporated pink granite, red Languedoc and brown, grey and green marbles, composed with great geometric clarity.

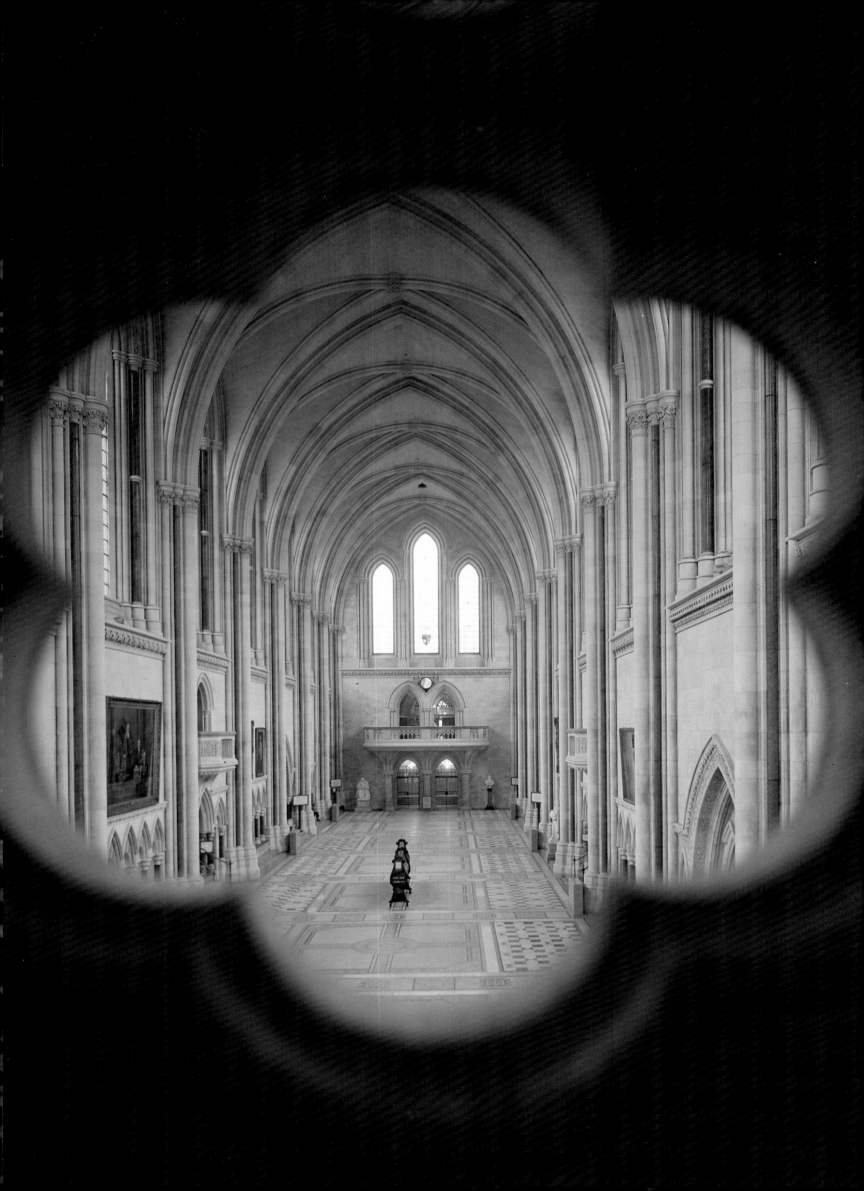

George Edmund Street followed Butterfield's example at All Saints in using brick polychromy in many of his buildings. This decorative device, intended to reveal the structural simplicity of Gothic architecture, became a characteristic aspect of High Victorian Gothic design. In his books, such as *Brick and Marble in the Middle Ages* (1855), he helped stimulate the taste for rich banded brickwork in architecture. His competition design for Lille Cathedral in France of the same year showed his ability to compose in coloured brick on a massive scale. In later buildings such as the St James the Less near the Thames (1859–61) and St Mary Magdalene in central London (1867–78), Street was able to realize his talents as an artist in brick. In the latter, the dramatic rocket-like spire is set off by tight horizontal bands of red and cream brick. Through relatively minor projects like these, Street acquired a reputation for absolute thoroughness. He relished attention to detail, writing of the 12 years it had taken to complete St Mary Magdalene: 'happy is the architect who is allowed to work in this way. Most of our churches in these days are built in a hurry, just as if what ought to last for centuries would do appreciably less work if it were, itself, less than a 12 months coming into full existence.' His churches of this period, both inside and out, are stunning examples of High Victorian Gothic concern with detail, colour and pattern.

As a Gothicist, Street did not restrict his architectural practice to churches and designed a number of secular buildings in this style. In fact, the last major state commission to be built in the Gothic style was Street's Law Courts on the Strand in London, which he secured in a competition in 1866. Ten years earlier, most of the entrants for the Foreign Office competition were Classicists: all the designs for the Law Courts were Gothic. The dominance of the Gothic in the 1860s is clear.

The building was begun in 1874 and completed eight years later. Its facade is a complicated asymmetrical series of turrets, castellated details and irregularly placed arched windows, fronting a great hall with a high vaulted ceiling. This building which was regarded rather unfavourably by both the lawyers and judges who worked there, who disliked the complex system of corridors and narrow stairs, and architectural critics who felt that the building lacked coherence. Street's attempt to design each and every detail of the building is believed to have contributed to his early death at the age of 57 in 1881, before the building was completed.

George Gilbert Scott was another prominent architect who employed the Gothic as a secular style. After his Albert Memorial of 1862, discussed in the preceding chapter, he is most famous for the Midland Hotel at St Pancras Railway Station, in London, designed in 1865. Somewhat paradoxically, this railway station hotel, a potent symbol of Victorian progress,

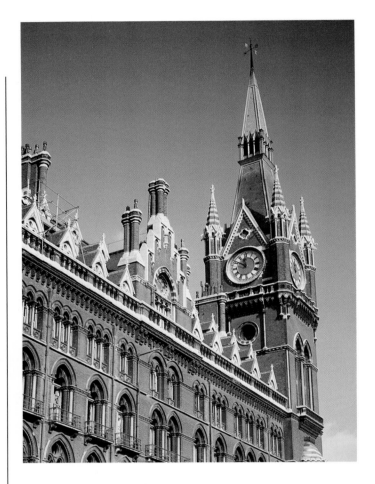

was cloaked in the architectural language of the 13th century. It stands today in the centre of London, looking a rather pale shadow of its former self, clothed in red Gripper bricks from Nottingham, Leicester slates and earthy terracotta mouldings. The highly profitable Midland Railway Company were looking for a building that would outshine Lewis Cubitt's Kings Cross station nearby. Scott certainly gave them one. It fronts a dramatic train shed designed by the engineer, William Barlow, which had an unrivalled span of over 243 feet. The hotel is a marvellous curved building climaxing in a clock tower and a spire at its western end. But beyond its picturesque qualities, in this building Scott also sought to prove that the Gothic was a suitable building style for the modern world. Cantilevered iron girders arched over open spaces; and he argued contra Ruskin that; 'iron constructions are, if anything, more suited to Gothic than Classical architecture'.

Scott bore the brunt of criticism from contemporary observers who felt that he had ignored the Pugin's ethos of 'propriety'. In 1872, as the building was rising, J T Emmett wrote:

 There is here a complete travesty of noble associations, and not the slightest care to save these from sordid contact. An elaboration that might be suitable for a chapter-house of a cathedral choir, is used as an advertising medium for bagman's bedrooms and the costly discomforts of a terminus hotel.

Part of John Ruskin and A W N Pugin's intellectual bequest was to persuade Gothic architects of the 1860s and the 1870s that they were responsible for the smallest of details in their buildings. Like Pugin himself, who had been employed by ceramic manufacturers such as Minton and producers of ornamental metalware such as Harman, and William Butterfield working for the Ecclesiological Society, younger Gothic architects built reputations for their furniture and decoration designs as much as their architectural practice.

One such key architect turned designer was William Burges, who had organized the Mediaeval Court at the London Exhibition of 1862. Burges' mediaevalism and symbolism closely associates him with the Pre-Raphaelite Brotherhood. He is credited with the design of the first piece of High Victorian Gothic furniture, a cabinet designed for H G Yatman in 1858. This piece, now on display in London's Victoria and Albert Museum, was designed in the style of 13th-century French *armoires* which he had seen in Noyon in 1853. It was painted by Edward J Poynter with classical scenes, and beautiful Gothic geometric patterning in gold, dusky red, veridian and sienna. Burges was a great academic, a member of the Royal Archeological Institute, and well known for his essays in the *Gentleman's Magazine.* His designs in metalwork were renowned for their historical veracity, and on one celebrated occasion in 1875, his Dunedin Crozier, a bishop's staff, was illustrated in a French magazine as an example of a 13th century antique.

LEFT *The clock tower of St Pancras Station reaches a height of 300 ft. Architect George Gilbert Scott was also responsible for the interior of the station hotel, its grand staircase supported on iron girders decorated with fine Gothic detailing (right).*

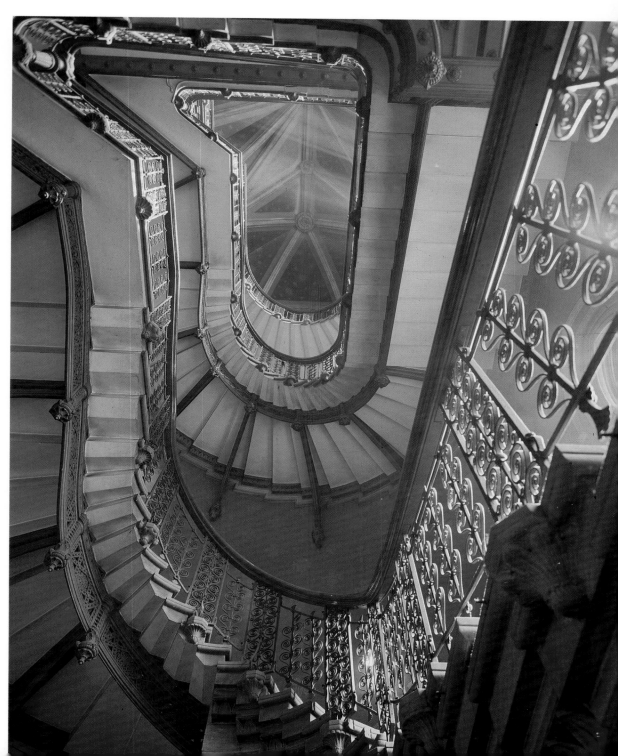

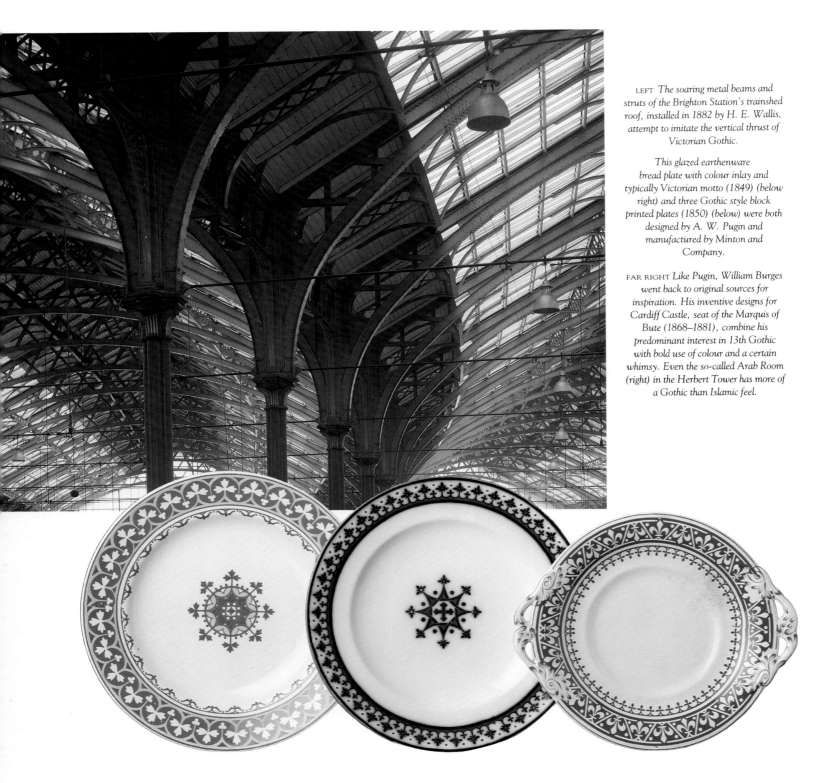

LEFT *The soaring metal beams and struts of the Brighton Station's trainshed roof, installed in 1882 by H. E. Wallis, attempt to imitate the vertical thrust of Victorian Gothic.*

This glazed earthenware bread plate with colour inlay and typically Victorian motto (1849) (below right) and three Gothic style block printed plates (1850) (below) were both designed by A. W. Pugin and manufactured by Minton and Company.

FAR RIGHT *Like Pugin, William Burges went back to original sources for inspiration. His inventive designs for Cardiff Castle, seat of the Marquis of Bute (1868–1881), combine his predominant interest in 13th Gothic with bold use of colour and a certain whimsy. Even the so-called Arab Room (right) in the Herbert Tower has more of a Gothic than Islamic feel.*

William Burges had already won a series of prestigious architectural competitions, including the one for the design of Lille Cathedral in 1854, and the memorial of the Crimean War in Costantinople in 1857, both designs in the High Gothic style. But he is perhaps best known for his association with the wealthiest man in Britain, the Marquis of Bute. His patron shared his interest in antiquity, and continued to commission metalwork, furniture and ceramic designs from Burges long after the fashion for 13th-century French Gothic design had passed. This relationship resulted in the most amazing and opulent artifacts and buildings of the Gothic Revival, dubbed by contemporary observers 'Burgesian Gothic'.

In 1868 he was employed by Bute to restore Cardiff Castle. This project, completed in 1881, resulted in a building that is more theatre than architecture. As if to spite the unfashionability of castle building in Britain in the 1870s, Cardiff Castle stands massive and solid. The upper reaches of the castle are like a mediaeval fantasy; ornate turrets, archery slits, finials and spires. In 1875 Bute commissioned Burges to restore Castell Coch in the same spirit. On a wooded hillside, this austere

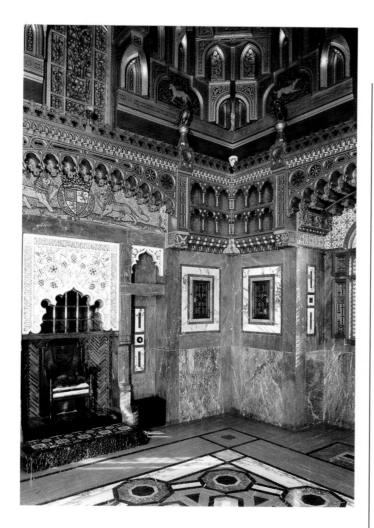

fort contained a host of mediaeval details: circular turrets and towers, rough stonework, deep eaves and even a moat.

In their opulence and luxury, the interiors of these two architectural fantasies far outstrip any castle of the Middle Ages. The drawing room at Castell Coch is a stunning vaulted chamber with richly decorated walls painted by Charles Campbell. The extraordinary Arab Room at Cardiff Castle of 1881 shows Burges at the height of his skills as a decorative designer; interestingly it is not in a Gothic style. This domed room is Arabic in inspiration, and its importance lies in Burges's ability to compose in pure form. The superb ceiling rises to a beautiful octagonal painting of eight eagles by means of jutting and scalloped cornices and niches.

Burges also designed for Lord Bute an amazing range of silver plates, vessels and cutlery, rich in ornamental detail, which were produced by the most skilled silversmiths of the day. In 1869 he designed a claret jug that is decorated with a leopard climbing a tree trunk. Two beautifully detailed characters like figures from early Christian art ornament its lid. The body of the vessel is decorated with mediaevalist forms; heraldic devices and floral motifs, a classical panel spans its neck, and a mask, in the Renaissance style, looks out below the spout. Although in its basic form this piece began with the Gothic, Burges's genius created a work of stunning eclecticism.

THE GOTHIC REVIVAL
IN AMERICA

The Gothic Revival in America was initiated by a leader of fashionable taste, Andrew Jackson Downing, and an architect, Alexander Jackson Davis. Together they steered America away from the neo-Classical tastes of the 1830s to the Gothic, by a series of books illustrated by Davis of Gothic cottages and picturesque ruins. Wealthy clients were persuaded by Davis to build houses along the Hudson River that resulted in a style known today as 'Hudson River Gothic'. One such patron was Jay Gould who had a house called Lyndhurst built for him in Tarrytown by Davis, begun in 1838. This building contains all the fashionable picturesque Gothic Revival details of the period: an informal plan, asymmetry, turrets, battlements, tracery and arches. Other architects followed the lead of Davis and Downing, including the English born Richard Upjohn who designed New York's Trinity Church in 1840 in the Perpendicular style. America saw similar shifts of architectural taste within the Gothic during the mid years of the century as there were in Britain. In 1870 Frederick Church, for example, designed a marvellously simple chapel in Olana near the Hudson river. In its polychromatic tiling and brickwork, this building echoes William Butterfield's architecture of the 1860s.

The classical design, constructed entirely of marble, boasts corinthian pilasters and columned portico (above). Not to be outdone, his brother Cornelius commissioned Hunt to build him a Renaissance style villa, "The Breakers" (above). Meanwhile as industrial wealth flooded into the cities housing was required for a new middle class. Brownstones in New York (right) and clapboard houses in San Francisco (opposite above left) aped their peers in the ecleticism of their architectural design.

Built by Richard Morris Hunt (1889–92), William K. Vanderbilt's imposing Marble House (below right) was the grandest of the baronial summer "cottages" built in fashionable Newport, Rhode Island.

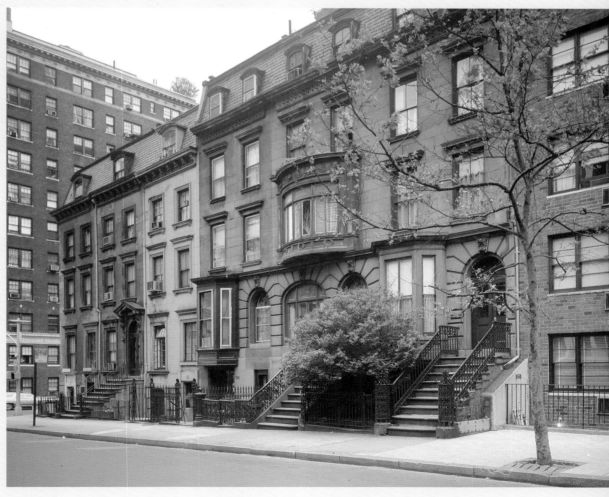

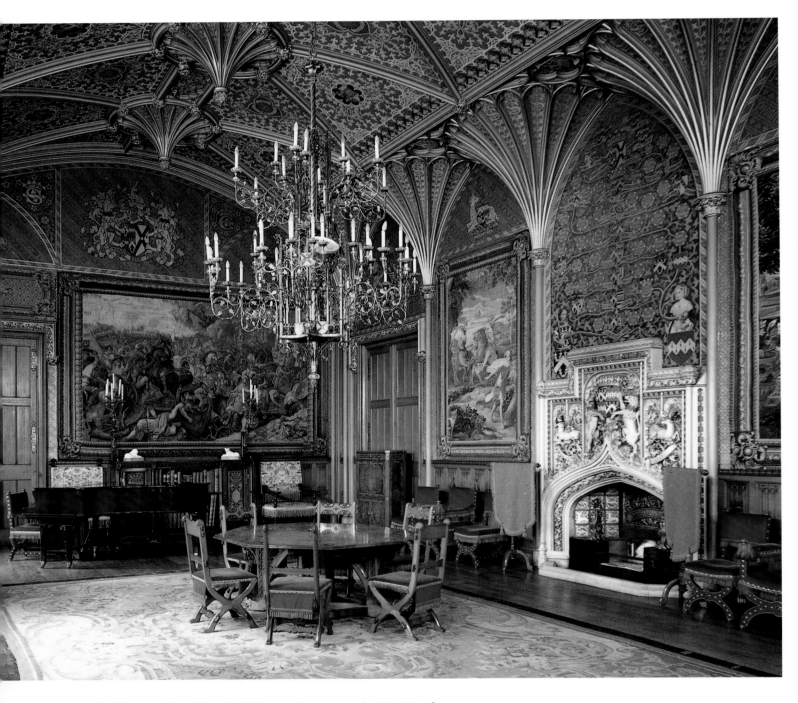

At the more humble end of the social spectrum the Gothic also proved to be popular with the middle classes. A number of major manufacturers commissioned architects to design Gothic furniture and decorative art. A W N Pugin led the way in the 1840s by working for firms like Minton and Company, the ceramic manufacturer. He designed a bread plate in 1849 for this firm which was displayed at the Birmingham Exhibition of that year. It is a delightful piece of glazed earthenware decorated with simple motifs based on sheaves of corn. Around the lip of the plate runs the maxim 'waste not want not'. Pugin was challenged for his use of a rich blue glaze by critics who noted that craftsmen in the Middle Ages did not have this colour available to them. Pugin responded in characteristic fashion by vigorously arguing that the Gothic was an evolving and

ABOVE *The late Medieval drawing room of Eastnor Castle, Herefordshire 1840.*

organic language of design that developed along the grain of Victorian society rather than a fossilized style.

Following Pugin, other architects designed Gothic domestic goods. William Burges organized a mediaevalist display at the London Exhibition of 1862. John Pollard Seddon exhibited a desk inlaid with beautiful coloured woods in geometric patterns, and Philip Webb showed mediaevalist pieces of furniture there.

The Gothic Revival found its way into the mass market through pattern books. In 1867 Charles Bevan and B J Talbert produced their *Gothic Forms Applied to Architecture*, which gave manufacturers excellent models with which to fuel the Gothic Revival.

THE PRE-RAPHAELITE INFLUENCE

PRE-RAPHAELITE BROTHERHOOD

The influence of the Gothic was not restricted to architecture and the applied arts. Through the inspired pen of John Ruskin, the Middle Ages called the most radical of mid Victorian artists to take up their brushes and crusade both morally and aesthetically.

The enigmatic initials PRB first appeared on Dante Gabriel Rossetti's small canvas *The Girlhood of the Virgin Mary* exhibited in 1849. The Brotherhood was the outcome of discussions between William Holman Hunt, Dante Gabriel Rossetti and John Everett Millais in the summer of 1848. Their debates about the nature and role of art, concentrating on its edifying and spiritual potential, brought them close to the ideas of the Nazarenes, German artists working in Rome in the first decades of the century. Led by Franz Pforr and Freidrich Overbeck, the Nazarenes were a community of artists dedicated to the church and the regeneration of German religious art.

This trio of English painters, all in their early twenties, decided to challenge the 'old gang', the entrenched art establishment of the day, and to revitalize English art. Rossetti and his fellow iconoclasts regarded English art as technically poor, morally bereft and intellectually barren. They were not entirely mistaken or alone in this opinion; *Punch*, a barometer of Victorian attitudes, pilloried leading artists of the day for the repetition of subjects in their paintings. Regarding Pickersgill's *The Burial of King Alfred,* the satirical magazine pleaded: 'King Alfred is dead at last; and we hope that British artists will leave off finding his body any more, which they have been doing in every exhibition these fifty years'.

Whilst Millais was away from London working on a series of commissions, Rossetti gathered together a number of other artists including his brother, Walter Rossetti, Thomas Woolner, Frederick George Stevens and James Collinson. At a meeting with Millais in London a brotherhood of seven was formed. Each artist placed differing emphasis on the role of their union, for example, while Collinson sought a specifically Christian art, Woolner saw the Brotherhood as a way of promoting humanist ideals. But they collectively shared a distaste for academicism in art, believing that artists should look to Nature and the intuitive skills of mediaeval artists.

At a further meeting of the group, the name was selected. Although it appears that they knew little about Italian art before Raphael, they were united in their dislike of much art after him and in particular, Roman and Bolognese 16th-century painting. In choosing the name 'Pre-Raphaelite', they intended the more general meaning of 'Early Christian' and 'Brother-

ABOVE *Dante Gabriel Rossetti was one of the founder members of the Pre-Raphaelite Brotherhood. While others were more concerned with social themes, Rossetti was renowned for his allegorical paintings of woman, such as his Le Joli Coeur of 1867.*

hood' called to mind a religious zeal. 50 years later, William Holman Hunt recalled the conspiratorial atmosphere of these meetings, writing:

 When we agreed to use the letters PRB as our insignia, we made each member solemnly promise to keep its meaning absolutely secret, foreseeing the danger of offending the reigning powers of the time.

Although the Pre-Raphaelites saw themselves as artistic revolutionaries, the subjects of their paintings were the classic themes of romantic art through the ages. They produced paintings on religious, historical and literary themes, and rarely on contemporary topics. Although it must be notd that some of the most successful Pre-Raphaelite works, such as *The Awakened Conscience* by Holman Hunt and Rossetti's *Found,* were sharp and highly moralizing interventions against contemporary mores.

J E Millais' 1851 painting *The Return of the Dove to the Ark* is a clear illustration of the Brotherhood's religious devotion. It is a painting of rich colour and great beauty. Through a powerfully simple composition, it depicts Noah's daughters holding the dove which has just returned with the olive branch. When this painting was displayed in the window of a frame maker's shop in Oxford it was seen by William Morris and Edward Burne-Jones and proved to be a great influence on the course of their careers.

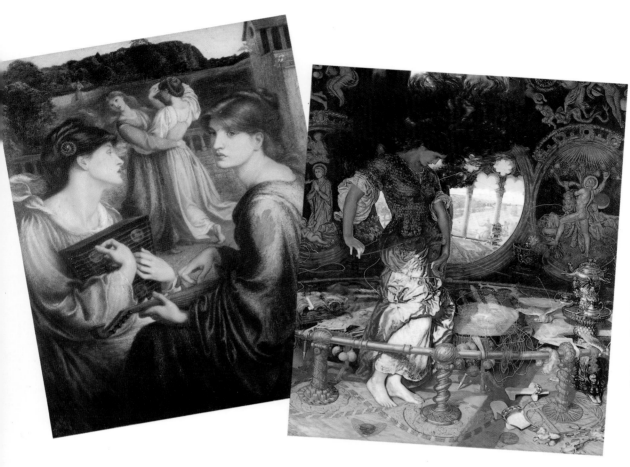

FAR LEFT *"The Bower Meadow" by Dante Gabriel Rossetti, poet, artist and with Holman Hunt and Millais, one of the three important founder members of the Pre-Raphaelite Brotherhood. Hunt's Lady of Shalott (1886) (left), based on Tennyson's poem, exemplifies the Brotherhood's penchant for historical and literary themes. The same year Millais painted "Bubbles", a portrait of his grandson, shortly to become famous as an advertisement for Pears Soap (opposite below).*

Literary themes in Pre-Raphaelite art are exemplified by Holman Hunt's late work *Isabella and the Pot of Basil* which took its theme from a poem by John Keats. A number of the Gothic details in this painting are worthy of note, such as the highly painted stand. The embroidered cloth that covers this piece of mediaevalist furniture was made by Hunt's own hands. He was frequently unable to procure the studio props needed accurately to render the scenes he wished to depict and was often forced to make his own.

Pre-Raphaelite ideas about 'truth to Nature' were not fixed by theories of plein-air painting, but were more concerned with an accuracy of detail and fidelity to the appearance of things. William Holman Hunt's painting of 1851 *The Hireling Shepherd* depicts a young couple sitting in a tree-lined field full of sheep. The young man holds in his hand a wasp, so lifelike that it is possible to make out its minute legs. Every leaf, blade of grass, and sheaf of corn can be clearly discerned.

The 1850s saw the ascendancy of the Pre-Raphaelites, although not without some criticism. A journal, lasting only four issues, was published called *The Germ*, which propagandized their ideas about art. When the Brotherhood exhibited seven works at the Royal Academy in 1850, including Collinson's highly underrated *Answering the Emigrant's Letter*, they drew very sharp attack from the art establishment of the day. The journal *Athenaeum* called their work 'a perversion of talent'. The art world felt affronted that its own young artists, trained in its academies, should be attacking its dearly held values. To the stale kinds of the Academy, this art seemed ugly and unconventional. But by 1852 the Pre-Raphaelites had moved out of the rarefied art world and achieved national acclaim. Rossetti, writing to William Scott Bell, said:

> Millais has been in Oxford as a witness in a trial regarding some estate or contested will. The judge, on hearing his name, asked if he was the painter of that exquisite painting in the Academy. This looks like fame.

Paintings by the Brotherhood began to be bought by the rising middle classes; northern industrialists and merchants. These patrons bought, with genuine pleasure, art which was directed at the emotions and experience. Today city galleries in manufacturing towns like Manchester and Birmingham have excellent collections of Pre-Raphaelite art through private bequests.

By the mid 1850s the Brotherhood started to move apart with Woolner leaving for Australia in 1852 and Holman Hunt going to Palestine in 1854. Interestingly, Millais became a member of the art establishment, despite the scorn he had poured on it as a Pre-Raphaelite. His work increasingly pandered to popular taste and depicted scenes of a sentimentality now and forever associated with the Victorian age. By the last year of his life in 1896, his career had turned full circle and he was made President of the Royal Academy of Art.

But the Pre-Raphaelite spirit was maintained by other artists who identified with their ideals. Ford Maddox Brown, for example, in 1848 impressed Rossetti with a painting called

Wycliffe Reading his Translation of the Bible to John of Gaunt. The effect of this highly mediaevalist painting on Rossetti was such that he asked to become Maddox Brown's pupil. This brought him into the Pre-Raphaelite circle. Paradoxically, the effect of the Brotherhood's thought on Maddox Brown's art was to deflect him from his mediaevalist interests. He adopted a more spiritual and moral attitude to Victorian society, as evinced by his paintings *The Last of England* and *Work.* These paintings also reflect the Pre-Raphaelite fascination with naturalism and detail. *The Last of England* was inspired by Woolner's departure to Australia and shows a couple looking from the bow of a departing ship carrying emigrants to new lives. This oval-shaped masterpiece is superbly composed. The young couple stand framed by their umbrella and the ship's netting. Maddox Brown wrote of this painting: 'The minuteness of detail which would be visible under such conditions of broad daylight, I have thought it necessary to imitate, as bringing the pathos of the subject to the beholder'.

During the late 1850s Rossetti produced some of his most beautiful work as an illustrator. From the early years of that decade, under Ruskin's influence, he had been working on a series of watercolour miniatures on literary themes from the works of Alighieri Dante and chivalric mythology. His first illustration proper was produced for William Allingham's *Day and Night Songs* in 1854. Both Morris and Burne-Jones recalled being greatly moved when they first saw it. It depicts a trio of singing women being watched intently by a handsome young man. They stand in a mysterious confined space pierced by rectangular openings through which can be seen the sea and a town at night.

Following this drawing, Rossetti was approached by Edward Moxon, who was planning to publish an illustrated edition of the poems of Alfred Tennyson. Rossetti agreed to contribute five drawings, which were to become some of the best known illustrations of the Victorian period and greatly contributed to his fame. He depicted *Sir Galahad, St Cecilia, The Lady of Shallott, The Weeping Queens* and *Mariana in the South.* All five are rich in mediaevalist detail appropriate to the subjets of these romantic poems, published by Moxon in 1859.

THE PRE-RAPHAELITES AND DESIGN

The Pre-Raphaelite torch was held aloft by a number of young Victorian designers. As has already been noted, in 1853 Edward Burne-Jones and William Morris came under the spell of Millais' captivating painting *The Return of the Dove to the Ark* in Oxford, when they were undergraduates. In the following year both saw Holman Hunt's *The Awakened Conscience* and *The Light of the World* at the Royal Academy. Although both had come to Oxford to study for the priesthood, they were deflected from their chosen careers by the example of the Brotherhood. They took up drawing and painting and started a journal, *The Oxford and Cambridge Magazine,* inspired by *The Germ.* Morris decided to become an architect and Burne-Jones resolved to be a painter.

In 1855 Morris, articled to George Edmund Street, the Gothic architect, and Burne-Jones, trying to make his way as a painter, moved into Rossetti's bohemian circle. Although Morris was working in Street's offices in Oxford, he spent his free time writing poetry and copying and studying early Christian art under the influence of Rossetti, whose paintings became increasingly mediaevalist as the decade passed. Morris decided to give up his apprenticeship with Street, and came to London. With Burne-Jones, he rented rooms in Red Lion

Square and unable to find furnishings to their taste, they decided to make their own. Rossetti wrote to the poet William Allingham:

> Morris is doing the rather magnificent there, and is having some intensely mediaeval furniture made – tables and chairs with incubi and succubi. He and I have painted the back of a chair with figures and inscriptions in gules and vert and azure, and we are all three going to cover a cabinet with pictures.

These solid and architectonic items of furniture, like William Burges's early pieces of the same period, were strongly influenced by French Gothic design of the 13th century. They were illustrated with Arthurian tales and stories by Dante, painted by Rossetti and Burne-Jones.

When Morris moved from Red Lion Square to his new house in Kent after his marriage to Jane Burden in April 1859, he again decided to draw upon his circle of artistic friends to design and decorate their home.

The Red House was designed by Philip Webb, who had met Morris in Street's office. In red brick and with pitched roofs, the house is a testament to the beauty of the unselfconscious tradition of English vernacular architecture that is often ignored as a major inspiration behind the Gothic Revival. Rossetti described the house as 'a most notable work in every way, and more a poem than a house such as anything else could lead you to conceive, but an admirable house to live in too'. Philip Webb also designed a solid oak table and some plain rush-seated chairs which were, in their simplicity, as far

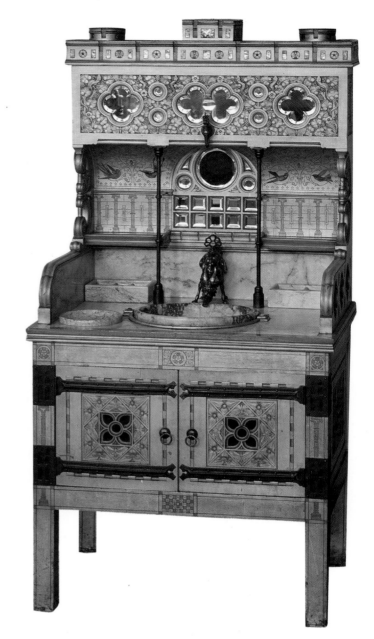

ABOVE *Carved and painted washstand embellished with original Chinese bronzes for taps (1879–80) by William Burges, installed in the guest bedroom of his home, Tower House in Melbury Road, Holland Park.*

LEFT *The Red House, in Bexleyheath, Kent, was designed by Philip Webb for William Morris and his new wife and completed in 1860. The firm of Morris, Marshall, Faulkner & Co. was founded a year later.*

RIGHT *Gothic style wardrobe designed by Philip Webb and painted by Edward Burne-Jones with scenes from Chaucer's "Prioress' Tale" given to William and Jane Morris as a wedding present.*

from anything that could be bought in the fashionable shops of London as possible. Rossetti painted tiles which were set around Webb's beautifully sculptural fireplace and Morris designed simple floral patterns to decorate the walls.

The decoration of these rooms in London and the Red House proved to be one of the most important events in Morris's life and in the history of design. These experiences turned his career away from architecture, and led him to become the most sophisticated practitioner and thinker about design of the period. Fired by the Gothic Revival and the example of the Pre-Raphaelites, Morris and his associates developed a language of decorative art that left behind the blind historicism of their predecessors and pointed toward design in the 20th century.

At Ford Maddox Brown's suggestion Morris rallied his friends to form a 'co-operative' to produce well designed and tastefully decorated furnishings. Formed in 1861, they called themselves Morris, Marshall, Faulkner and Company, Fine Art Workmen in Painting, Carving, Furniture, and the Metals (usually simply described as 'The Firm') with Burne-Jones, Webb and Rossetti as partners and designers.

The Victorian design establishment and the furniture trade, although highly critical of these amateurs, were not untroubled by their arrival on the scene, because The Firm had the support of the leading critic and design thinker of the day, John Ruskin. Despite the obvious distance between the Cole Group and Morris and his colleagues, echoes of the former can be heard in Morris's calls for 'artists of repute' to devote their energies to the decorative arts. The Firm was able to do this most admirably and in 1862 showed a number of items at the International Exhibition in London, including a sofa and a number of hand-painted tiles by Rossetti; a sideboard and washstand by Webb; and the St George Cabinet which was designed by Webb and painted by Morris. These pieces were designed by members of The Firm and put out to skilled craftsmen to be made. Walter Crane, the graphic designer and friend of Morris described these pieces as:

> representing in the main a revival of the mediaeval spirit (though not the letter) in design; a return to simplicity, to sincerity, to good materials, and sound workmanship; to rich and suggestive surface decoration, and simple constructive forms.

11 years after Pugin's death, Morris, Marshall, Faulkner and Company had realized his dearest wishes.

Initially they were only able to secure commissions for stained glass, notably at All Saint's in Bingley in 1864, designed by Richard Norman Shaw. But by the end of the 1860s The Firm had become fashionable in artistic circles. 'Soon',

noted Walter Crane, 'no home with any claim to decorative charm was felt to be complete without its vine and fig tree so to speak – from Queen Square'. In 1865 Morris sold the Red House to move to Queen's Square in London to concentrate his energies on The Firm.

The Firm's designs in that decade were delightfully simple, usually drawing their inspiration from nature. In Morris's wallpapers and fabrics like Daisy and Fruit, both of the early 1860s, floral motifs were highly stylized and flattened, in subdued, tasteful colours. If they appear complex to modern eyes they ought to be compared to contemporary tastes for realistic representations of nature in the brightest possible hues. Philip Webb cultivated an aesthetic of the everyday, writing: 'I never begin to be satisfied until my work looks commonplace'. In fact many of The Firm's products at this time, were almost pure re-creations of vernacular forms; in about 1860 Ford Maddox Brown designed a chair that is in essence a traditional rush-seated Sussex chair.

But underneath these very beautiful designs for fabrics, wallpapers, stained glass, ceramics and furniture lay a very considered philosophy about the alienation wrought by Victorian industry and the democratic potential in art. Following Ruskin, Morris established the link between industrialization and the decline in the standards of design in manufacturing. He fulminated against 'those inexhaustible mines of bad taste, Birmingham and Sheffield'. Through its products, the members of The Firm sought to redirect the society in which they lived.

Morris defined handicraft as 'the expression by man of his pleasure in labour'. This philosophy moved him to learn all the craft techniques in which he designed. A host of tales have entered the mythology of the history of design which

WILLIAM MORRIS DESIGNS

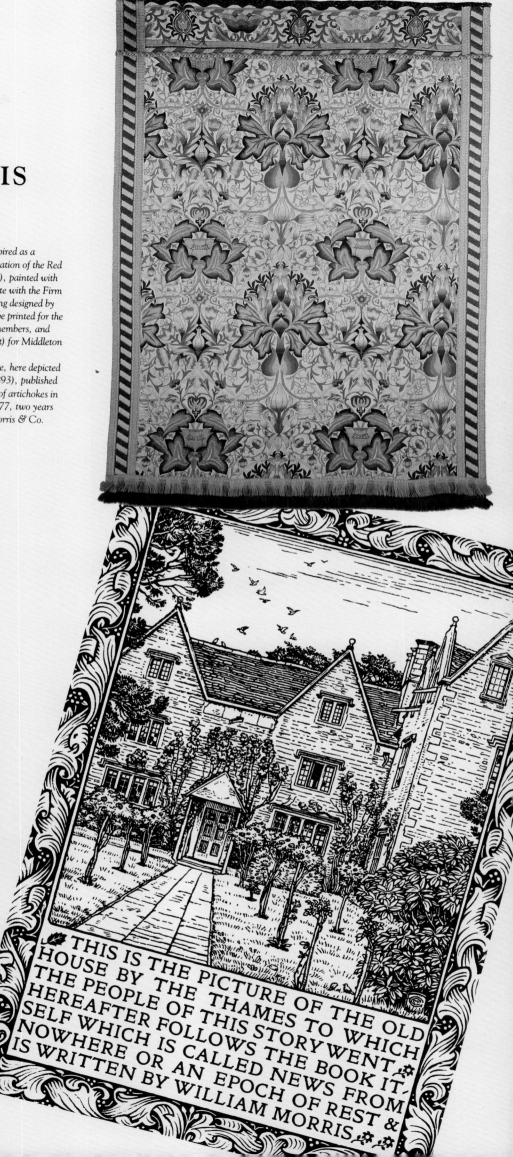

The firm of Morris, Marshall, Faulkner and Company transpired as a result of the communal effort of Morris and his friends over the decoration of the Red House. Architect Philip Webb, designer of this wall cabinet (c.1861), painted with scenes from the life of St George by Morris (below), was to collaborate with the Firm until well into the 90's. (far left) "Daisy", inspired by a wall-hanging designed by William Morris for the Red House, was the first of his wallpapers to be printed for the Firm between 1864–6. Ford Madox Brown, one of the founder members, and Morris designed this stained glass window of St Peter and St Paul (left) for Middleton Cheney, Northamptonshire in 1865.

In 1871 Morris took on the lease of Kelmscott Manor, Oxfordshire, here depicted on the frontispiece of his Utopian novel, "News from Nowhere" (1893), published by the Kelmscott Press (below right). This exquisite Morris hanging of artichokes in crewelwork embroidered on linen (above right) was produced in 1877, two years after the designer had become sole owner of the now renamed Morris & Co.

describe Morris arm deep in bright blue vats of boiling dye or handmaking the paper for the books published by his Kelmscott Press. Morris declared his aim to be to make 'artists craftsmen and craftsmen artists'. The irony of Morris's socialist aspirations and his desire to bring his own aesthetic within reach of the common man was that inevitably the price of his handcrafted designs was in almost all cases well beyond the means of the Victorian working classes.

By the end of the 1860s Morris's place in the history of art was guaranteed. The development of his thought and his influence on other designers makes him the most important figure in 19th-century design in Britain and, arguably, throughout the world.

THE QUEEN ANNE MOVEMENT

The 'Queen Anne Movement' was a label attached to a small group of artists and designers in the 1870s that stuck. It was a misnomer on two accounts; it had little to do with Queen Anne or the early years of the 18th century, nor did it constitute a 'movement' for those associated with it lacked the self-consciousness of a cabal like the Pre-Raphaelite Brotherhood, or the intellectual programme of the Arts and Craft Movement of the 1880s.

The Queen Anne Movement does not fit neatly in the sequence of historical revivals that make up this chapter. Its artists and designers were all of a younger generation than the figures discussed earlier, bar William Morris and Edward Burne-Jones. The leading Queen Anne architects, Richard Norman Shaw and Philip Webb, for example, were both born in the 1830s. Fierce attachment to one style over another was characteristic of an earlier generation of men like the Goth, Pugin, and the neo-Classicist Alexander Thomson, both dead by the time the Queen Anne Movement was in full swing. But it must still be acknowledged as a historicist style, albeit a pluralist one.

Queen Anne was, like all the other revivals described, led by architects, but its influence can be seen in other areas of art and design, including fashion and illustration. It was a bridge from the High Victorian period to the final decades of the century, when architects and designers shed historicism and developed genuinely new stylistic languages. The influence of the movement can be seen in a number of *fin-de-siècle* progressive trends such as the Garden City movement and dress reform. But it is its High Victorian characteristics and stylistic origins that will be described here.

The Gothic started to lose its exclusively Christian associations in the late 1850s and the 1860s. As practised by younger Gothicists, it became a highly aestheticized style. It has already been shown that the work of artists and designers like Edward Burne-Jones, Dante Gabriel Rossetti and William Burges brought to the Gothic Revival ideas that would have been anathema to figures of the 1840s such as Pugin.

Younger architects and designers following in the wake of these figures, including Philip Webb and Richard Norman Shaw, were to form the nucleus. Both had worked in George Edmund Street's architectural practice in the 1850s, and began to reject the out-and-out mediaevalism of the Gothic Revival. Others left the embrace of this style because they felt it had been corrupted by commerce. One Queen Anne architect, John James Stevenson, described his disaffection with

OPPOSITE ABOVE LEFT *Stained glass window for Christ Church Cathedral, Oxford, by Burne-Jones for Morris & Company, 1871.*

Painter and illustrator Walter Crane (1845–1915), designer of Sleeping Beauty wallpaper (opposite below left), collaborated with Morris in the 1870s and later became an influential figure in the Arts and Crafts Movement, providing some relief panels for Norman Shaw's "aesthetic Eden," Bedford Park (left). White-painted wooden gable-ends, as featured in this gatehouse, soon became a fashionable decorative feature (below).

Massiveness and grand schemes were rejected by Queen Anne designers, who sought the domestic and the homely. In this they felt kinship with Morris and his circle, who were developing a parallel aesthetic in furniture and decoration. By the mid 1860s, Morris and his colleagues, Maddox Brown, Rossetti and Burne-Jones had moved on from their heavy mediaevalist furniture and were producing and selling in their shop in London near-copies of traditional country furniture and plain, tasteful fabric and wallpaper prints derived from Nature. Like the early buildings by Webb, such as Val Pricep's studio in Kensington (1864–5) or W E Nesfield's Kew Garden Lodge (1866), this furniture appeared to have characteristics adopted from English domestic buildings and furniture of the 17th and 18th centuries. Rush seating and ladder backs seemed the stylistic equivalents of red brick chimney stacks and oriel windows. As early as 1862, Warrington Taylor, in his correspondence, began to use the phrase 'Queen Anne' to describe this new style.

The Queen Anne Movement was not the first expression of interest in English vernacular architecture in the Victorian period. Although Stuart and Georgian styles were widely dismissed by fashionable architectural taste of the 1850s, two very interesting maverick buildings were erected under their influence. In 1855 Wellington College in Berkshire was built in the style of Sir Christopher Wren, the architectural visionary of the original Queen Anne period, by John Shaw the Younger. William Makepeace Thackeray, the Victorian

the Gothic; it had 'lent itself with fatal facility to the expression of loudness, vulgarity, obtrusiveness and sensationalism more objectionable by far than the dreariest classic of Gower or Wimpole Street'.

They came under the sway of intellectuals like Walter Pater who argued that 'all periods, types, schools of taste, are in themselves equal'. After years of studying French 13th-century cathedrals, and 14th-century Venice, young architects felt themselves at liberty to look at English domestic and vernacular traditions, such as tile hanging, weather-boarding and half timbering. The embryonic Queen Anne circle, which included Charles Swinburne, a poet, the painter Simeon Soloman and Warrington Taylor, Morris, Marshall, Faulkner and Company's business manager, developed a cult of Englishness. Warrington Taylor wrote:

> Everything English, except stockjobbing London or cotton Manchester, is essentially small, and of a homely farmhouse kind of poetry . . . Above all things nationality is the greatest social trait, English Gothic is as small as our landscape is small, it is sweet picturesque homely farmyardish . . . French is aspiring, grand, straining after the extraordinary, all very well in France but wrong here.

But true to Pater's thesis, Queen Anne was an amalgamation of a broader range of influences than merely national ones. In Queen Anne architecture, for example, traces of Dutch and Japanese styles can be found. Philip Webb's later houses, built between 1879 and 1891, even display the marked influence of Classical and Elizabethan design, for example, his country house Standen (1891–2) in Sussex.

novelist whose books were set in the 18th century, similarly built himself a house in Kensington (1860–2), which contained the most unfashionable of details: great sash windows and red brick with clumsy cream Portland stone dresswork. He proudly called it 'the reddest house in all the town'. But Queen Anne as practised by Norman Shaw and his friends was a much more sophisticated affair. It produced the most widely loved of English architectural styles which still exerts an influence to-day on domestic building.

QUEEN ANNE STYLE ARCHITECTURE

The Queen Anne style is epitomized by a number of houses built by Norman Shaw in Chelsea in the 1870s, described by William Morris as 'elegantly fantastic'. All of these houses combine similar details composed in ingenious ways giving each building its individual character. Old Swan House (1875–7), overlooking the Thames, has an immediate appearance of rather plain symmetry and regularity. But Shaw took great pleasure in small details such as the positioning of different window types. The first floor has small paned oriel windows with ornamental stonework decorated with swans, the over-sailed second floor has slender bowed and sash windows set flush with the brickwork, and high dormer windows push out of the pitched roof. The unique character of this building comes from Shaw's ability to compose in a number of English architectural traditions.

Oriel windows were prominent in Shaw's two houses in Cadogan Square in Chelsea designed in 1877, as were other Queen Anne features: pitched roofs, red brick and ornamental

RIGHT AND BELOW *The Bedford Park housing project, described in the prospectus of 1881 as built in the "picturesque Queen Anne style," was predominantly of red brick with hanging tiles, steeply pitched and gabled roofs, and leaded windows.*

stonework. But the appearance of these buildings was quite different to the Old Swan House. They took on a Flemish character, with dominant Dutch-style gables emphasizing their verticality, and porches capped with broken pediments in the 17th-century fashion.

The peak, of the Queen Anne Movement came with the building of the Bedford Park suburb on the western edges of London. Inspired by the fashionable cult of ruralism, Jonathan T Carr, a property speculator, planned to build a 'village' for the artistic middle classes and approached E W Godwin and Norman Shaw to design its first homes in 1877. The 500 houses that they, and other architects such as E J May and J C Dollman, built here, were modest homes in ambling leafy streets with picturesque names like Queen Anne's Grove and Marlborough Crescent. The quaint Queen Anne style, employed for these houses at Bedford Park, can also be found in its church, school of art and pub, or as it was apt to be called 'the inn'. The church of Saint Michael and All Angels designed by Norman Shaw, constructed in 1879, was unusual because it lacked a spire – a notably aesthetic gesture.

The significance of this 'village', as Carr liked to call it, lay not in architectural novelty, for most of its buildings were plain domestic forms originating in Tudor or Stuart England, but in Carr's vision of an artistic community living in a semi-rural setting. It was populated by affluent and progressive middle class people. They were often exceptional Victorians: writers, actors, artists and political and cultural radicals. Accordingly, life at Bedford Park did not follow the humdrum patterns of suburbia. An afternoon spent discussing a radical topic such as women's suffrage, at the Conversazione Club, could be followed by evening at a garden party attended by Ellen Terry and other glittering figures of Victorian theatre.

The Queen Anne style was brought to greater public notice by the *Ballad of Bedford Park*, which was published in the St James Gazette in 1881:

> Here the trees are green and the bricks are red
> And clean the face of man
> We'll build our gardens here he said
> In the style of good Queen Anne
> 'Tis here a village I'll erect
> With Norman Shaw's assistance
> Where man will lead a chaste
> Correct, aesthetical existence.

THE QUEEN ANNE STYLE AND DESIGN

The Queen Anne impulse can also be found in a number of other fields of design and graphic art. Queen Anne interiors drew upon an eclectic range of styles. Fashionable artistic taste dictated that subtle, natural colours were preferable to modern ones such as mauve and magenta. Antiques were also in vogue, and 18th-century Chelsea and Worcester porcelain and Chippendale furniture were considered highly fashionable. The architect Norman Shaw was a great collector of blue and white china, and he designed a shop-front for the leading dealer in this ceramic ware, Murray Marks, in 1875. The influence of the East could often be found in Persian carpets and Japanese fans and plates. This eclecticism resulted in many cluttered and crowded rooms filled to the ceiling, or at least to the frieze, with fashionable bric-a-brac. In this respect owners of Queen Anne style homes chose to depart from the self-consciously humble origins of this style.

Modern furnishings were not banished from this aesthetic world and a number of Queen Anne architects practised as designers. One, R W Edis, produced a charming volume called *Decoration and Furniture of Town Houses* in 1881. This book not only illustrated fine designs for furniture and patterns for tiles and wallcoverings in a range of styles, but animated these sets with light-filled scenes of children at play.

The Queen Anne influence can also be seen in the work of a number of illustrators, who helped to popularize the movement internationally. Walter Crane, Kate Greenaway and Ralph Caldecott produced picture books that paralleled the enthusiasms of Queen Anne architects. Books such as Crane's *Cinderella* or Greenaway's *Under the Window* contained similar mixtures of vernacular, historicist and exotic details. These books proved to be phenomenally successful. Walter Crane's illustrated song book of 1877, *The Baby's Opera*, sold over 40,000 copies.

THE INFLUENCE OF THE QUEEN ANNE STYLE

The Queen Anne Movement had greater impact on the fabric of Britain's cities than any other revivalist architectural style of the 19th century. This may not be readily obvious to the casual observer who strolls through town and city centres up and down the country. But this style was largely a domestic affair and its importance lies in the thousands of suburban homes, and minor pubs, hotels and shops built in its wake.

All the leading Queen Anne architects produced designs for such commonplace buildings. In 1876 Ernest George designed a shop for the firm of Thomas Goode and Company, in South Audley Street in London in which they sold glass and ceramics. It is an elegant building in the Flemish style with prominent gables and chimneys. Similarly, Norman Shaw's place in the history of architecture was largely secured by his New Zealand Chambers of 1872 which was renowned for its oriel windows,

Walter Crane's 1870's Christmas card (far left) and Kate Greenaway's illustration for "The Marigold Garden" (right) echo the fashionable aesthetic emphasis on linear simplicity.

The complex, typically Victorian design of this invitation to a Colonial and Indian ball and reception at the Guildhall in London (below right), seems very different to the clarity of Randolph Caldecott's and Kate Greenaway's nursery rhyme illustration (left and below).

incorporated as much for their illuminating properties as their picturesque qualities. But beyond these architectural heroes innumerable practitioners across the country adopted the Queen Anne architectural language for their projects.

Although its major practitioners left the style in the 1880s and 1890s, with figures like Norman Shaw moving closer to forms of Classicism, characteristic Queen Anne forms proved popular with thousands of homeowners across the nation. Even today, homeowners appear most fond of architectural details revived by Queen Anne architects, such as weatherboarding, tile hanging, classical porches and so on.

During the same period, the United States witnessed a revival of domestic and vernacular architectural traditions that has become known to architectural history as the 'Colonial Revival'. Aware of debates in England, American architects, reflecting a middle-class dissatisfaction with urban life, designed buildings in the country and by the sea which borrowed heavily from national traditional architectural forms. While Norman Shaw employed the English tradition of tile hanging, American architects, such as H H Richardson at the Watts-Sherman House in Newport of 1874–5, used their American equivalent, wooden shingles.

In the later 1870s, the Queen Anne style provoked debate in American architectural practice. 'To those that believe in revivals,' said the architect R S Peabody in 1877, 'Queen Anne is a very fit importation to our offices'. Peabody was the architect of one of the most important vernacular revival buildings in America in the period. His 'Kragsyde' in Manchester-by-the-Sea (1882) actually owed little to Norman Shaw's own 'Cragside' of 1876. The American house, replete with dramatic gables, measured shingling, massive stonework, and erect chimneys befits its magnificent site.

But it ought not to be suggested that American architects worked in the shadow of their British Queen Anne colleagues, for they quite outshone them in the radicalism of their rejection of historicism, and their use of vernacular forms in architecture. Men like Stamford White designed homes of quite stunning innovation by 19th-century standards. His 1887 house built for William Low in Bristol, Rhode Island (unfortunately demolished) was a unique creation in wooden shinglework: a single gable sitting low and long on the brow of a hill.

THE INFLUENCE OF THE EAST

In the 19th century the West encountered the East through colonial life, wars, commercial expansion, safer and easier travel, popular journalism and scholarly works. Writers and artists romanticized the East, Rudyard Kipling's writings about India were very popular in Britain in the 1880s. Whereas the East had appeared to observers in earlier ages an exotic, alien place that was unintelligible to civilized minds, Victorian observers investigated these new worlds with vigour and enthusiasm. Some orientalists became so enamoured with

"Where are you going, my pretty Maid?"

— The Milkmaid —

From the Original Drawing by RANDOLPH CALDECOTT

PUBLISHED BY F. WARNE & C°

their new-found world that they rejected the comforts of Victorian domesticity for a lifetime of nomadic travel in North Africa, the Far East or Asia Minor.

Although Western collectors had been acquiring the triumphs of Eastern craftsmanship for many centuries, the East was also brought to life for a broader public through international exhibitions. The Chinese section at the Great Exhibition of 1851 and the Japanese court at the London International Exhibition of 1862 were both critical and popular successes. At the latter the Victorian public were able to see beautiful hanging lanterns, delicate silks, and masterly pottery, including a superb *Satsuma* bottle which now resides in the Victoria and Albert Museum. This exhibition triggered off a fashion for all things Japanese. The firm of Liberty's founded in 1875 by Arthur Liberty was the consequence of his enthusiasm for these exhibits. The leaders of fashion would visit his Regent Street shop to buy blue and white china and peacock feathers with which to decorate their homes in the highly fashionable Japanese style of the day. Fans were the pre-eminent symbol of this taste; artists such as Albert Moore and James Abbott McNeill Whistler used them as props in their canvases and in modish homes they would be positioned on mantelpieces or attached to walls.

Architects and designers led fashionable taste by incorporating Japanese characteristics in their work. The key figure in this development was Edward William Godwin, who began his career strongly under the influence of John Ruskin's ideas about the Gothic in the 1850s. He is widely credited with the design of the first item of Japanese-style furniture in Europe in a sideboard of 1867. Constructed by William Watt in dark mahogany with grey paper panels in the style of embossed leather work and silver metal details, it is a highly striking piece of furniture. Its resemblance to any known item of Japanese furniture was very slight, but its restrained and geometric qualities were widely believed to have caught the spirit of Eastern design. In fact, Godwin's knowledge of authentic Japanese craftsmanship was very thin, and he derived the style of his furniture designs from details in Hokusai prints. In 1877 he designed a house in Chelsea for the American painter, James Whistler, which was the fullest expression of the Japanese influence to date. Its interiors were very simple, with white walls, matting covering the floor, plain curtains and each room full of Chinese porcelain and Japanese prints.

The influence of the East can also be found in the fine arts. Whistler's own painting owed much to the style of Japanese woodcuts which had been arriving in Europe and America in increasing numbers since trading links were established with that nation by the United States in 1854. In fact, he was a

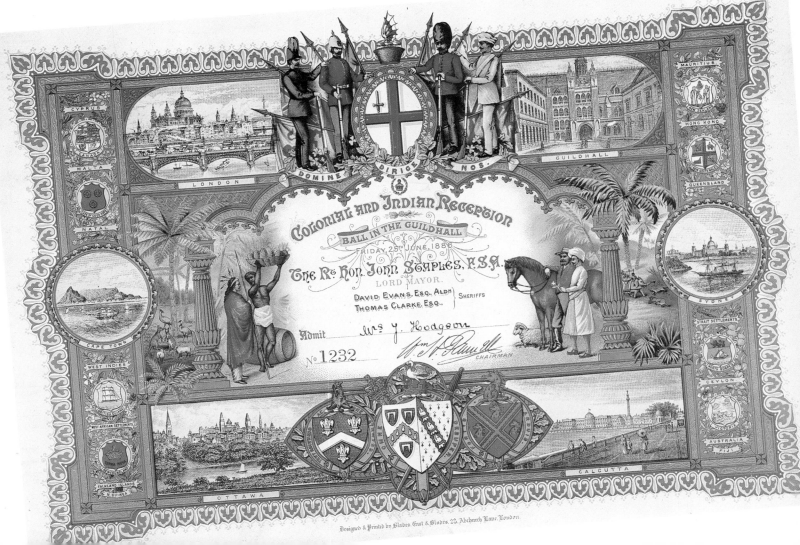

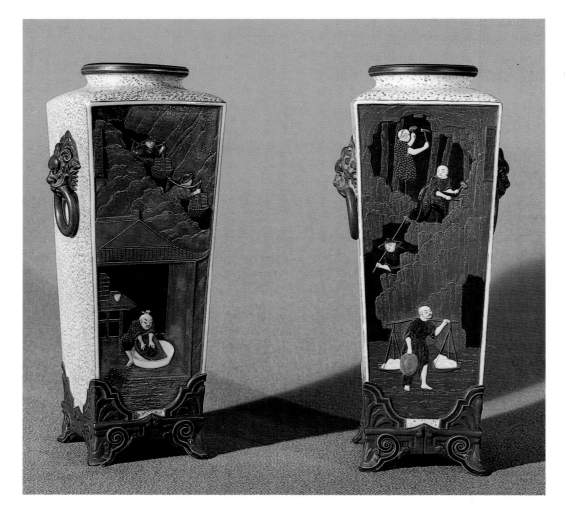

LEFT *Oriental pottery was influential in Europe throughout the century but it was the novelty of Japanese imports in the 1860's that made the most impact. This is reflected in James Hadley's Royal Worcester porcelain vases (1872).*

RIGHT *Pieces like this copy of a 16th century Persian bottle were displayed by Minton at the London International Exhibition of 1871.*

great champion of this art, as confirmed by William Rossetti:

> It was through Whistler that my brother and I became acquainted with Japanese woodcuts and colourprints. It may have been early in 1863. He had seen and purchased some specimens of those works in Paris, and he heartily delighted in them, and showed them to us; and we then set about procuring other works of the same class.

Not only did he paint explicitly Japanese themes in such works as *The Princess from the Land of Porcelain*, but he learned much about composition and colour from the prints for which he scoured Paris. His works of the 1870s and 1880s, such as *Nocturne in Blue and Gold, Old Battersea Bridge*, have superb oriental scale and atmosphere.

The Near East provided more direct inspiration for other orientalist artists. For some, like Frederick Goodall, it provided a backdrop for their religious paintings. He first travelled to Eygpt in 1858 and made over 130 oil studies of domestic life and a number of these works were exhibited at the Royal Academy in 1869. Others became fascinated with the lifestyles they found on their travels and painted scenes of con-temporary life for its own sake. John Frederick Lewis was one of the first such artists to 'go native'. He first visited Egypt in 1842 and for the following 11 years he rarely left the city of Cairo. He adopted the local style of dress and was described by William Makepeace Thackeray as living 'like a languid lotus-eater – a dreamy, hazy, lazy, tobaccofied life'. His works, such as *The Carpet Seller* of 1860 are a documentary source for the life of the city, showing local customs, costume and trade. One of his best known works is *The Hareem* of 1850, although the version illustrated here is only a fragment of a watercolour exhibited at the Royal Academy in 1850. In that picture the sultan on the left of the picture stares intently at a demure, semi-naked concubine who is being brought to join his hareem by a Nubian eunuch. There were several theories speculating as to why she is missing from the picture. It was thought that some Victorian 'Bowdler' took offence at her nudity and had the picture cropped. But recent evidence suggests that this is an entirely different painting, despite the remarkable similarity between it and the original work, which is known to art historians through a 1908 photograph. When Lewis's painting was first exhibited it was highly commended by both the public

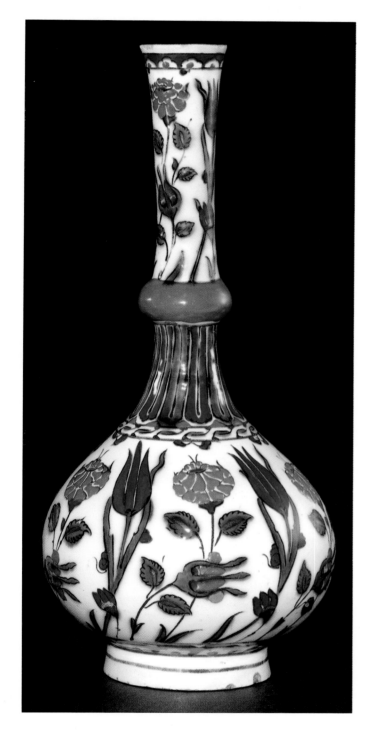

and art critics alike. The *Athenaeum*, in heaping praise on this watercolour, also anticipated public interest in the Eastern interior in the 1860s and 1870s, when it noted:

> The Appartment . . . is plain; the walls being white, with beams and supports in white wood. The only objects within it on which the riches and the taste of the owner have been lavished are the windows – one of which possesses a gorgeous enrichment of coloured glass – and the exquisitely designed lattice work.

Such praise marked the beginning of this watercolour's venerable career; it was shown at the Paris *Exposition Universelle* in 1855, and the France–British Exhibition of 1908.

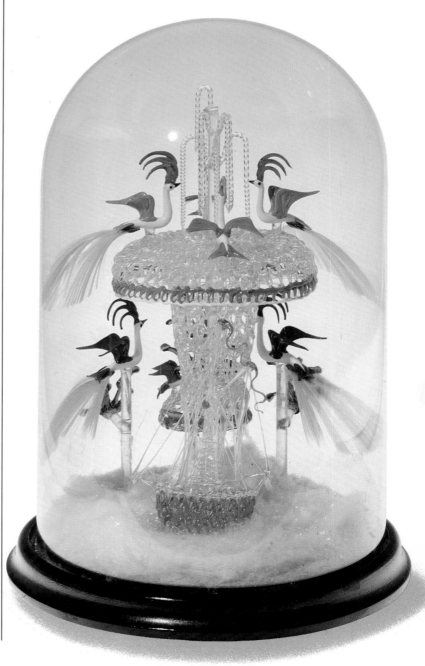

RIGHT *This elegant spun glass fountain decorated with birds was made in Stourbridge c.1900. Wax fruit and stuffed animals were also popular items similarly encased within glass domes.*

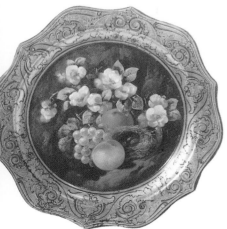

LEFT *Japanned tin ware was fashionable since Regency times. This tray, edged with decorated medieval style tracery and painted with flowers and fruit dates from c.1865.*

ROMANTIC VISIONS

The Victorians built another kind of architecture, often drawn on historical models, that was outside conflicts over style. Follies, even if they were in the form of Greek temples or Gothic towers, owed less to debates over appropriate styles for empires or swings in fashionable taste than the legacy of picturesque ideas from the 18th century. These functionless buildings were like architectural ornaments for the estates of wealthy men. The motivations of the patrons of these bizarre architectural fantasies were as unique as the buildings they erected. They include monkless abbeys; illusionary castles only one wall deep; temples for dead religions; re-creations of Stonehenge; and arches for avenues that led nowhere. Furthermore, the tales which surround their flights of fancy often make it difficult to distinguish fact from fiction.

In 1840, Walter Burton May built his lovely May's Folly in Kent. Although described by some contemporary observers as a 'gimcrack with horrid stucco', it is a magnificent soaring Gothic house and tower, decorated with roman plasterwork. It is widely believed that he had it erected so that he could see the sea. It is a classic explanation of folly building, and

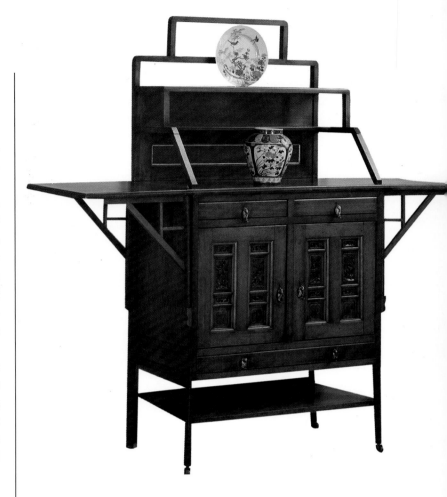

ABOVE RIGHT *The geometric shape of this elegant walnut cabinet by E.W. Godwin, embellished with carved Japanese boxwood plaques and ivory monkey handles, has a distinct Japanese influence.*

BELOW *No lady with aesthetic pretensions could afford not to have a fan decorated in oriental or more particularly, Japanese style.*

John Frederick Lewis (1805–76) is best remembered for his exotic depiction of Egyptian life in such works as "The Harem," painted during and after his ten year stay in Cairo in the 1840's.

typically in tales of this kind, his ambition was never realized. In May's case he failed to note that the Kent Downs stood in the way of a clear view. Another explanation was that his wife had left him for a local farmer and that he built this tower in order to lure her back.

Peterson's Tower, built in Hampshire in the late 19th century, was commissioned by Andrew Peterson. He was a retired High Court Judge who had returned from India in 1868. He built this austere tower in pre-cast concrete blocks, a novel constructional departure for the period. In fact it was a little too novel as the building had to be made safe less than fifty years later. In the local area a number of rumours concerning Peterson's motives circulated. One said he was trying to introduce Hindu burial rituals to Britain and planned to be laid to rest at the top of the tower and his wife at the base. Another suggested that the ghost of Sir Christopher Wren had visited him and wished to prove the strength of Portland cement through the agency of the good judge.

Another tower, overlooking Halifax in Yorkshire, was built by John E Wainhouse, a dye manufacturer, in the 1870s. His works issued dense smoke into the surrounding neighbourhood. He planned to build a chimney connected with his Washer Lane Dyeworks by means of an underground pipe. This was to be a tower encircled by steps, and punctuated with balconies. Unlike many folly builders who wished to make

their mark on their surroundings, Wainhouse was distressed that this chimney disturbed his view. He commissioned a second architect to redesign it as a 270 feet tall, beautiful tower topped by a cupola and a colonnade. Ironically it was never used for its original function as the dye works were bought by another owner who was less concerned about the smoke emitted from the factory. Wainhouse kept his tower, which had cost him £14,000 to construct, for use as a 'general astronomical and physical laboratory'.

McCaig's Folly, built in the 1890s in Argyll, Scotland is a breath-taking ruined amphitheatre that stands above the town of Oban which overlooks the beautiful Firth of Lorn. It was built by John Stewart McCaig, a wealthy banker, who had a passion for Graeco-Roman culture. He believed that the Colosseum in Rome was the greatest achievement of Roman culture and that such a monument would be an inspiration to the town's inhabitants. He set about building this folly as a philanthropic exercise that would provide gainful labour for the town's unemployed. Unlike the Colosseum in Rome, McCaig's building is circular rather than oval, and has a slight Gothic character in its arched windows.

Such bizarre buildings are valuable reminders of the fact that not all Victorians were dour and conscientious, that some possessed great poetic sensibility, some a great sense of humour, and others were extraordinarily eccentric.

VICTORIAN LIFE
AND DEATH

*An idealised picture of the tranquillity of a middle class Victorian home
from an 1860s children's book entitled "Pretty Tales for the Nursery."*

lthough the 'Battle of the Styles' was fought in the houses of the aristocracy, major national architectural commissions, international exhibitions and in the salons of Victorian aesthetes, the lives of ordinary people were not untouched by Victorian style. The middle classes were receptive to changing fashions in decoration, furnishings, and everyday objects and Victorian manufacturers and retailers were happy to encourage them in this. In this respect Victorian commonplace objects are like buried artifacts to an archaeologist, for they tell us much about the lives and enthusiasms of the people who bought and used them.

To judge the tastes and lives of everyday Victorians by the most celebrated products of that culture would be a misrepresentation. Much-championed Victorian artists today such as George Frederick Watts, the author of works of great poetic sensibility such as *Hope* of 1886, did not come close to matching the mid-century popularity of a painter like William Powell Frith and his works like *Derby Day* and *Ramsgate Sands*.

THE HOME IN THE HIGH VICTORIAN PERIOD

The Victorian period was one of great domesticity. They planned, built, furnished and fitted out their homes with extraordinary vigour. Books, magazines and legislation on the subject abounded. Even at the most humble levels of society, Victorians regarded their homes as a vivid reflection of their taste and status in society. Only the very poorest, living in the harshest of cramped slum conditions, did not place great store in a gleaming doorstep or a shining door knocker, or set aside some little space in their home to display their ornaments. But it must be remembered that in Britain those very poorest constituted a large proportion of the population.

Social investigators such as Edwin Chadwick, the author of the *Report on the Sanitary Condition of the Labouring Population of Great Britain* (1842), brought to the attention of the Government and the public the extent of poor housing conditions in Britain's inner cities. As the increasingly urban population grew, the pressure on the existing housing stock became intolerable. It was typical for two families, each with children, to make their home in the dank basement of a slum house. Under these circumstances disease was rife, and the mid years

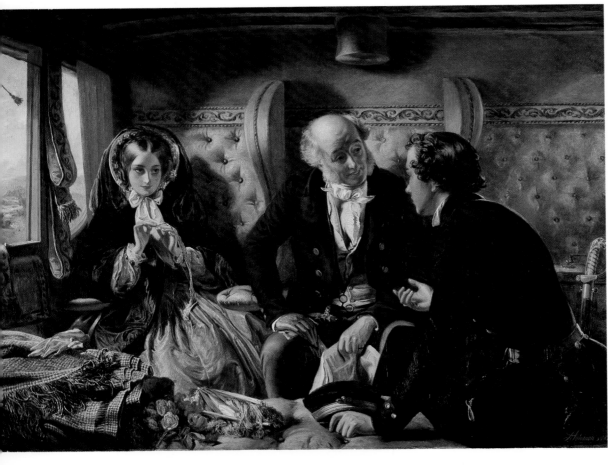

Abraham Solomon wittily
points the difference between travelling
First Class (left) and Third Class
(below) by rail during the 1850's.

OPPOSITE RIGHT Originally designed in
1891 for the billiard room at Buscot
park in Oxfordshire by William Atkin
Bury, this eight foot high ceramic
fireplace was modelled and
manufactured by the Martin Brothers of
Southall, Middlesex.

OPPOSITE BELOW Rosewood love-seat
by American designer John Belter
(fl. 1840–60) specialist in richly
upholstered neo-rococo style furniture.

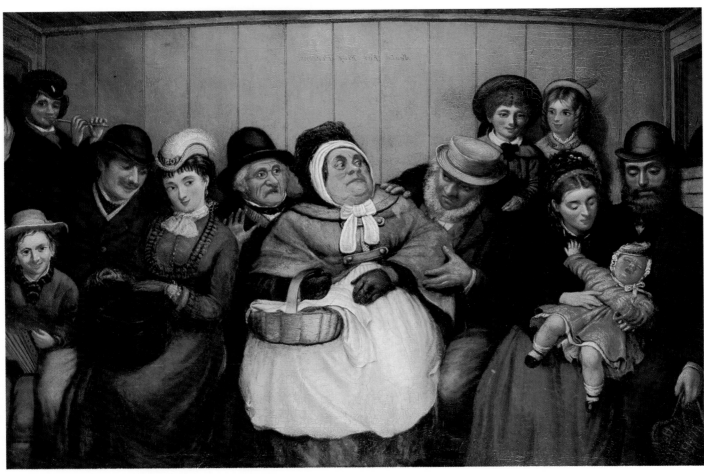

of the century saw waves of cholera epidemics which killed great numbers of slum dwellers. In the 1870s politicians such as Benjamin Disraeli took up the cause of the badly housed and encouraged speculative building. Large numbers of houses were built of varying quality to be rented by the lower classes. At the same time a few municipal schemes in Liverpool, Nottingham and Huddersfield resulted in homes for the poor, and charitable institutions such as the Peabody Trust built tenements for the working classes financed by middle-class philanthropy. But the majority of these homes were erected through private enterprise. Such houses tended to be laid out in terraces, and were broadly derived from vernacular housing traditions or a much diluted form of 18th-century Classicism. They occasionally have very charming details, such as neat tiled porches and simple decorative mouldings above gound floor windows. Although much of this housing was defective in many respects, it must be noted that the small terraced house brought about a marked improvement in the quality of life for many who lived in them.

The middle classes were also courted by speculative builders who built suburban homes on the fringes of most cities. With their leafy streets and respectable gardens they appealed to those who longed to live in the country but had to work in the city. The Queen Anne style of the 1870s was the most popular architectural language employed in these schemes because of its modest, domestic feel.

Taken as a whole, the period between the 1860s and 1900 has been aptly described by social historians as a 'housing revolution'. The established nobility and gentry played their part in this enthusiasm for building. Relatively modest Georgian family homes were remodelled in 'new' fashionable styles such as the Gothic. An elevation to the peerage was often accompanied by a comparable rise in the status of the house. Charles Brudenell-Bruce, for example, spent £250,000 improving his family seat, Tottenham Park in Wiltshire, when he was made Marquis of Aylesbury.

New money earned in commerce sought old status by buying country homes and acting out the role of the squirearchy. These rich magnates would immediately mark their arrival with the construction of ostentatious wings and towers, new houses for their tenants displaying their philanthropy and prominent entrance lodges. The very rich would even have built entirely new houses in the grand style of country residences at very great cost. John Walter III, the owner of *The Times* newspaper, had Bearwood erected between 1865 and 1874 at the price of £250,000. This Tudor-style mansion with some Gothic detailing was designed by Robert Kerr, the author of *The Gentleman's House*. In 1864 Kerr, a guide to taste, offered rich patrons the opportunity to own homes in 11

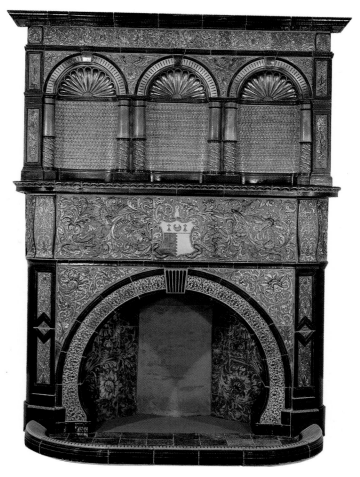

different styles including Rural Italian, Revived Elizabethan and Palladian.

These grand homes of the rich led popular taste, and the correspondence of domestic values from the affluent through to the working classes in the Victorian period is striking. All classes pursued the same values of comfort and elegance. Echoes of drawing rooms in the grandest of mansions could be found in Victorian parlours throughout the nation.

A classic item of Victorian furniture was the *etageré*, sometimes known as the 'whatnot'. These pieces were screens or

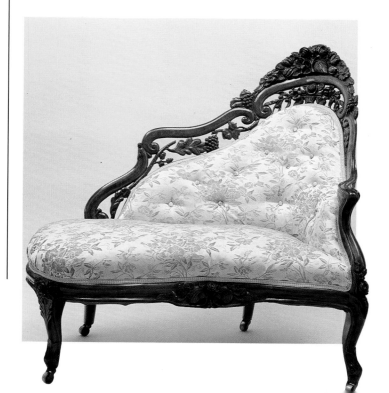

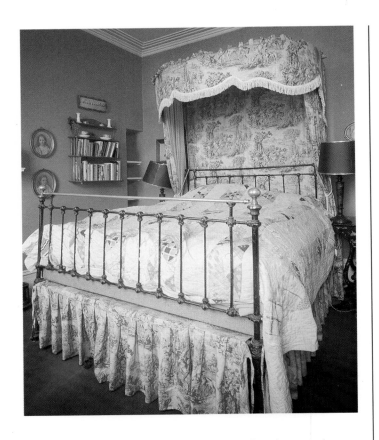

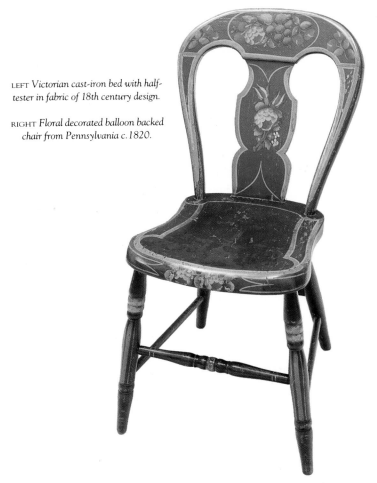

LEFT *Victorian cast-iron bed with half-tester in fabric of 18th century design.*

RIGHT *Floral decorated balloon backed chair from Pennsylvania c.1820.*

stands supporting shelves on which were placed artistic bric-a-brac, vases with flowers or stuffed animals protected by glass domes, or whatever took the owner's fancy. At their most ornate these highly decorative items of furniture would contain mirrors and all kinds of artistic motifs such as rococo carving, classical pediments and so on. But even the homes of the lower middle class had similar items of display furniture, even if of a smaller scale and poorer quality. The ornaments placed on them marked social distinction: Staffordshire figurines, for example, would not be found in a Marquis's *etagere*.

Another item of furniture widely associated with the Victorian age is the davenport, although it should be noted that this piece of furniture originated in the 18th century when a Captain Davenport charged the firm of Gillow to produce a small neat desk. In the late 19th century they had increased in popularity such that they were a characteristic feature of most middle-class homes. For the affluent these items of furniture could display the heights of Victorian cabinet-making, with ingenious hidden drawers, skilful marketry and curving cabinet lids on runners, but even the more commonplace desks made by the 'furniture factories' were highly sought after. In fact, their status lay in their decorative rather than their functional aspect, much to the annoyance of some observers. *Furniture and Decoration* commented: 'The aesthetic advantages of modern writing tables have in many instances, been obtained at the expense of convenience'.

Some items of Victorian furniture can be divided by gender, for the marked differences in lifestyle and dress of men and women dictated suitable furniture for each. The Spanish Chair, for example, was designed so that women, dressed in bulky crinolines, would be able to sit and rise gracefully. It was a kind of low, armless seat which allowed these large skirts to hang gracefully over the sides of the chair. The Grandfather, or Firesider were affectionate terms for the comfortable wing-backed, upholstered armchair in which many Victorian patriarchs would relax by the hearthside.

The name 'grandfather' also lent itself to an essential feature of middle-class drawing rooms, the grandfather clock. Long case clocks driven by pendulums, developed in England in the 17th century, were given this endearing name in 1878 by Henry C Work in a song *My Grandfather Clock*.

America made a special contribution to Victorian life with the popularization of the rocking chair. It appears to have originated in both England and the American Colonies in the 1760s, but the classic form of the rocker is known as the Boston. This simple piece of furniture, found on every porch across America, evolved from the Windsor chair with a tall comb back and a curved seat. Many people decorated their chairs with floral motifs in the style of Lambert Hitchcock, a Connecticut craftsman of the 1820s. They were imported into Britain in vast numbers and were sold as 'American Common Sense Chairs', and aids to digestion. A number of European

furniture makers sought to surpass the simple excellence of the American rocker by producing upholstered chairs with spring rockers or tensioned steel frames, but only Michael Thonet, an Austrian, came close with his elegant bentwood chair exhibited at the Great Exhibition of 1851.

To modern eyes the atmosphere of mid-Victorian rooms would have appeared quite overpowering. Every possible surface was covered, decorated or draped in some way. From floor to frieze, walls were covered in richly coloured flock wallpapers, much to the distaste of figures like William Morris. He designed over 60 wallpapers between 1862 and 1896 to stem the tide of elaborate, fussy machine-made papers. Curtains made from heavy velvets or serge in the vivid colours produced by aniline dyes, and decorated with tassles and fringes, hung from massive, ostentatious frames. Mantelpieces, tables and chair backs were all copiously covered with lace and other decorative fabrics. These luxurious feasts of colour and texture were the consequence of dramatic developments and technical innovations in the cloth making industries based in the north of England. They brought these symbols of great wealth in earlier centuries down to the pocket of the lower middle classes in Victorian Britain.

In the 1870s it became increasingly fashionable to buy and furnish homes with antiques. This coincided with a general lightening of decorative taste and an interest in exotic designs. Rooms across the country began to incorporate lightly patterned wall coverings and fabrics in pale, pastel hues and were furnished with examples of Gothic, 18th-century and Japanese craftsmanship. Although both of these trends were led by fashionable taste, the extent to which this aestheticism percolated throughout society can be seen in Charles Eastlake's *Hints on Household Taste*. Here he felt it necessary to caution his readers; 'No doubt good examples of mediaeval furniture and cabinet work are occasionally to be met with in the curiosity shops of Wardour Street; but, as a rule, the 'Glastonbury' chairs and 'antique' bookcases which are sold in that venerable thoroughfare will prove on examination to be nothing but gross libels on the style of art which they are supposed to represent'. There was also a vogue for decorating different rooms of a house in differing styles. The very rich would even commission exacting reproductions of authentic period rooms. To stroll through a fashionable house of the 1880s was like touring a museum. One might leave an Adam drawing-room, pass through a hallway with Tudor-style panelling, to arrive in a Georgian dining-room.

The hearth was a particularly important place in all Victorian homes. It became a highly romanticized symbol of home, comfort and assurance and a focal point of domesticity. A number of observers remembered Prince Albert leading discussions with prominent intellectuals of the day, while warming his back in front of a roaring fire. Robert Kerr wrote in *The Gentleman's House* of 1864:

> For a sitting-room, keeping in mind the English climate and habits, a fireside is of all considerations practically the most important. No such appartment can pass muster with domestic critics unless there be convenient space for a wide circle of persons around the fire, embracing indeed in some degree the table; and this without inconvenience or disturbance being created at some point by the passing out and in and to and fro of all parties.

FAR LEFT *The simplicity of this writing desk designed in 1893 by C.F.A. Voysey, the last important architect-designer of the Art and Crafts movement, is worlds apart from this Italian ebonised writing desk, virtually writhing in neo-rococo ornament.*

LEFT *Described as a "Patent Independent Plunge, Spray, and Shower Bath" in the Shanks catalogue for 1899, a virtually identical version figures in a Doulton catalogue of 1898 as a "Hooded Bath."*

Although ostensibly a method of heating a room, the hearth was treated in the same fashion as any other aspect of Victorian furnishing, and could be made from ostentatious materials. They were as highly ornamented as the room in which they were to be placed demanded. At their grandest they could be constructed from mahogany or any number of hard woods, lined with marble, and decorated with hand-painted tiles, classical plaques or ornate carving. The area above the entablature would receive similar decorative treatment with niches for small sculptures and shelving for fashionable *objets d'art*.

Screens were placed in front of the fire to deflect its heat. Embroidering the panels with floral motifs or sentimental sayings for these wooden frames became a popular pastime for ladies of the leisured classes. Fashionable primers such as *The Young Ladies' Treasure Book* instructed their readers on how to make a variety of screens in the shape of banners or geometric forms. Similarly, authors of these guides to domestic life suggested that less ornate mantelpieces ought to be covered in richly decorated velvets known as *mantel-valences*.

The bathroom largely escaped the ornamental excesses found in the rest of the Victorian home. Herman Muthesius, a German civil servant in Britain in the 1890s researching design and industry, was greatly impressed with the rationalism he found in this functional room. The development of the fully plumbed bathroom was relatively speedy. In the 1860s it was unusual to find water on tap, and baths had to be laboriously filled from large matching cans. Yet by the end of the century builders proudly proclaimed their attention to sanitary detail in advertisements for new suburban homes for the lower middle classes.

SHOPPING IN THE LATE 19TH CENTURY

The nature of shopping changed dramatically in the Victorian period. As incomes and living standards rose across the nation in all classes and the population became more urban, a new generation of business men, led by figures such as William Whiteley, the department store entrepreneur, geared up the retailing industry to meet an ever increasing demand. In the early 19th century most people met their day-to-day needs in local shops such as grocers and haberdashers. Those who were less affluent relied upon the services of itinerant salesmen and travelling fairs for such simple goods as needles and cotton. Shopping was then a local affair. By the end of the century the situation had changed. Large department stores, such as Harrods and Selfridges in London, could be found in most large cities and a number of national chain stores sold their wares across the whole of the country. They encouraged sales through sophisticated advertising campaigns, fixed pricing, pre-packaged goods and product branding.

Lipton's, the grocers, was the first major chain store in Britain. It was formed in 1871 and by 1899 it ran over 500 shops. Concentrating on a small number of lines of goods sold at fixed prices, it led the way for a number of well known companies to follow its path, including Hepworth's, the made-to-measure tailor and Boot's the chemist. Stores such as these brought about marked changes in the nature of retailing. Until the 1870s advertisements and posters were usually placed by manufacturers, but then chain stores took over the function. The nature of shopping changed as well, with a new emphasis on efficient service. Stores owned by firms such as Boot's tended to be long and narrow, with a continuous working area bordered by shelves around a central aisle. These shops were made attractive through high quality fittings and decorations such as Minton tiles illustrating appropriate themes. Chairs were placed around the shopfloor should a customer feel tired and wish to rest.

The rise of Marks and Spencer, one of the most successful firms in Britain today, is worthy of comment. In 1884 Michael

Marks ran a penny stall in a Leeds bazaar under a sign which read 'Don't ask the price – it's a penny'. He sold many different kinds of small manufactures, such as cotton, needles, buttons and so on. Influenced by the experience of companies such as Woolworth's in the United States, the firm quickly expanded and by the early 1900s it owned 60 penny bazaars. These shops placed little store by lavish interior design or expensive fittings but traded under the banner of value for money.

Victorian retailing received a great boost from men such as Jessie Boot, the proprietor of the chemists Boot's. A classic Victorian entrepreneur fixated with the idea of expansion, he aimed to make his company the 'biggest and the best'. He inherited his first shop from his father in Nottingham which sold folk medicines and herbal treatments to working people. He introduced household goods to the shop's stock and employed an aggressive selling strategy undercutting his rivals. His tactics proved so successful that he was able to open a new shop in 1868, marking the beginning of a great period of expansion. Within 30 years he owned 180 shops. He believed in courting his customers, and decked out these establishments on upmarket sites with mahogany and glass fittings and electric lighting. Some shops in middle-class areas were even treated to fittings with mediaevalist touches. He was no less progres-

sive in his advertising techniques. He quickly moved on from newspaper advertisements to hard-hitting show-business-style promotions imported from the States. In the 1890s he developed the firm's corporate image, used on all packaging and promotional material. It is still used today.

Department stores were another significant feature of Victorian retailing. Their development in Britain can be traced back to Madam Boucicaut's Bon Marché founded in Paris in 1852, and Macey's of New York founded in 1860. It was only in the 1880s that Britain saw a comparable development of large shops selling a great variety of goods in departments. Against the background of an extending transport network allowing easy access for those living in suburbs to the centre of cities, firms like Harrods in London grew from a small grocers to large retailing concerns.

Whiteley's of Bayswater was founded in 1863 by William Whitely. He had been greatly impressed by the Great Exhibition of 1851, and thought that the kind of experience evoked there could be brought to shopping. He wished to give it the character of a fashionable leisure activity. He sought to attract middle-class custom through a genteel approach to salesmanship: customers were never to be pestered by sales staff but informed and encouraged in their purchases. His empire expanded through the 1870s and 1880s: his staff grew from 15 to over 600, and he invested in four warehouses. Innumerable items were offered for sale, including drapery, jewellery, fashionable Japanese-style _objets d'art_. He offered a number of services to the public alongside the goods on display. After spending a pleasant half an hour in the refreshment room then having her hair styled, a Victorian lady could seek the advice of Whiteley's housing agency. Unfortunately, Whiteley and his store were dogged by bad luck. In the 1880s the building was badly damaged by a series of mysterious fires and in 1907 Whiteley himself was murdered in the store by a man claiming to be his son.

During the last quarter of the 19th century the great department stores such as Whiteleys, Selfridges and Harrods (above right) took on the role of "universal providers," merchandising everything from groceries to travelling cases and hat boxes (below).

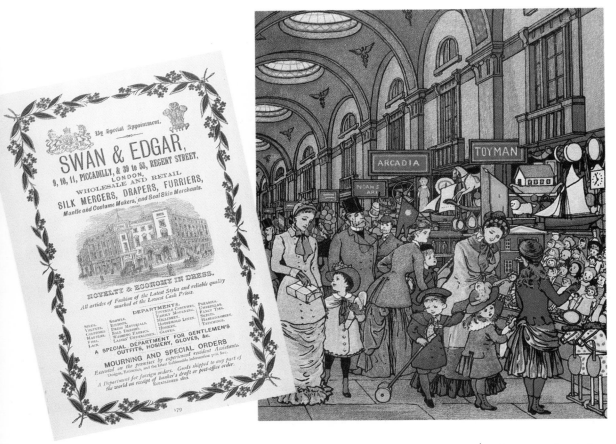

Department stores such as Swan and Edgar (far left) helped to democratize fashion. These 1840 summer fashions with their leg of mutton sleeves, cinched waists and wide skirts for the ladies contrast with the slimmer line of four decades later (left) though a narrow waist, achieved through the torture of whalebone corsetry, was still considered vital.

HIGH VICTORIAN FASHION

The Victorians were as involved in one 'battle of the styles' as any age before or since: the turns of fashion. Key characteristics of ornamental excess and invention, so notable in architecture and applied art, can also be seen in their clothes. Style was led by couturiers like Charles Worth, an Englishman who owned a salon in Paris patronized by Princess Eugénie and the leading figures of all the courts in Europe. As with most expressions of taste, Victorian fashion was formed in the upper levels of society and affected the most humble of working people.

Fashions changed as the Victorian world changed: in the economic revival after the 1840s, which had been a period of great hardship, women's dresses began to be made from lighter, brighter fabrics, waistlines rose, skirts became fuller and leg-o'-mutton sleeves, which had been tight at the wrist, began to fill again.

Dress also came to the attention of inventive Victorian minds. The quintessential silhouette of the mid-Victorian period was a tight bodice blossoming out from the hips into a bell-like voluminous skirt. This was achieved by the invention of a light dress frame made from steel hoops called the crinoline. Up to 35 steel springs increased in diameter as they reached the ground. The largest firm producing this fashionable accoutrement, W S and E H Thompson, became a multinational concern on the strength of their Crown crinoline. The crinoline replaced large numbers of stiffened petticoats lined with horsehair which women had been wearing to achieve a fashionable form, despite their weight and discomfort. Its major disadvantage was considered to be that it occasionally tilted and revealed the ankles. Less socially gauche difficulties, such as the discomfort of sitting, were overcome with better materials and design.

The 1860s saw greater restraint in fashionable dress. The number of steel hoops was reduced to three or four at the bottom of the skirt. The bell-like shape evolved into a flat skirt front. In the later 1860s this shape, known as a half crinoline, became the bustle, a small frame attached to the lower back, which supported a pronounced mass of material often running into a long train.

As in architecture, Victorian dress was frequently historicist. In 1869 the *Englishwoman's Domestic Magazine*, a reliable index of fashionable taste, noted the comments of one fashionable couturier: 'Each lady comes to ask me not what is worn but what has not even yet been seen or worn . . . so I open an album of historic costumes and copy'.

In the 1880s, the 18th-century style of draped overskirts and tight-fitting bodices, associated with the marquises of the Pompadour period, were revived. But these were rarely pure historical re-creations, for the Victorians brought the character of their age to their costume. A full-skirted dress derived from 18th-century patterns, in a richly coloured fabric, would be decorated with machine-made embroidery and lace. Aniline

dyes were discovered by Sir William Perkin in 1856 as a by-product of his researches for the new gas industry. Cloth manufacturers quickly realized their potential for producing brilliant colours such as mauve, magenta and a vivid pink.

Victorian fashions could be hazardous to women in various ways. The weight of the large number of petticoats placed a great stress on the pelvis. Numerous accounts circulated through society of women blown over cliffs in high winds. In a packed Santiago Cathedral in the 1860s, over 2,000 people died when a crinoline caught on fire, and people were unable to escape. Incredibly, narrow waistlines were considered so fashionable that some women went to extraordinary lengths to be in vogue. Tight lacing and corsetry were *de rigueur* in fashionable society. Waists of less than 20 inches were achieved at the cost of damage to internal organs. In 1895 two women are reported to have had ribs surgically removed to be able to wear narrower corsetry.

These trends in fashion dress prescribed delicate and ornamental roles for women in society. A long box-pleated train hanging from a bustle in a beautiful silk with applied decoration of floral motifs, not only indicated obvious wealth, but also leisure. Its owner always travelled by carriage, for such a train could never be allowed to drag the streets.

This ornamental vision of Victorian womanhood was reinforced by the jewellery and accessories so necessary for the maintenance of sartorial face. Elegant women would not be seen promenading without the appropriate paraphernalia: long gloves, monogrammed fans and ornate parasols made in rouched chiffon with lace flounces and ivory handles. Prestigious events in the social calendar demanded ostentatious displays of wealth. Aristocratic women were bedecked with flashing jewellery and accompanied their husbands like glittering symbols of accomplishment. For the very wealthy, even the most basic of accessories, such as hair grips, could be encrusted with diamonds or set with pearls. Such accoutrements were subject to turns in fashion, for example, at the beginning of Victoria's reign, *cannetile* jewellery· was considered highly modish. It is a complex lacy goldwork, sometimes set with precious and semi-precious stones. In the 1880s taste had moved to more ostentatious, although less skilled, jewel-encrusted pieces based on simple shapes.

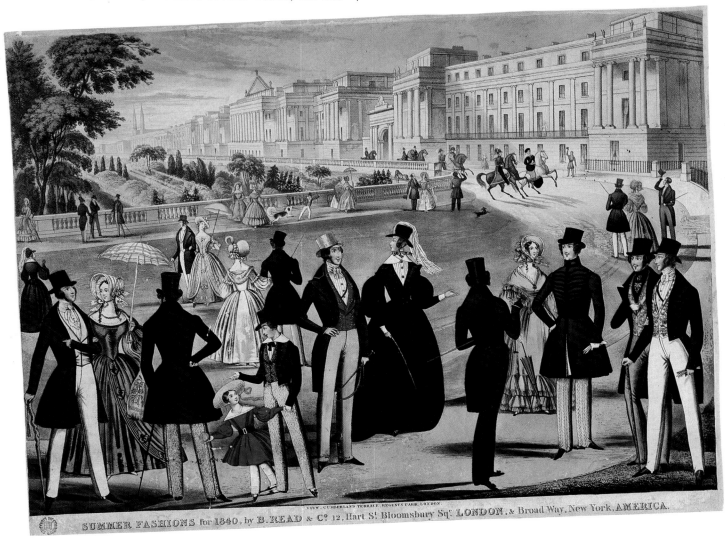

SUMMER FASHIONS for 1840, by B. READ & Cº 12, Hart Sᵗ Bloomsbury Sqᵉ LONDON, & Broad Way, New York, AMERICA.

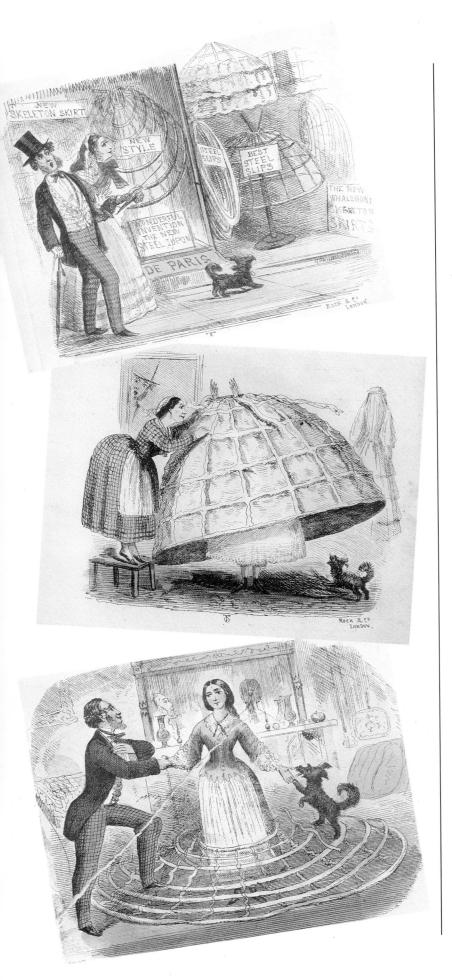

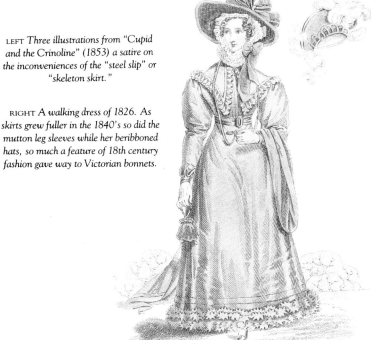

Much scorn was poured on working women who attempted to emulate the fashionable tastes of the leisured classes. The magazine *Punch* satirized working girls who adopted the crinoline, depicting a maid moving though a drawing room like a hurricane, her billowing skirt disturbing everything in its path. The lower classes appear not to have been inhibited by this. Cheap illustrated magazines showed what fashionable society was wearing and they sought to emulate it; skirts could be purchased, for example, with a band to hold the train up while a woman worked.

Against this background of highly impractical clothes, a number of attempts were made at dress reform. In 1851 an American, Amelia Bloomer, came to England proclaiming the merits of a sensible and not unfeminine costume known as bloomers. She proposed that women should wear a simple bodice, a wide skirt reaching just below the knee, and underneath that a pair of loose fitting trousers reaching to the ankles and tied with lace. This notion was derided by the British press and public. The greatest attempt at dress reform did not happen until the 1880s under the auspices of the Aesthetic Movement.

By the somewhat exaggerated standards of women's costume in the period, male dress in the Victorian period appears relatively practical. Although social convention wrapped masculine dress in strict social codes, where different occasions demanded particular costume, men were not greatly inhibited by the clothes they wore. The essential character of men's dress was in most respects little different from the formal dress of the 20th century. Lounge suits first worn in the 1850s, were a useful and comfortable style of dress. It is the fashionable

accessories of the period that mark the characteristic Victorian differences in masculine fashion. Top hats, and silver- and ivory-topped canes have long since fallen out of use.

Victorian men appear to have allowed colourful novelty to enter their wardrobes in one respect: their waistcoats. Often known as 'fancy' waistcoats, these were fashionable until the 1870s when the three-piece-suit came to dominate taste. They were often decorated with lavish embroidery, figured silks with small patterns, or woven velvet. Under the influence of Prince Albert, tartan waistcoats became very popular in the 1850s.

VICTORIAN TOYS

Social historians have argued that children became visible in the late 18th century. In earlier ages they had simply been regarded as young adults. The Victorians created a picture of childhood as a time of innocence and wonderment that remains with us today. That they doted on their offspring is proven by the thousands of toys that they showered on them. A French observer wrote:

 They have an extraordinary regard in England for young children, always flattering, always caressing, always applauding what they do . . .

Victorian parents combined love for their children with a passion for education. The period marked the greatest development in the British educational system. By the end of the 1870s every child, however humble his or her origin, could expect to receive a rudimentary education. Similarly, homes across the country were filled with pedagogical toys such as building blocks and teaching board games imparting knowledge of the Empire or regal genealogy.

The doll was the essential Victorian toy for little girls. Producers brought to dollmaking all the characteristic Victorian inventiveness of their age. Dolls at the beginning of the young Queen's reign had wax modelled heads and rag bodies. The rich could import from Germany and France talking china manikins which exclaimed 'Mama', or 'shut-eye' dolls whose eyes would roll back when tilted. In the middle decades of the century manufacturers tried a number of different materials to bring the look of expensive china dolls to the growing middle class market, including papier-mâché. In the 1860s, they came up with an unglazed porcelain called bisque, which gave a matt surface and realistic appearance. Bisque dolls ranged from miniature princesses in ballgowns with elaborately looped hairstyles, to gardeners in green velvet jerkins with miniature tool kits. Around this time it also became fashionable to have little baby dolls with chubby faces and jointed limbs. The Victorian public were fascinated by dolls. Some of the most popular exhibits at the 1851 Great Exhibition were dolls made by a Parisian, Madam Augusta Montari.

Dolls' houśs rank alongside dolls as Victorian toys of the first degree. These toys date back to the 16th century, and

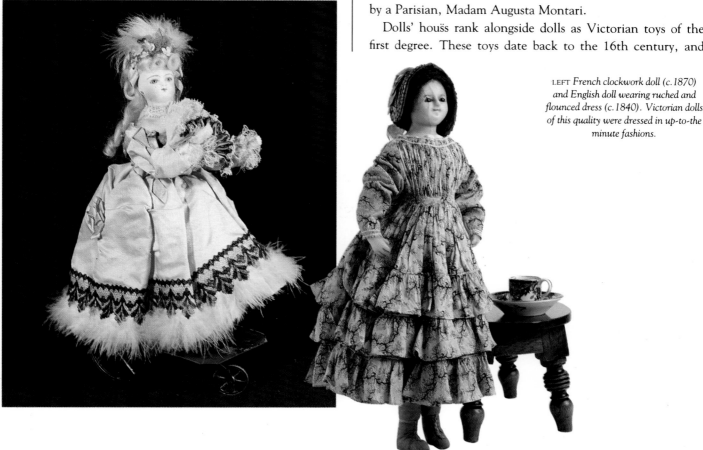

LEFT *French clockwork doll (c.1870) and English doll wearing ruched and flounced dress (c.1840). Victorian dolls of this quality were dressed in up-to-the-minute fashions.*

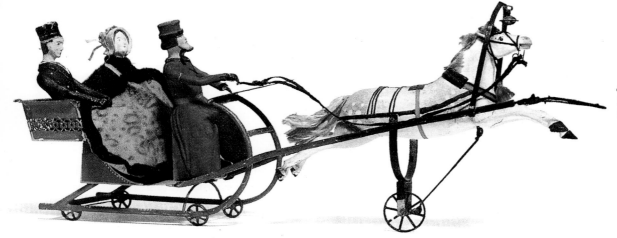

LEFT *A Lutz-type, tinplate,
one horse sleigh made in Germany in the
1870's. German toys were very popular
in Britain for their skilful workmanship.
Here, a mechanism causes the horse to
dip realistically.
Girls amused themselves with dolls
(below left) and, if the family could
afford it, dolls' houses. (below) A
modern reproduction of the mid-19th
century German dolls' house used by
the Royal children at Osborne House.*

German craftsmen had built a great reputation for amazing inventiveness and attention to detail. In the 19th century, dolls' houses proved to be very popular and could be found in many Victorian nurseries. Young middle-class girls played out their future roles as mistresses of large households with them. These little homes were precise re-creations of Victorian domestic life: servants were ensconced in the attic; drawing rooms filled with scaled-down sets of Rococo chairs with tiny cabriole legs and authentic stuffed seats and in kitchens ovens would cast a glowing light over tiny sets of china neatly displayed on tall Chippendale-style dressers. These homes were populated with tiny 'poured wax' dolls dressed in authentic costumes, wearing tiny mohair wigs. English dolls' houses tended to be made in wood and followed the form of the Georgian townhouse; classical porches, painted red brick and tall facades. They opened at the rear to allow little hands to direct the lives of their inhabitants. Toward the end of the century, German dolls' house makers produced less expensive houses with paper facades that were exported throughout the world.

Just as girls' toys displayed the Victorians' domestic concerns, toys for boys displayed enthusiasm for technological

tin armies soon invaded Britain and the rest of the world. Britain responded by producing superior cast figures authentically painted in regimental colours.

American toys became popular in Europe in the last decades of the 19th century. They often displayed a wittier character than many of their European equivalents. American ingenuity produced many wind-up and mechanical toys in tin, such as circus merry-go-rounds, walking toys, and mechanical money boxes. In return, the German toy industry exported colonial-style dolls' houses to the States, playing on American picturesque sensibilities.

FLOODS OF PRINT

If a pressman working in a small printing office at the turn of the 19th century had been transported in time to the end of Victoria's rule, he would not have recognized his trade. Encouraged by the growth of literacy, the repeal of the 'taxes on knowledge', and the demands of magazine publishers and manufacturers who wished to promote and package their products, this industry underwent a dramatic technological transformation. *The Times* newspaper, in the 1810s, was printed by skilled pressmen on two small iron-framed hand-presses, 65 years later it was produced on a gigantic steam-powered Walter Press watched over by an unskilled machine minder. The catalogue of innovations in 19th-century printing is impressive. In 1851 lithographic printing received a great boost from Georg Sigl, an Austrian engineer, who patented a machine which could print 800 to 1,000 coloured sheets an hour; in the 1870s a number of inventors developed off-set lithographic techniques which increased production rates many times. Similarly in type setting attempts were made to speed up labour intensive methods. In the 1840s, Young and Delcambre from Lille built a machine called the *Pianotyp*

progress. The last quarter of the century saw the great rise of tinplate toys. Against the background of the massive growth in the railway system in Britain known as 'Railway Fever', young boys received tinplate locomotives as birthday and Christmas presents. These beautiful scaled-down models of the great trains and carriages of the Great Western Railway or the London, Midland and Scotland Railway, were correct in every detail, including their richly coloured liveries. Again, German skill proved far superior to that of British toymakers, and the best of these toys were made by the firm of Marklin. They produced railway masterpieces complete with miniature tracks and signals.

Toy soldiers often populated the other shelves of nursery cupboards. Originating in Germany in the 1870s, these tiny

ABOVE *Crandall's menagerie, a painted wood American toy of 1874. Detachable parts meant that a variety of hybrid animals could be constructed.*

RIGHT *The toy train made its first appearance in the Victorian era . . .*

FLOODS OF PRINT

Invented in 1798 by Alois Sennenfelder, lithography was further developed to print colour to replace the expense of laborious handcolouring. From 1840, with the publication of the first colour sheet music covers, chromolithography was employed for posters, cards, invitations and book illustrations. The printers' skill can be seen in the variety of effects achieved. The "Louise Quadrille" cover (below) and the "Crystal Falls Waltz," both by the celebrated graphic artist Alfred Concanen c. 1880–90, could appear hand drawn to the untutored eye. So rapid were advances that the "British Isles March" of c. 1870 (below right), cannot match the quality of this programme for Gilbert and Sullivan's "The Gondoliers" (below left) of two decades later.

RIGHT Woodcut techniques were still used, as seen in this "Puss in Boots" pantomime poster.

LEFT Jules Cheret (1836–1932) began the French vogue for art posters in the 1860s. The glowing colours and immense verve of his lithographic work is unmistakable.

which could set over 6,000 characters an hour compared to 500 by a skilled compositor.

Newspapers and magazines were the primary beneficiaries of these radical innovations. They reduced costs, increased print runs and brought graphic images to a public hungry for vivid depictions of the dramatic news stories of the day; wars, sordid court cases and national disasters. The Victorian era saw the great days of illustrated journalism and the weekly *Illustrated London News*, founded in May 1842, was the king of them all. It specialized in visual hyperbole and sensational stories. In its first edition the leading article described 'The Great Fire of Hamburg', and was illustrated with a woodcut copied from an old print of the city augmented with clouds of smoke and raging flames. *The Illustrated London News* employed artists who recorded important events, such as royal visits and international exhibitions. Their sketches were then worked up as elaborate and careful woodcuts by highly skilled wood engravers, pre-eminently John Gilbert and Walter Wilson. An average of 1,500 graphic images were produced in this magazine every year. It was so successful that it was followed by a host of competitors including *The Graphic* which was founded in December 1869. In the 1880s both journals began to incorporate photographic images as illustrations for their news items and the highly skilled trade of wood engraving began to decline.

Another, less auspicious kind of news sheet was popular with the Victorian public, which has become known as the Penny Dreadful. In the time-old tradition of chap books, these slight reports of licentious happenings and sordid crimes satisfied voyeuristic appetites. Victorian readers, or even those who were unable to read and bought them simply for their graphic content, were able to enjoy the horrors of tales like 'The Murder of Eliza Short late of Shoreditch who was strangled by a masked man', published in 1864.

This taste for the macabre received official sanction in *The Illustrated Police News* which reported dramatic and violent crimes with graphic accounts of dastardly deeds. The attempted murder of Mrs Moratti by her husband was illustrated in the May 1865 edition of the paper with a woodcut of a naked woman, her throat gashed and bleeding, fleeing across the roof tops of Hackney pursued by her husband.

Equal inventiveness was applied to advertising material in this period. In characteristically Victorian fashion, posters and publicity material were densely laid out and typographically busy. The 'Egyptian', 'Antique' and 'fat faced' types first used in the 1810s and 1820s, came to prominence in the Victorian period. Advertisers quickly realized the advantages of these bold letterforms which grabbed the attention of potential customers. In the mid years of the century a great variety of

different display typefaces were designed. Commerce increasingly employed specially engraved wooden letters to bring novelty to their promotional material. Handbills announcing a local cattle market, for example, would be printed with types decorated with farmyard tools and animals.

Newspapers were the primary advertising media employed by manufacturers, despite the reluctance of the newspaper proprietors themselves. In the early years of the 19th century they placed strict restrictions upon these public communications. Although the whole front page of newspapers of the time were given over to public notices and advertisements, these conservative proprietors felt that illustrated notices, broken columns or the use of larger, bold typefaces would give unfair advantage to the companies that used them. Ingenious advertisers thought up eye-catching ways of getting round these restrictions such as repeating the same notice down the entire length of a column. These restrictions were slowly relaxed though the century and woodcut illustrations began to surface in the classified pages of newspapers. The most notable example of this occurred in the 1820s when the English artist, George Cruikshank, was employed by the firm producing Warren's Shoe Blacking to design an illustration of a cat with its hackles raised standing before a black riding boot. This image was printed above a 32 line verse called *Ned Capstan, or a Land-Cruise Postponed*, extolling the merits of this product in a number of newspapers of the day.

Toward the end of Victoria's reign, manufacturers found other ways to promote their products. The most important of these was branding. Some of the best known products today owe their identity to anonymous graphic designers in the late

LEFT AND RIGHT *The Valentine card, a Victorian invention, was often decorated with flowers, intended to impart volumes to the initiate of "the language of the flowers."*

BELOW LEFT *Greetings cards grew more elaborate as the century drew to a close, a testament to increasing mechanization as these pierced wedding and souvenir cards demonstrate (below right).*

19th century who produced striking packaging for everyday items. It is hard to visualize a Coca-Cola bottle now without thinking of its curvilinear bottle, or of Cadbury's chocolate or the firm of Boot's, founded by James Boot in 1850, without remembering their famous calligraphic logos. This iconography was reinforced by newspaper advertisements and posters that often simply depicted the product, little more was needed to register in the subconscious of 19th-century consumers.

Handbills were also a key advertising medium for Victorian commerce. People walking through the streets of London would have hundreds of sheets of paper pressed on them urging attendance at choral concerts or abstinence from alcohol, persuading them to see 'the miraculous giantess' or exhibitions at the Royal Academy. One late-Victorian recorded collecting over 30 such bills on a short morning stroll through Holborn. Sandwichboard men were also a characteristic feature of Victorian street life. William Smith, the manager of the New Adelphi theatre, in promoting Watts Philip's play, *The Dead Heart* in 1859, had five million handbills printed and distributed, and employed men to walk around the streets of the capital carrying heart-shaped boards.

Phineas Taylor Barnum, the greatest circus leader of the 19th century who greatly entertained the Queen when he

brought the Barnum and Bailey Circus to London in the 1880s, was a master of hyperbolic advertising. His use of trumpeting 'fat' typefaces echoed the fanfare style of his posters. 'WHAT IS IT? MAN OR MONKEY' questioned one such poster in 1861 in letters six inches high.

The shaded, florid, and three-dimensional faces for these bold advertisements were to the distaste of this traditionalist who lamented the Victorian pursuit of novelty. He wrote:

> The chaste and dignified black letter and Old Face sprouted horns and were dishonoured. They bellied out into obesity, they were eviscerated and herring-gutted; they thickened to Dorics, shrieked to hysterics, shrank to hairlines. The world of Caslon and Baskerville, Janson and Boldoni and Aldus became the world of Caliban.

Lithography was a revolutionary colour printing technique developed in the 1790s by Aloys Senefelder in Munich. It was a highly elaborate process which was slowly refined over the course of the century so that by the 1890s artists in France, such as Jules Cheret and Henri Toulouse-Lautrec were able to exploit its graphic fluidity to produce great works of poster art. But in the High Victorian period it must be noted that one field of commercial graphic art utilized this technique to great effect; the song sheet. In fact, Senefelder developed the art of lithography expressly to produce attractive song sheets. They first appeared in Britain in 1840, and by the middle of the century a number of graphic artists had built their reputations on the strength of their designs for music covers. One of the most prolific, Alfred Concanen, produced witty caricatures of Victorian characters; music hall singers such as George Leybourne known as 'Champagne Charlie', one-man-bands, dandies and fops. The letterings used for the song titles were often beautiful examples of Victorian taste; highly florid and ornamental.

The establishment of the penny postage system in the 1840s by Roland Hill enabled Victorian Britain to become the first society to celebrate anniversaries and special occasions with greeting cards. Henry Cole inaugurated this tradition when he asked the painter J C Horsley to design a Christmas card in 1843. This 'new' tradition established itself so quickly that by the 1880s the Post Office had to make its first appeal to post early for Christmas. In contrast, the tradition of sending Valentine cards was a genuinely old one. Despite being married, Samuel Pepys recorded in his diary sending gifts on 14th of February to the object of his affections, Sir William Batton's daughter. 19th-century conventions demanded not the sending of gifts but rather the despatch of written messages of love. Printers in dark back streets produced thousands of sentimental cards with glowing verses like:

How can I want the love to grant.
And thou so kindly pressing,
I am thine own, my dearest one
Scorn not this heart confessing.

In their design these cards were no less sweet, decorated with flowing floral borders, cupids and putti, doves and ribbons and lace. Churches, not surprisingly, were popular motifs, for whilst Pepys' motives may have been somewhat less than honourable, the Victorian mind was bound by a strict sense of moral propriety, (publicly at least).

VICTORIAN FUNEREAL CULTURE

The Victorian age was a highly romantic one, and there was no greater expression of this than in attitudes toward death. They created a complete funereal world in architecture, dress, and social codes. Queen Victoria herself was the main protagonist in this grand theatre, spending virtually the whole of the 1860s in mourning for her husband, Albert. She became nationally known as the 'Widow of Windsor', and spent the rest of her long life surrounded by mementoes of their two decades together.

Funerals of national figures gave the public the opportunity to participate in this grand pageantry. The extraordinary funeral of the Duke of Wellington, a national hero and a legend to the troops that had served under him, was one such affair. He died in November 1852 and was laid in state for one week before his burial. On the first day the public were admitted, three people were killed in the crush, such was the clamour to see this subject of national veneration. On the last day, 65,073 people filed past his body in the Chelsea Hospital.

The procession began in the early morning of the 18th of November, 1852 from Buckingham Palace. It was led by six battalions of infantry, followed by five squadrons of cavalry. The slow pace of the procession was marked by military bands playing death marches and dirges. The stately funeral car, designed by Prince Albert and Gottfried Semper, was majestic. Decorated with Renaissance-style forms such as dolphins, heraldic devices and ornamental militaria, it was was 27 feet long, made from bronze and weighed over ten tons. The Duke's coffin was covered with a silver pall and lay on a guilded bier. It took 12 horses to pull it through the streets of London.

In the drizzling rain, tens of thousands lined the route of the funeral cortège leading to St Paul's Cathedral. The Times

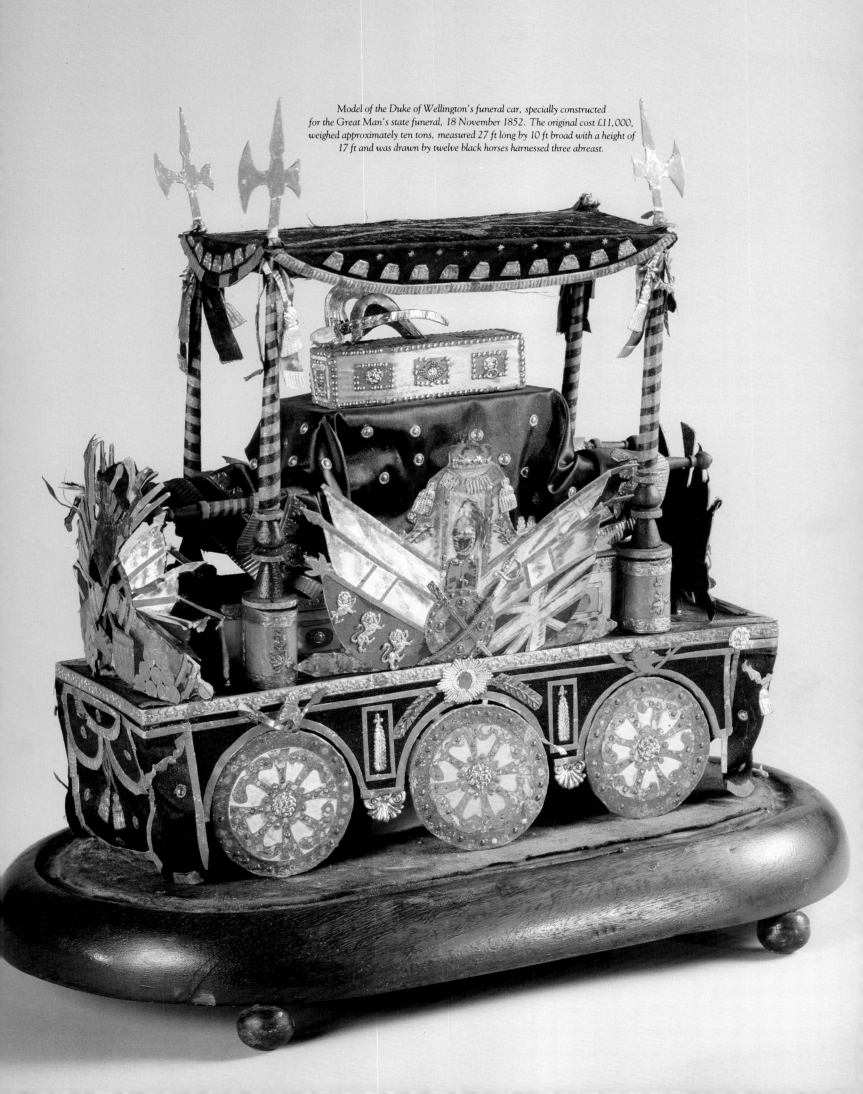

Model of the Duke of Wellington's funeral car, specially constructed
for the Great Man's state funeral, 18 November 1852. The original cost £11,000,
weighed approximately ten tons, measured 27 ft long by 10 ft broad with a height of
17 ft and was drawn by twelve black horses harnessed three abreast.

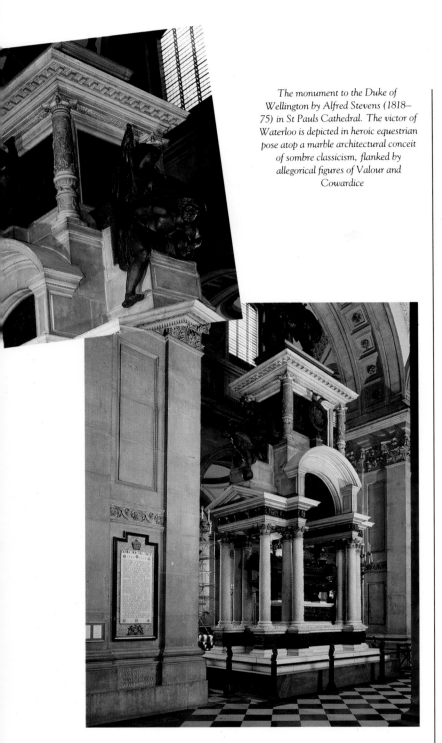

newspaper reflected the pitch of feeling when it stated: 'It was impossible to convey any idea of the emotion felt by the nation, nothing like it had ever been manifested before'. As the cortège passed the thronging crowds, who had travelled from all over the country, all the men present doffed their hats as a sign of respect.

Inside St Paul's 1,800 people were packed into the naves and aisles. Here the pageantry intensified, with the Duke's coffin followed by his insignia, his spurs borne on a velvet cushion by York Herald, his sword and target by Leicester Herald, his surcoat by Chester Herald, and his coronet by Clarenceux King of Arms. The final act of this grand perform-

ance was when the Duke's Comptroller broke Wellington's staff into pieces and Garter King of Arms laid them in the grave, at which point guns fired across London.

It is interesting to note that the Queen, while approving of the pomp and ceremony of this event, disapproved of 'black' funerals, in which every element of the ceremony was covered in black crepe. Even Temple Bar, the entrance to the City, was entirely cloaked in this fashion, at Albert's behest. Her own funeral, in 1901, which she planned down to the minutest detail, was to be a cheerful event. The pall covering her coffin was white and gold, and the streets of London were bedecked in purple cashmere and white satin.

The importance attached to state funerals was almost matched by the consecration of lesser individuals. It was commonly thought necessary 'to provide silver-plate handles of the very best description, ornamented with angels' heads from the most expensive dies. To be perfectly profuse in feathers. In short, to turn out something absolutely gorgeous'.

Funerals were excellent opportunities for conspicuous displays of wealth and status. Even the lower classes placed great store in having a 'decent' ceremony. One writer estimated that nationally over £4 million was spent on funerals a year in the 1850s, a very great sum at that time.

Strict social codes were established concerning mourning. *Sylvia's Home Journal*, for example, advised its readers that a period of 21 months was the appropriate length of time for a mother to be in mourning for a dead child. A widow was expected to spend an even longer period dressed in black and wearing mourning jewellery. Although visible expressions of grief were to be found in all ages, the Victorian period took this phenomenon to new heights. It was not unheard of for a woman to be married in a black wedding dress should a period of mourning coincide with her wedding. Mourning was divided into stages so that the immediately bereaved would be expected to wear the plainest and darkest of costumes and those further into their period of mourning were able to wear greys, striped silks in black and white, and a greater range of trimmings. Bonnets, capes and shawls were considered appropriate items of mourning dress as they encouraged modesty. Whole industries sprang up to supply the accoutrements of grief. The Whitby producers of jet, a black semi-precious stone, prospered through the fashion for mourning jewellery. A 'Mourning Warehouse' owned by Peter Robinson in London's Regent Street kept 'garments in stock for every degree'.

Cemeteries and graveyards also received much Victorian attention. This was a most religious of ages and some objected to the use of classical, ie pagan, decorative forms in Christian memorials. The Gothic ideologue, Pugin, thundered: 'If we worshipped Jupiter, or more Votaries of Juggernaut, we would

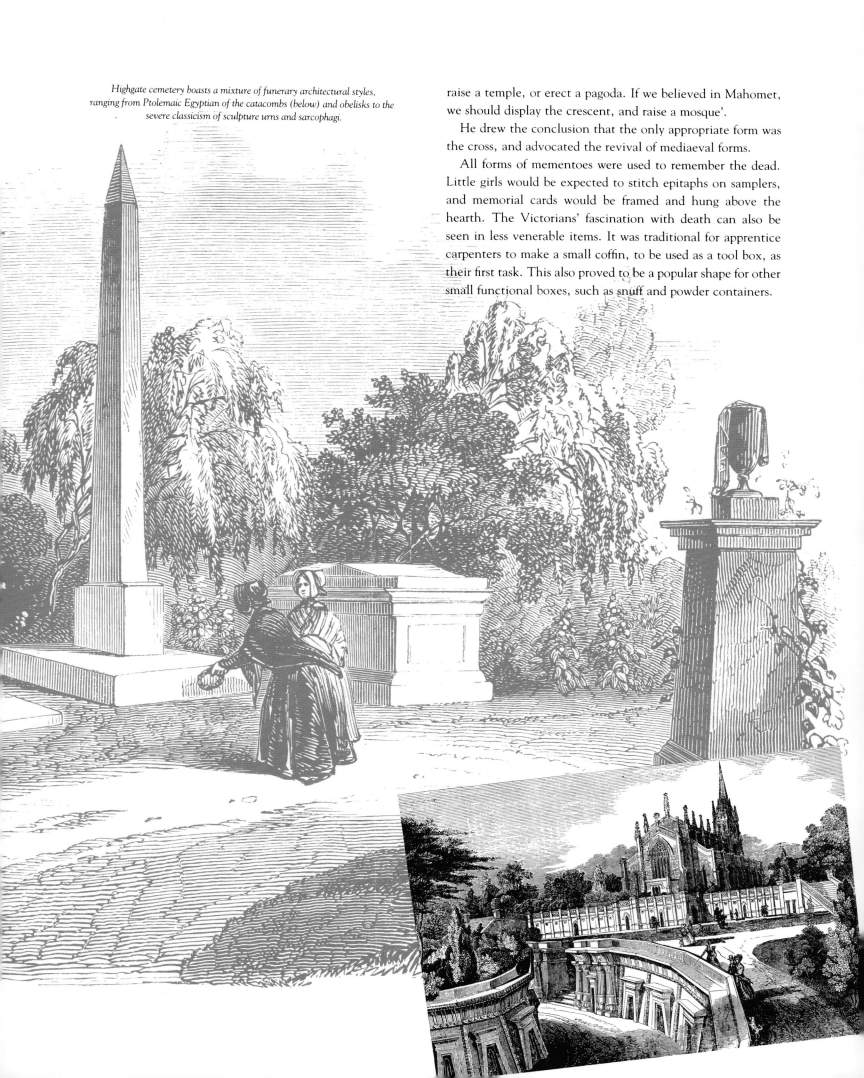

Highgate cemetery boasts a mixture of funerary architectural styles, ranging from Ptolemaic Egyptian of the catacombs (below) and obelisks to the severe classicism of sculpture urns and sarcophagi.

raise a temple, or erect a pagoda. If we believed in Mahomet, we should display the crescent, and raise a mosque'.

He drew the conclusion that the only appropriate form was the cross, and advocated the revival of mediaeval forms.

All forms of mementoes were used to remember the dead. Little girls would be expected to stitch epitaphs on samplers, and memorial cards would be framed and hung above the hearth. The Victorians' fascination with death can also be seen in less venerable items. It was traditional for apprentice carpenters to make a small coffin, to be used as a tool box, as their first task. This also proved to be a popular shape for other small functional boxes, such as snuff and powder containers.

CRITICS OF
VICTORIAN TASTE

ABOVE *James McNeill Whistler, an American trained in Paris, was instrumental in
bringing the influence of French Impressionism to England. With its emphasis on
mood and atmosphere* Nocturne: Blue and Gold *(1872–75) moves away from the
anecdotal tradition of Victorian painting.*

uring the Victorian period there were many critics of society and its values. Challenges were issued to every aspect of 19th-century life. Thomas Carlyle, in his book *Past and Present* of 1843, related the development of the industrial revolution to the erosion of spirituality that he saw around him. Charles Dickens criticised many facets of Victorian society from housing to the legal system.

Artists, designers and architects played a significant role in this attack on Victorian values. It is possible to find challenges in every area of art, design and industry, issued to Victorian orthodoxy. The tight-laced corset and the bustle were met by the long, freely-flowing robes of the dress reformers. Commercial retailing derived from American selling techniques found their aesthetic equivalent in Liberty's in Regent Street which sold the fashionable and exotic. The advertising posters in bold fancy types on the streets of every city were quietly attacked by William Morris and his Kelmscott Press. The great symbol of Victorian comfort, the deeply upholstered, wing-backed 'Grandfather' armchair found its match in the great icon of the Victorian domestic revival, a Morris and Co. rush-seated, ladder-backed Sussex chair. Even colours were immediately recognizable as belonging to one side of Victorian society or another: newly invented aniline dyes which gave rich purples and green reeked too strongly of Victorian commerce and industry for their critics, who preferred natural dyes produced by traditional means or gentle pastel hues.

WILLIAM MORRIS

The seeds of dissent were sewn early in Victoria's reign with the highly moralist writings of figures such A W N Pugin and John Ruskin. As shown in earlier chapters William Morris was strongly persuaded by their anti-machine age philosophies. He proved to be a great influence both as a theorist of design and as a practising designer. Proposing an art for the people, produced by the people, he rallied against Victorian industrial production which had achieved pre-eminence in the world at the cost of great ugliness and bad taste. As a socialist he believed that in promoting vernacular craft skills, he would restore to the working man his dignity, and to everyday objects the natural ease which they had possessed in years gone by.

Morris's practice and philosophy is complex and his ambitions were rarely realized. The Firm's designs of the 1860s in

LIBERTY FURNITURE

Though fortunes of
Liberty & Co. were initially based on
the vogue for Japonaiserie, the company
soon branched into other exotic
decorative items. Moorish style oak
furniture with mushrabiya fretwork of
c.1880 (below opposite) was followed
four years later by the "Thebes"
stool (opposite left), based on Egyptian
originals in the British Museum. By the
end of the century the Celtic revival was
inspiring designers such as Archibald
Knox, responsible for this earthenware
jardinière (left).

RIGHT The "Sussex" chair, a traditional
rush-seated armchair of ebonized
beechwood by Philip Webb, was a
popular Morris design. Much of the
later furniture for the Firm was designed
by George Jack, Webb's former
assistant, including this dining table
from the 1890s (below).

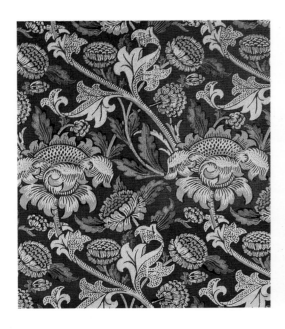

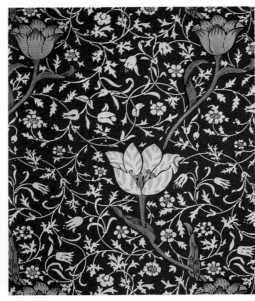

In 1881, two years after Morris had set up at Merton Abbey, he patented 17 printed cotton designs including "Wey" (far left) and the still popular "Strawberry Thief." "Medway" (left) was designed and registered in 1885.

BELOW Marquetry escritoire and stand designed by George Jack for Morris & Co. in 1889.

fabric and stained glass were resolutely Morrisian, but in the 1870s the will appeared to falter. Under commercial pressure they produced hundreds of wallpaper and fabric designs which became increasingly florid and detailed. Chintzes such as Honeysuckle of 1875, and Wey of the early 1880s, appear to be concessions to public taste. Morris's silks were produced by mainstream producers such as the firm of Nicholson's, and his carpets by Wilton and Axminster, none of whom paid much heed to arguments against the division of labour. Similarly, Morris's pleasing embroideries of the late 1870s were not made by Morris and his friends but put out to skilled embroiderers. Despite his ideas about bringing together art and craft, only one of the craftsmen employed by the Firm progressed to becoming a designer for them. But Morris was always concerned with the nature of the work he expected his craftsmen to perform. He encouraged the hand knotting techniques of tapestry making, for example, because he believed that they allowed the worker more artistic freedom.

Morris's designs, despite his dearly held ambitions to improve the lot of the working classes by raising the standard of design in all areas of life, remained the province of the aristocratic and the rich. Morris put this much more graphically, regarding his career as 'ministering to the swinish luxury of the rich'.

After Morris took up politics in 1883, joining the Democratic Federation led by H M Hyndman, his attitude to industrial production shifted. Looking around at the soul destroying factories producing shoddy and showy products, but realizing that the benefits of good design through craftsmanship could not be afforded by the majority of society, he advocated a highly restricted use of machinery. In books like News from

Nowhere he painted a visionary picture of a world in which machines ran for four hours a day in factories bordered by beautiful gardens filled with sculpture. He envisaged a society free of the conspicuous consumption of Victorian materialism where the values of education and goodwill would dominate.

Although Morris's designs were only to be found in the homes of the affluent and fashionable in late 19th-century Britain, his impact on the development of art and design was enormous. Morris's thought and practice were the primary inspiration behind the avant-garde of the 1880s; the Arts and Crafts Movement. This loose alliance of artists, craftsmen and designers united around a twin asethetic and social philosophy, based on the importance of making.

RIGHT *Handmade carpets, known as "Hammersmith rugs" to distinguish them from machine-made carpets manufactured by Morris & Co., were highly labour intensive.*

BELOW *The Green Dining Room designed by Webb in 1866 for the South Kensington Museum was a tremendous success. The stained glass and wall paintings were by Burne-Jones, the polychrome raised gesso decoration by Webb, embroidered screen by Morris and his wife, and the piano was decorated by Kate Faulkner.*

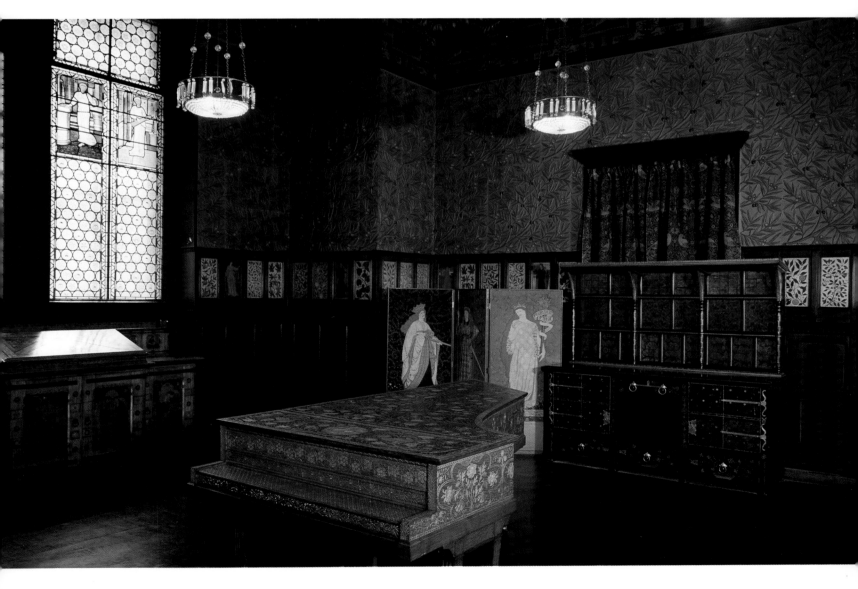

THE ARTS AND CRAFTS MOVEMENT

The Arts and Crafts Movement gathered momentum with the formation of the Century Guild in 1882 by Arthur Heygate Mackmurdo and Selwyn Image. Mackmurdo had travelled through Italy in 1874 with John Ruskin as his companion and assistant, and had absorbed much of his social and aesthetic ideology. This can be seen in the development of his career, for, although trained as an architect, he had spent much time working in the East End of London with the poor. As an architect he aimed to design, build and furnish complete buildings down to the minutest of details: from the whole façade down to each key hole. He lamented the decline of the guild system of the Middle Ages which would have presented the corporate means with which to do this. He resolved to form his own guild of like-minded people who could work together to evolve a collective style. His Century Guild was constituted by Selwyn Image, a poet and designer; Herbert Horne, a designer of fabrics and wallpapers; Clement Heaton, who specialized in cloisonné enamel work; and George Heywood Sumner, who was renowned for his *sgraffito* designs, a pottery technique in which a surface glaze is scratched away to reveal bright colours.

The Century Guild aimed to turn design into art, overturning the prevailing aesthetic hierarchy. Their collective aim was 'to render all branches of art the sphere of not the tradesman but the artist'. They promoted their aesthetic philosophies through their journal *Hobby Horse* which was first published in 1884. They believed that art was too important to be hidden away in the private world of salons and the academies and wished to see it in everyday things. The Guild had its first opportunity to do this at Pownawy Hall in Chesire, when H Boddington commissioned them to design all the furnishings and fittings there.

The Century Guild aimed to develop an aesthetic that was appropriate to their own time. They rejected the historicism of Victorian art and architecture in favour of an artistic language derived from nature. This was a major departure in the late Victorian period. Although William Morris had designed simple patterns for wallpapers and fabrics in the 1860s that were derived from natural forms, his work always carried traces of historic languages. His later works, for example the books produced by the Kelmscott Press founded in 1891, maintained a Gothic character. In contrast, Mackmurdo, under the auspices of the Century Guild designed some of the most strikingly original works of the century. His title page for his *Wren's City Churches* published by G Allen in 1883, is remarkable for

its use of undulating and whiplashing floral motifs which prefigured Art Nouveau. This was not an isolated incident in Mackmurdo's design *œuvre* for in the early 1880s he designed a chair for the firm of Collison and Lock, the back of which employs brilliantly composed twisting plant forms.

A H Mackmurdo was in many respects quite unlike most of his Arts and Crafts contemporaries who were often rather serious and dour. With a flamboyant and colourful character he was somewhat closer in temperament to figures associated with the Aesthetic Movement of the 1880s and was in fact friendly with James Abbott McNeill Whistler, the painter and renowned dandy.

The conscientious core of the Arts and Crafts Movement was found in The Art Workers Guild founded in 1884 and which was later absorbed into the Arts and Crafts Exhibition Society of 1888. The Guild included some of the leading designers of the day including Lewis F Day, W R Lethaby, John D Sedding and Walter Crane. They held similar ambitions to Morris and their colleagues in Mackmurdo's Century Guild, aiming to revive the decorative arts by improving standards of design and craftsmanship. With the formation of the Arts and Crafts Exhibition Society they sought collectively to challenge the Victorian art and design establishments of the Royal Academy and the Royal Institute of British Architects. A

RIGHT *Walter Crane's "Margarete" wallpaper designed for Geoffrey & Co in 1876. Crane was later to become an influential member of the Arts and Crafts movement.*

LEFT *An oak wardrobe in the revived Queen Anne Style by Gilbert Olgilvie for the Guild of Handicraft, the co-operative group of artist-craftsmen founded by Ashbee in 1888.*

BELOW *This oak cabinet by CFA Voysey exemplifies the restraint and simplicity of much Arts and Crafts furniture.*

OPPOSITE *English Oak writing desk designed by Arthur Heygate Mackmurdo and made by the Century Guild, c. 1886.*

series of exhibitions were held in the late 1880s and 1890s, displaying works by the most able designers and artists to the public. Sharing Morris's belief in the indivisible unity of the arts, they aimed to show the fine arts alongside decorative objects, so that paintings by Walter Crane, or a youthful Roger Fry could be found hanging alongside an elegant brass teapot designed by Charles Francis Annesley Voysey.

C R Ashbee's Guild of Handicraft of 1888 was the last of the Arts and Craft guilds of the 19th century and appropriately it held the most complete vision of Arts and Crafts life. Ashbee developed his ideas as a teacher of Ruskinian philosophy in a working men's college in Whitechapel in the 1880s. He devised the idea of a pedagogical guild in which young men would be taught to design in a number of fields including cabinet-making, coppersmithing and lithography. Their designs would then be produced in workshops by craftsmen and sold to the public. The revenue from these sales would finance the organization. This system of production was to be established as a direct challenge to 'the unintelligent ocean of competitive industry'. In 1902, after 12 years based in the East End of London, Ashbee moved the Guild, the Guildsmen and their families to Chipping Camden in the heart of the Gloucestershire countryside. Here, 150 men, women and children established a communal life based on the values of hard work and wholesome living. But the scheme failed under the economic pressure to sell their lovely furniture, ceramic and metal ware to a late Victorian market that was not satisfied with such well made works of simple beauty.

THE ARTS AND CRAFTS INFLUENCE

C S Ashbee and his Guild achieved greater fame on the European continent than at home. In 1897 the Grand Duke of Hesse commissioned designs from C S Ashbee and Mackay Hugh Baillie Scott, which were made by the Guild of Handicraft. Both men stayed in his Darmstadt residence, to design two rooms. Influenced by their Arts and Crafts philosophy, the Duke then proceeded to form his own artists' colony in Darmstadt along the lines of Guild of Handicraft. He employed some of the leading artists, architects and designers of the day including Joseph Maria Olbrich and Peter Behrens.

Another group of artists and designers influenced by the philosophy of the Arts and Crafts was the *Wiener Werkstatte* (Viennese Workshops) formed by Joseph Hoffman and Koloman Moser in 1903. Their 1905 manifesto stated:

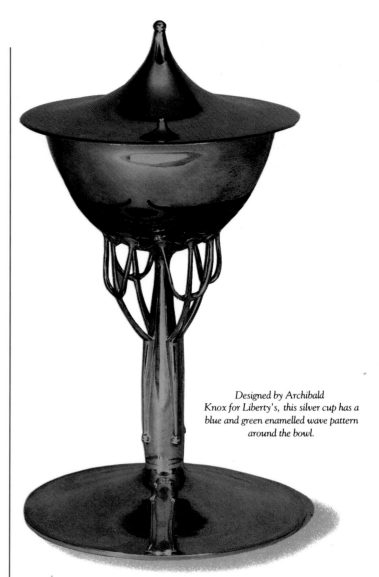

Designed by Archibald Knox for Liberty's, this silver cup has a blue and green enamelled wave pattern around the bowl.

We have founded our own workshop. Our aim is to create an island of tranquility in our own country, which, amid the joyful hum of the arts and crafts, would be welcome to anyone who professes a faith in Ruskin and Morris.

Morris and Ruskin's influence was also to be found in America. There, figures like Frank Lloyd Wright took Arts and Crafts' themes and fixations and developed a visionary design practice that anticipated Modernist design of the 20th century. In his early buildings such as the Winslow House of 1893 and designs for furniture in the last years of the 19th century he developed a stark, undecorated design aesthetic. Despite his own home, which appears from photographs to have been rather cluttered in the Victorian style, he designed low houses with open plans and plain unornamented furnishings that are described by architectural historians as the Prairie Style. His highly abstract and geometric stained glass designs, for example, at the Dana House in Springfield, Illinois of 1902, pre-date design trends of the 1930s.

ART NOUVEAU

The English Arts and Crafts Movement was also a major inspiration behind Art Nouveau, the leading movement in art and design in the late 1890s and early years of the 20th century in continental Europe. Leading Art Nouveau figures, such as Henri van de Velde and Victor Horta in Belgium, Louis C Tiffany in America, Hector Guimard in France, Stanislaw Wyspianski in Poland, and Peter Behrens and Richard Reimerschmid in Germany, all owed debts of varying degrees to the English Arts and Crafts Movement. Stylistic precedents for Art Nouveau can be found in British design of the 1880s, for example, in the Gothic architect William Burges' own house built in Kensington between 1875 and 1880 and A H Mackmurdo's works described above. But more importantly, the Arts and Crafts Movement raised the status of applied art from that of a commercial trade to an art form.

In England Art Nouveau was widely dismissed by practitioners because it lacked the critical social philosophy, so crucial to the Arts and Crafts Movement. Walter Crane, the socialist graphic designer, spoke for many when he sneeringly described it as a 'decorative disease'.

Very few British artists and designers came close to the Art Nouveau spirit found on the continent. Those few that did were even more antithetical to the Victorian age than their sober Arts and Crafts colleagues who at least preached the values of hard work and national form. To compare the qualities found in the designs by Charles Rennie Mackintosh, a Scottish designer associated with European Art Nouveau, with those found in the work of Ernest Gimson, a figure in the mainstream of the Arts and Crafts Movement, is revealing. The Arts and Crafts Movement is beautifully summarized in Ernest Gimson's masterly furniture, simple and solid works, barely decorated and in a near functional style drawn from the materials used and the method of construction. In contrast, Mackintosh's designs are enigmatic and highly aesthetic. His sculptural pieces of furniture were decorated with symbolic motifs, mother of pearl and ivory inlays, and painted; all anathema to English Arts and Crafts thought.

Another British artist widely associated with Art Nouveau, although never part of the mainstream of the movement, and much admired by progressive tastes all over the world was Aubrey Beardsley. His reputation in the history of art was largely secured for his illustrations for Oscar Wilde's *Salome*

Beardsley's designs for the Yellow Book covers introduced a new illustrative style which featured heavy black masses, evidence, once again of the oriental influence.

LEFT AND BELOW *Mackintosh's creative employment of organic forms, in particular his imaginative use of metalwork and stained glass seen here in the doors to the Willow Tea Rooms (left), and his furniture (below) had a tremendous influence on the development of European Art Nouveau.*

OPPOSITE *Design for a dado by Walter Crane.*

and a journal entitled *The Yellow Book* in 1894. His black and white drawings, populated with strange characters and bizarre plants composed with large areas of blank space in the Japanese style, caused much indignation when first published. Their unconventional eroticism scandalized polite society. Beardsley was associated with a circle of *fin de siècle* artists and writers and his work often contained sly caricatures of them. His tailpiece for Wilde's *Salome*, for example, depicted Max Beerbohm, the author of *Zulieka Dobson*, as a foetus and Whistler, the American painter, as a faun.

Whistler was a controversial figure in Victorian society. He shocked Victorian mores with his public affairs, dashing dandyfied dress and his sardonic wit. He began his career as a navy cartographer and travelled to Paris in the 1850s. There he came under the sway of radical French painters such as Henri Fantin-Latour and Edgar Degas and joined their number by exhibiting at the *Salon des Refuses* in 1863. In his enigmatic canvases he rejected the emphasis in Victorian art on subject matter, be it sentimental, moral or patriotic, for a pure aestheticism that celebrated formal qualities. His celebrated painting, a portrait of his mother in profile, is better known by its subtitle *The Artist's Mother*, than its revealing title *Arrangement in Grey and Black*. Ruskin, who dominated orthodox art criticism by the late 1870s, described Whistler's sublime painting *Nocturne in Black and Gold* as a 'pot of paint' flung 'in the public's face'. The painter responded by issuing a writ for libel in 1878. Although Whistler won the court case, the judge summed up the public mood by awarding damages of only one farthing, the smallest possible amount. Whistler was bankrupted by the legal costs.

In the 1880s Whistler was the magnetic centre of a decadent circle in Chelsea that incurred the wrath of late Victorian morality. His friend Oscar Wilde was imprisoned for his sexual behaviour and Frank Miles, a wealthy friend and aesthete went mad and died in an asylum in 1891.

Despite the somewhat clouded picture we have of trends in art and design in the late 19th century, partly as a result of the character of its leading practitioners, the dominating concern was to find solutions to the problem of Victorian style. In turning away from historicism and conspicuous excess, these artists and designers pointed towards the 20th century. In this respect, even Walter Gropius, the founder of the radical Bauhaus school of architecture and design in Germany in the 1920s and a leading proponent of Modern Movement in design, owed a debt to William Morris and his followers.

Futhermore, these late 19th-century movements were concerned with larger issues than just style. They issued a challenge to Victorian society and its dearly held values. For Ashbee and the Guild of Handicraft, this entailed a considered retreat into

communal living, and for others it took the less reasoned form of displays of decadence designed to shock middle-class morals.

To Queen Victoria and her husband Prince Albert, Victorian style, as found in the best British works at the Great Exhibition of 1851 or in the paintings by such artists as Edwin Landseer, confirmed the success of their age. They were like jewels on the crown of Victorian achievement. At the end of the century, Victoria's grandson, Ernst Ludwig, the Grand Duke of Hesse, looked to the English designers Baillie Scott and Ashbee to point towards a new world. Above the entrance to his artists' colony, intended as the cornerstone of a new utopian city, were the words:

 Let the artist show his world that which has never been nor will be.

RIGHT *Ernest Gimson, a disciple of William Morris produced furniture characteristic of the arts and crafts ideal, such as this walnut cabinet with ebony base.*

PICTURE CREDITS

Angelo Hornak Library, page **11**, **12(tl)**, **23(tr)**, **30(br)**, **33(br)**, **36(tl)**, **36(bl)**, **37(b)**, **50**, **52(tl)**, **53**, **56**, **62**, **69**, **70**, **76/7**, **79**, **80/1**, **82/3**, **84(t)**, **85(b)**, **87**, **92(t)**, **93**, **96(t)**, **103(r)**, **104(t)**, **111(l)**, **115**, **119**, **125**, **126**, **130(tl)**, **132(b)**, **133(b)**, **138(l)**; Angelo Hornak Library (American Museum, Bath), page **110**; Angelo Hornak Library, G H Pownall, page **86**; Patricia Bayer, page **92(b)**; Ian Bennett, page **10(tr)**; Bernard & S Dean Levy Inc, page **33(bl)**; Birmingham Museums and Art Gallery, page **67**, **132(t)**; Bridgeman Art Library, page **9(bl)**, **12(br)**, **19(tl)**, **34(t)**, **35**, **66(b)**, **85(tl)**, **88**, **90–91**, **95(bl)**, **102**; British Museum, page **10(bl)**; British Philatelic Bureau, page **18(tr)**; The Corning Museum, page **19(br)**; Christies, page **139(b)**; Design Council, page **32(tl)**; Francis Du Pont, page **34(b)**; Liz Eddison, page **49**, **52(b)**, **59(t)**; English Heritage, page **9(tr)**, **18(bl)**, **40(tl)**, **40br)**, **44(t)**, **45(tr)**, **45(l)**, **46**, **47(t)**, **47(b)**, **65(br)**, **57**, **118(br)**; E T Archive, page **8**, **10(br)**, **15**, **16**, **24(tl)**, **24(b)**, **27(tr)**, **29**, **30(tl)**, **31**, **32(tr)**, **33(tr)**, **35(r)**, **41(t)**, **52(tr)**, **54(tl)**, **54(bl)**, **54(br)**, **55**, **58**, **59(b)**, **74**, **95(tr)**, **96(b)**, **98(t)**, **98(c)**, **100/101**, **104(b)**, **108**, **113(b)**, **117(l)**, **120(t)**, **120(b)**, **121(t)**, **122**, **123**, **135(r)**, **139(t)**; Clive Hicks, page **97**; Cecil Higgins, page **37(t)**, **117(r)**, **130(tr)**, **130(b)**; Holman Hunt, page **60**; The Illustrated London News Picture Library, page **21**, **41(b)**, **63**; Images Industrial, page **32(br)**; Institute of Agricultural History, page **28(t)**; Lenswork, page **73**; The Mansell Collection, page **78**; Mary Evans Picture Library, page **22**, **22(inset)**, **23(br)**, **25(c)**, **25(inset)**, **26(c)**, **27(l)**, **27(br)**, **28(bl)**, **48**, **54(c)**, **64**, **98(b)**, **106**, **113(t)**, **114**, **116**, **118(bl)**, **120(c)**, **121(b)**, **127**; Pitshanger Manor Museum, page **109**; RCHM, page **99**; The Royal Collection, page **38(c)**, **42**, **43**; Royal Doulton Ltd, page **14/15(c)**, **15(tr)**, **35(bl)**, **65(bl)**, **84(b)**; Arthur Sanderson & Sons Ltd, page **20**; Sotherby's, London, page **118(t)**, **135(b)**; Tyne and Wear Museums Service, page **65**; Victoria and Albert Museum, London, page **75**, **103(t)**, **136**, **137**; Visual Arts Library, page **6**, **60**, **89**, **128**; Walker Art Gallery, Liverpool, page **66(t)**; Elizabeth Whiting, page **36(br)**; William Morris Gallery, Walthamstow, page **94**, **95(br)**, **131(b)**; Wolverhampton Art Galleries & Museums, page **103(l)**.

INDEX

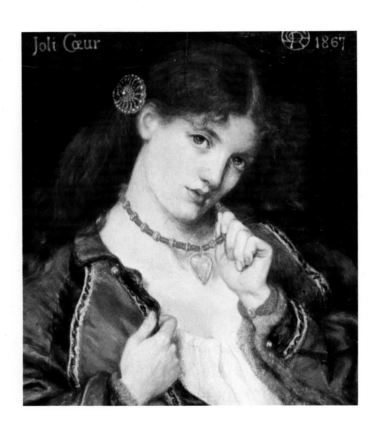